ESTIMATES IN ART

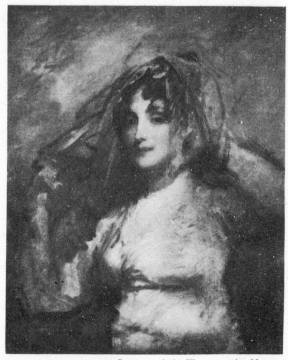

GILBERT STUART, "Mrs. Perez Morton" (sketch)

ESTIMATES IN ART

SERIES II

SIXTEEN ESSAYS ON AMERICAN PAINT-
ERS OF THE NINETEENTH CENTURY

BY

FRANK JEWETT MATHER, Jr.

Essay Index Reprint Series

 BOOKS FOR LIBRARIES PRESS
FREEPORT, NEW YORK

STANDARD BOOK NUMBER:
8369-1527-5

LIBRARY OF CONGRESS CATALOG CARD NUMBER:
70-93356

PRINTED IN THE UNITED STATES OF AMERICA

To

MY DAUGHTER

SHARER OF MY TASTES

FOREWORD

From a series of essays written over a period of twenty years no intelligent reader will demand complete consistency of opinion. So, while I have retouched and amplified these studies where it seemed necessary, I have made no attempt to edit them into an artificial coherence. They must stand as the best I could do at the time of writing. Most have been published in magazines, but the Inness and Fuller are here first printed. While there has been no endeavor to make a group of essays serve as a systematic history, I believe no highly significant American painter of the nineteenth century has been omitted, saving always John La Farge, whom the reader will find not inappropriately treated among the old masters, in the former volume of "Estimates." For courteous permission to reprint copyright matter thanks are expressed to the publishers of *Scribner's*, *The Nation*, *The Review*, *Art in America*, *The International Studio*, and *The Saturday Review of Literature*. A special acknowledgment is due to *The Phillips Publications* and to Mr. Frederic Fairchild Sherman for the

exceptional magnanimity with which they have authorized the reprinting of considerable passages from their books, respectively on Arthur B. Davies and Homer D. Martin.

F. J. M., JR.

Princeton, N. J.

CONTENTS

FACE-PAINTER AND FEMINIST

THE ART OF S. F. B. MORSE

GEORGE INNESS

ELIHU VEDDER

AFTERTHOUGHTS ON WHISTLER

GEORGE FULLER

HOMER D. MARTIN

ALBERT PINKHAM RYDER

WINSLOW HOMER

THOMAS EAKINS

THE ENIGMA OF SARGENT

CONTENTS xi

ARTHUR B. DAVIES

ILLUSTRATIONS

I

GILBERT STUART

FACE-PAINTER AND FEMINIST

FACE-PAINTER AND FEMINIST

An excellent painter, Gilbert Stuart was far from an exemplary character. He was capable of neglecting attached parents, of ridiculing a benefactor, of accepting advances for portraits which he never painted and possibly never intended to paint. His return to America, far from being a patriotic pilgrimage to the feet of Washington, as Dunlap glowingly represents it, was an incursion into an unspoiled field of patronage, London, and Dublin having become too hot for the artist adventurer. All this may seem unimportant, but I think not. A face-painter with fewer foibles of his own would not have caught with Stuart's uncanny insight the foibles of others, while an almost illiterate colonial youth of low degree would hardly have made himself a favorite in the best society of Dr. Johnson's London had he offered as qualification simply a steady and dependable character. Instead Gilbert Stuart offered an extraordinary tact and wit and a competent mastery of his craft. It was enough wherever he turned.

For some weeks I have been turning over the plates in Lawrence Park's monumental catalogue, reviving old memories of the originals, with the result that one old impression has been confirmed, and an entirely new impression has been gained. I remain of the old opinion that while Gilbert Stuart was not quite a great portrait painter, he was one of the greatest of face-painters, whereas I realize for the first time that Stuart was one of the ablest interpreters of womanhood that the art of painting has seen. Intending nothing derogatory by the term, I feel that the word face-painter precisely defines Stuart's notable excellences and his equally patent limitations. Within his lifetime worked Reynolds, Gainsborough, Raeburn, Goya, David, and Ingres. None of them painted a face better than Stuart, and several of them painted it less well, but all of them have a stronger claim to be regarded as great portraitists. Stuart's interest was usually exhausted with capturing the forms and character of a face. He was a specialist, and contentedly so. There was an early moment when under the influence of Gainsborough he aimed at style. Later he cared only for likeness and character. His compositions are the entirely adequate improvisations of a very clever per-

son. His accessories and costumes are bril-
liantly touched in, but often remain extraneous
to the pictorial effect. And this neglect was
from choice and not from lack of ability. The
costumes and accessories in the portraits of Don
Josef de Jaudenes y Nebot and his wife in the
Metropolitan Museum are of exquisite fitness
and character. Stuart could paint hands beauti-
fully, but usually avoided the task, and often
painted them badly. Except for the very pic-
turesque "A Gentleman Skating—William
Grant, of Congalton," a canvas emulative of
Gainsborough, Stuart's rare full-lengths are
tritely composed. Again, unlike all his por-
trait-painting contemporaries, Stuart was never
tempted away from his specialty. But is not
the great portrait painter normally a great
painter who incidently makes portraits?

Indeed it is doubtful if the man who paints
only portraits will ever paint great portraits.
Stuart painted hundreds of amazingly true and
vivid masks—the Vaughan Washington, the
Mrs. Perez Morton are types, but did he ever
paint a portrait that would hang quite comfort-
ably beside a Titian, a Vandyke, a Goya, a
David, or an Ingres? Which only means that
Stuart could or would not provide that surplus

beyond fine face-painting, that sustained pictorial richness and character, which the finest portrait painting demands. In Titian's "Ariosto" the quilted satin sleeve is as eloquent as the sensitive olive face and the silky raven beard. Rembrandt's "Lady with a Fan" would without the exquisitely painted fan lose half her existence. It is doubtful if these extensions of meaning, this animism in the inanimate, can be learned solely in portrait painting. At least Stuart never did learn this magic, and his place, a very honorable one, is rather with the Moros, Mierevelts, and Knellers than with the Holbeins, Velasquezes, and Hogarths.

Again a scrutiny of Park's fine reproductions produces the disconcerting surprise that the male portraits which Stuart made in his eighteen British years are as a class far superior to those which he painted in America, and withal that one could form from his entire work a group of women's portraits which for character and vitality have been surpassed by no painter except Rembrandt. In order that the reader may check these bald assertions, let me propose a game with him. I will make a group of a dozen British male portraits by Stuart, challenging the reader to make a group of male Americans by Stuart that shall be equal

in character and pictorial beauty. Throughout, the British group will show with an equally vivid character a finer and more studied pictorialism. Here is the British group; it may readily be considered in Park's illustrations, which are alphabetically arranged: Sir Cropley Ashley-Cooper, James Boydell, William Kerin Constable, Dr. John Fothergill, James Heath, Ozias Humphrey, Dr. William Smith, Gilbert Stuart, Thomas Baron Sydney, James Ward, Benjamin West, Edmond Sexton, Viscount Pery. If the reader loses in this game, as I am confident he will, I must further remark that, with a few exceptions, the finest male portraits that Stuart painted after his return to America are those of foreigners—notably Don Josef de Jaudenes y Nebot, Count Volney, the Marquis d'Yrujo. These are all finer pictorially than most of the American male portraits, and expressed with a more complete sympathy.

Let us play the second hand of the game. I will choose a list of a dozen American female portraits which for sheer vitality and vivid personal presence will bear comparison with any dozen female portraits by any painter whatsoever—Rembrandt only barred. The list is: Mrs. William Bingham, Miss Maria Bartlett,

Miss Clementina Beach, Mrs. John Bullus, Mrs. Samuel Cary, Mrs. Henry Clymer, Mrs. Charles Dearborn, Mrs. James Greenleaf, Miss Elizabeth Inches, Mrs. Perez Morton (the sketch), Mrs. Edward Tuckerman, the Marchioness d'Yrujo (née Maria McKean). The addition of an English portrait or two, such as that of the Marchioness of Dufferin, would enrich the list. Now I am perfectly aware that from many painters could be chosen a dozen female portraits of finer pictorial accomplishment, but I doubt if any other dozen save Rembrandt's would yield so many keen and irresistible impressions of so many actual women. Merely turning over the relatively unspeaking reproductions, there comes over me the old pathos of François Villon's deathless ballade—the deep pity that so much charm, character, and warm life are now but scattered bones, white as the snows of yesteryear, and a handful of brown dust.

I feel the reader will find not only that my list will bear the proposed hard test, but that two or three alternative lists could be chosen that would meet the test nearly as well. If this be so, my initial assertion that Stuart is the

greatest painter of woman's character stands, and we gain the further point of view that when Stuart painted women the usually clear line between fine portraiture and consummate face-painting tends to disappear.

We may attempt to interpret these facts in terms of Gilbert Stuart's life and character. Returning at forty to the native land which he had willingly left at her moment of greatest need, Stuart really returned as a distinguished foreigner, with a foreigner's attitude. For that robust and varied man's world of which he had been a large part, in the London of Dr. Johnson, Reynolds, and Pitt, Stuart found no equivalent in New York, Philadelphia, or Boston. His nostalgia he was too tactful to reveal, though it appears plainly enough in his anecdotage, and he assuaged it by wit and work. To the American man he gave what the American man wanted, a most resolute and resemblant face-painting. The value of this work as record has been acclaimed from the first and needs no further eulogy. But he rarely found in any American man that challenging charm which graces nearly all the portraits of his London patrons and familiars. In part this may have rested on lack of sympathy or on simple inattention to whatever lay behind the appear-

ance. There could, for example, hardly have
been a more interesting male anywhere at the
moment than Aaron Burr, yet Stuart painted a
dull and perfunctory portrait of him. This is
merely the extreme case of Stuart's always fine
face-painting falling short of fine portraiture.

Towards the American woman Gilbert
Stuart's attitude was that of all perceptive
foreigners. She was a marvel, a puzzle, and a
delight. She was irresistibly herself, an inde-
pendent and unconditioned existence, in a sense
that the American man busied with nation
making could not be. So Stuart read her, con-
fessed her, and most gallantly celebrated her,
with the result that the mothers and daughters
of the early Republic are today about twice as
alive as the fathers and sons. And Stuart's
admirable face-painting of women is ever tend-
ing to be much more than face-painting, going
over the line towards fine portraiture. How
Gilbert Stuart learned his magic as a feminist is
between himself, Mrs. Stuart, and his God. It
is enough to ascertain the fact without seeking
an explanation.

I should be glad if these reinterpretations of
an artist who through official and patriotic
eminence has nearly vanished as a man should

be considered my homage to the late Lawrence Park's long labor of love upon which this and all subsequent interpretations of Gilbert Stuart must chiefly depend.

[1925.]

II

THE ART OF S. F. B. MORSE

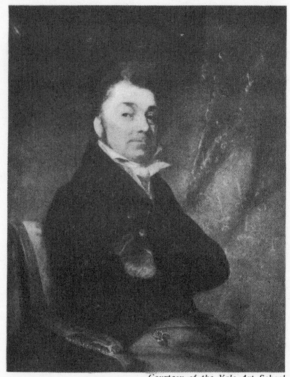

S. F. B. MORSE, "Mr. David de Forest"

THE ART OF S. F. B. MORSE

Samuel Finley Breese Morse, despite his fame as inventor of the telegraph, was born out of due time. He has that eighteenth century many-sidedness which was exemplified in Franklin and Jefferson and, in a measure, by his master, the poet-painter Allston. His fame as inventor of the telegraph has almost wholly obscured his considerable accomplishment as an artist. One of the most valuable features of the excellent official memoir by his son is the clearing up of this early and tragically abridged chapter. Morse was a good correspondent and diarist. Thus it is possible to trace his life almost entirely in his own words.

Finley Morse, as his friends called him, was born in Charlestown, Massachusetts, on the 27th of April, 1791. His father, Jedediah Morse, was an orthodox Congregational clergyman, an energetic person of various talents. He compiled the first American geography and gazetteer, thus eking out a slender salary; he was an esteemed correspondent of Washington, and of such early British Liberals as Zachary

Macaulay, Wilberforce, and Owen. The mother, Elizabeth Finley, was a daughter of the President of Princeton College, a shrewd, humorous, masterful woman as her letters show her, resilient though she had borne eleven children and lost eight. Of this patriarchal family Finley Morse was the eldest. At nine he was a preparatory student at Andover. At ten his father admonished him—"steady and undissipated attention to one object is a sure sign of superior genius, as hurry, bustle, and agitation are the never-failing symptoms of a weak and frivolous mind."

At the age of fourteen, 1805, the boy was enrolled at Yale, the family college. There is amusing correspondence about his expenses. It was necessary to keep brandy, wine and "segars" in his room. But in the intervals of snipe shooting and miniature painting on ivory, at five dollars a likeness, he seems to have been a fairly diligent student. Literary tastes began to crop out, guided, however, by an austere Yankee morality. At Mr. Beers's shop he bought a Montaigne in French, eight volumes handsomely bound, for two dollars. On horrified inspection he writes: "The reason they are so cheap is because they are wicked and bad books for me or anybody else to read. I got

them because they were cheap, and have ex-
changed them for a handsome English edition
of Gil Blas, price $4.50." Evidently moral
fastidiousness had its compensations in the case
of this sixteen-year-old lad. It is possibly the
only time that "Gil Blas" has served as first
aid to the morally injured. But the paradox
after all illustrates that permanent trait in
Calvinistic morals by which sin is located not
in practice but in theory. There was no theory
of any sort in "Gil Blas," hence no harm.

Morse did not leave Yale without seeing elec-
trical experiments under Professor Dwight,
in the "Philosophical Chamber," and hearing
Mr. Day lecture on this new science. These
phenomena, so important for his subsequent
career as an inventor, interested him only in
second order. In his senior vacation he writes
to his father in the somewhat Olympian vein
already well marked. "As to my choice of a
profession, I still think that I was made for a
painter, and I would be obliged to you to make
such an arrangement with Mr. Allston for my
studying with him as you shall think expedient.
I should desire to study with him during the
winter, and, as he expects to return to England
in the spring, I should admire to be able to
go with him." There was an interval of con-

formity to parental reluctance—as a clerk in a book shop. Then the dream accomplished itself. Finley became Allston's disciple, planned a composition in the grand style, "Marius on the Ruins of Carthage," and by the middle of July 1811 was sailing with the Allstons for England, on the good ship *Lydia*.

So for four years Morse was one of that remarkable colony of Americans who for a generation postponed the inevitable decline of the British School of painting. Copley was already senile, but Benjamin West ruled and did much for the young man, until the magnanimous Allston humorously insisted that Morse was after all his pupil. Soon Morse joined forces with the genial and able Philadelphian, C. R. Leslie. In London De Quincey's adept of murder as a fine art was still at large, and the young men habitually slept with pistols at their bolsters. Morse duly visited the Elgin marbles at Burlington House. He observed that they show "the inferiority of all subsequent sculpture. Even those celebrated works, the Apollo Belvedere, Venus di Medicis, and the rest of those noble statues must yield to them." Every morning Morse and Leslie woke at five and walked for a mile and a half to sketch the Phidian marbles. At the moment when the Par-

thenon pediments were accounted rubbish by the multitude this was no banal enthusiasm.

For a drawing from the Laocoön Morse was admitted to the life class of the Royal Academy. Within a year he was working at his first painting of heroic scale and subject, "The Dying Hercules," first modelling it in clay. The model won the prize for sculpture at the Society of Arts, the picture made something of a sensation in the Royal Academy. There is little enough pleasure to be got today from this bituminous canvas, which adorns the Yale Art School. It illustrates the more glaring faults of a master whom Morse unhappily admired, Ribera. Yet for a half-trained youth of twenty-two, it is a powerful and by no means unpromising performance.

Soon after Morse's arrival at London the relations between England and America, already embittered by the orders in council and the embargo, drifted into war. He was unmolested personally, but harassed by poverty, opposition, declining patronage, and even more by the faineancy of his family at home. They were complacent peace-at-any-pricers, irritatingly indulgent to the active patriotism of the eldest son. Yet there were compensations amid war's vexations and alarms. He saw fre-

quently and with admiration the conquerors of Napoleon, the noble figure of Czar Alexander I., Blücher, Yorck, the Cossack hetman, Platoff. He saw Wilberforce weep for joy when the guns verified the news of "a great victory in Flanders." The great philanthropist "expatiated largely on the prospects of a universal peace in consequence of the probable overthrow of Napoleon." Here surely one comes near a permanent fount of equally vain hopes and tears in things mortal.

England was becoming impossible for a high-spirited young American. His valedictory to London was a mythological piece, "Jupiter in the Case of Apollo, Marpessa and Idas." It failed of an Academy prize through a technicality. A letter to his parents reveals the pathetic high hopes with which he turned homeward:

"If I could get a commission or two for some large pictures for a church or public hall, to the amount of two or three hundred dollars I should feel much gratified. I do not despair of such an event, for, through your influence with the clergy and their influence with the people, I think some commission for a scripture subject for a church might be obtained, a crucifixion, for instance. Had I no higher thoughts than

being a first-rate portrait painter, I would have chosen a far different profession. My ambition is to be among those who shall revive the splendor of the fifteenth century, to rival the genius of a Raphael, a Michael Angelo, or a Titian; my ambition is to be enlisted in the constellation of genius now rising in this country; I wish to shine, not by a light borrowed from them, but to shine the brightest."

It would be a mistake to dismiss this plan simply as evidence of a young man's inordinate ambition. The generation nourished æsthetically on Sir Joshua Reynolds's "Discourses," had a programme which it regarded both as meritorious and practicable. In particular the Americans had the grace or the naïveté to take Sir Joshua literally. Where he merely preached, they most strenuously practiced. Copley in his military canvases, West in his copious mythological production, Allston in his great imaginative designs—these were regarded as the harbingers of the resurgent Historical School. They and their works have gone the way of Southey's epics. Ambition and even nobility of spirit alone are poor gages for immortality. To us they are merely thwarted dreamers of the impossible. Happily they were not that to themselves. Only the unfor-

tunate Haydon was to live through the whole tragedy of this mistaken high endeavor. Morse was to settle down to being nearly a first-rate portrait painter. But fortunately the realization that it was merely for that that he was foregoing the evening chats with Coleridge and the practice of the historic style came to him gradually.

Boston characteristically cold-shouldered her returned prodigy, so, after the practice of face-painters of the day, he went on the road. As he painted heads up and down rural New Hampshire and Massachusetts at fifteen dollars apiece, his intention was to collect funds for an Italian trip. Love at this point intervened in the person of Lucretia Pickering Walker, of Concord, New Hampshire. Her short-lived and rather pensive grace still lives in the charming picture which he did of her with their two children. Under his persuasion she experienced religious conversion, thus unwittingly preparing herself for her early death. The young lovers had pitifully little of each other's society. During most of the engagement he was south, in Charleston, where for the first time he found a really generous patronage. There he took his young bride in the winter of

1818-1819. There he received his first public commission, to paint the full-length portrait of President Monroe which still hangs in the City Hall.

It was knocked off in two weeks of December 1819, with enthusiasm, though amid all manner of interruptions. The city of Charleston commissioned it at what was then the handsome fee of seven hundred and fifty dollars, and it got what is one of the best examples of official portraiture ever executed in America. The presentment has picturesqueness without sacrifice of dignity; there is something unexpected and alert about the characterization. The sense of race is strong in the work. Very notable is the focus of the strong and sensitive face retained unimpaired amid the oddness of the accessories. President Monroe was not wrong in preferring it to the more famous full-length portrait by Stuart.

At the moment Charleston was probably the best trained city in art in America. In the mansions which lined the Battery were Raeburns, Romneys, Sir Joshuas. The Huguenot colony possessed excellent pictures of the recent French school. The planter aristocracy was proud, generous, hospitable. Charleston was probably the only city in America where a num-

ber of painters had lived by their art like gen-
tlemen. Morse thought of settling there, but
in three years he had exhausted what was after
all a limited field. His hazards of new for-
tunes in Albany and New York it is unneces-
sary to follow. Struggling along, deprived
mostly of the companionship of his wife and
children, he felt himself settling down to the
average gait of the journeymen face-painters
of the day. In something like desperation he
obtained an appointment as attaché on a special
legation to Mexico. The precedent of Rubens
encouraged him to the step, but the legation
was recalled long before reaching the border.
Meanwhile, in 1823, he did the group of the
House of Representatives which is now in the
Corcoran Gallery. It brought him a certain
repute but no money. From every point of
view this picture is the most remarkable Amer-
ican painting of its moment. In it Morse with
a flexibility all his own concentrated all that
he had learnt twenty years earlier from the
great Napoleonic canvases of David. The
scale and dignity of the fine interior are fully
realized as is the delicate effect of early candle-
light. The tiny portraits are at once charac-
terful and unobtrusive. They have a serious-
ness worthy of their spacious setting. Among

American painters then living only Henry Sargent, painter of the charming "Tea Party" and "Dinner Party," in the Boston Art Museum, could have coped with the technical difficulties of the theme with any success, and indeed of all contemporary painters only the aged Goya could have carried off the thing with an equal beauty and impressiveness. David still lingering on in Brussels was no longer capable of anything so sincere and accomplished. To find such a work unappreciated must have been a breaking point for Morse.

In these wandering years he had painted many fine portraits. Two of the most famous and accessible are those of Mr. and Mrs. David C. de Forest, which were painted in 1823, and are now in the Yale School of the Fine Arts. What immediately strikes one in the man's portrait is its probity, force, and geniality. It has the candor and simplicity of make of a fine Hogarth or a Raeburn. The quite modern attack of Morse is perhaps even better shown in the gaunt sketch of the head of Lafayette now in the New York Public Library. It is not an agreeable work, but full of character and the memory insists on retaining the impression. Morse in his portraiture of men had in a higher degree the merits common to the face-

painters of that day. He seems to me as much superior to the Hardings, Jarvises, Rembrandt Peales and Jouetts of the time as he is generally inferior to Copley and Gilbert Stuart.

As a technician he seems more contemporary and a bit further from the old masters. Startlingly modern is the Mrs. de Forest at Yale, probably the most brilliant portrait painted in America between the death of Stuart and maturity of Sargent. Without loss of character, it has extraordinary material richness. The touch is swift, the impast heavy, the sharp balance between the full blue of the turban and the deep cream and red of an India shawl as happy as hazardous. There is a gorgeousness and fulness of life in the work which is most exceptional in American portraiture of that time. It is as far from the safe discretion of Stuart as it is from the superficial prettiness of Sully. On entering the gallery you are both dominated and perplexed by it. Oddly it carries no English or American suggestion. One would say a magnificent Isabey. That work of this merit should have had little vogue is probably due to the fact that portraiture was as yet regarded not as an art but as a purely commemorative function. I should add that this richness and gusto are somewhat

exceptional even in the work of Morse. His portrait of his daughter Susan in a yellow gown, for example, is lovely as a characterization, but thinly and timidly painted.

In 1825, his thirty-fourth year, he once more tried his fortunes in New York, this time successfully. It was the moment of Lafayette's triumphal return to America. Morse was chosen to paint the hero's portrait for the city over such competitors as Vanderlyn, Sully and Peale. The sittings at Washington resulted in a lifelong friendship. The work was tragically interrupted by news of the sudden death of Morse's young wife. "With her was connected all that I expected of happiness on earth," he writes to a friend. The full-length portrait of Lafayette in the New York City Hall betrays something of the lassitude and despondency under which it was completed, yet it also has a bizarre and romantic impressiveness—something compellingly Byronic. The sketch which has already been mentioned is probably the truer memorial. What was to have been the means of reuniting the little family at New York was to be the prelude to a lonely struggle that also must end in bitterness.

I suppose bereavement has made many a public career. It was so in Morse's case. His

high seriousness made its impression on the easy-going New York of the 'twenties. The artists of the city were restless under the mismanagement of the American Academy of Arts by that testy veteran of the Revolution, Colonel John Trumbull. On the 8th of October, 1825, this discontent organized itself in the rooms of the Historical Society, in the innocent guise of a New York Drawing Association. Morse was elected president. January 1826 the Association became the National Academy of the Arts of Design with thirty professional members, of whom oblivion has spared for one reason or another only half a dozen—Durand, Dunlap, Rembrandt Peale, Thomas Cole and Alexander Anderson. For ten years Morse held the presidency. He lectured regularly in behalf of the movement. "The cause of the artists," he writes, "seems, under Providence, to be in some degree, confided to me, and I cannot shrink from the cares and troubles at present put upon me." He probably did more than any other man to bring about what if not the best period of American art was at least the most normal and generous condition of art patronage in America. The time he thus diverted from his painting he made up by intense industry, "sitting in my chair from seven

in the morning until twelve or one the next
morning, with only about an hour's intermis-
sion."

His position as a portrait painter was now
established, but we hear little of the old ambi-
tions. Still, the warmth with which he wel-
comed a commission for an historical subject
for the cabin of a new steamboat proves that
the old desire was not dead. It was probably
with some notion of returning to the grand
style, that Morse, in 1829, sailed for a long
trip in Europe. It was perhaps too late for
the fullest enjoyment and profit from such an
experience. He was already thirty-eight, cele-
brated, and fixed in his artistic habits and ad-
mirations. It is an interesting question what
his development might have been had he
studied in the Louvre, as was his plan, in the
ardent years of preparation. At London in
his pupilage there was far too little accessible
in the way of old art to offset the teaching of
Allston and the precepts of West.

His impressions of travel give a mixed flavor
of openmindedness and commonplaceness. It
was not at the time a usual sentiment to write
of Canterbury: "The effect of the long aisles
and towering clustered pillars and richly carved
screens of a Gothic church upon the imagination

can scarcely be described—the emotion is that
of awe." Such notes are rare in the scanty
journals of this belated *Wanderjahr*. At Paris
he was cordially received by Lafayette. At
Rome he met his old friends the Fenimore
Coopers, made pleasant acquaintance with
Horace Vernet, then chief of the Villa Médé-
cis, and Cardinal Wiseman. He painted the
portrait of the venerable sculptor Thorwald-
sen, and years later the painter had the pleasure
of presenting it to the Danish government. At
Naples he was inclined to think the "Dead
Christ with the three Marys and Joseph," by
Ribera, the finest picture he had yet seen.
After this it is reassuring that he took the pains
to copy Tintoretto's "Miracle of the Slave" at
Venice. It was lightly considered there and
as he worked actually threatened with damage
from a thunder storm through a leaky roof.
Generally speaking the journals of 1829 to
1832 are perfunctory. He notes small annoy-
ances, is outraged by the theatre, beggary and
Sabbath breaking. The Puritan seems to
dominate the artist. Or Morse may merely be
exercising the middle-aged man's privilege of
indulging whim and taking much for granted.

At Paris he shared rooms with the sculptor
Greenough. Lafayette, generously occupied

with the doomed cause of Polish freedom, was most hospitable to his two artist friends. There were hopeful talks of impending government patronage of art at home, doubtless the decoration of the rotunda of the Capitol. For his homecoming Morse planned an innocent sensation, an interior of the Louvre gallery with a great array of miniature copies of the masterpieces. It fell flat, was sold at a loss. Worse disillusionment was in store. In 1834 Congress had voted four great historical pictures to adorn the rotunda of the Capitol. Morse, from his general prominence and as president of the National Academy, seemed sure of one. But President John Quincy Adams, distrustful of native talent, submitted a resolution opening the competition to foreign artists. This was the occasion of indignant protest in the already censorious *Evening Post,* and the article was generally but erroneously believed to be Morse's. It was, as a matter of fact, James Fenimore Cooper who thus unwittingly dealt a death blow to the lifelong hopes of his friend. Morse never recovered from the disappointment. Yielding to persuasion, he retained the presidency of the Academy until 1845, and resumed it for the year of

emergency, 1861. But it had become an impersonal loyalty; his heart was elsewhere.

On the return voyage in 1832 the idea of the telegraph had dawned clearly. A new struggle was at hand. To tell of it is like describing another man, and it does not now concern us. From his art Morse declined longer to ask a livelihood, although it would have maintained him and the bantling invention most handsomely. In 1835 he accepted a pittance from the University of New York as Professor of the Literature of the Arts of Design. It was, I suppose, the first post of the sort in America. He occupied living and laboratory quarters in the old Gothic building on Washington Square, the scene of much romance in its day, and there he worked out heroically through all adversity the telegraph for the world, and for himself wealth and immortality.

In 1849, when victory in the new adventure was assured, he wrote a pathetic letter to Fenimore Cooper:

"Alas, My dear sir, the very name of pictures produces a sadness of heart I cannot describe. Painting has been a smiling mistress to many, but she has been a cruel jilt to me. I did not abandon her, she abandoned me. I have scarcely taken any interest in painting for

many years. Will you believe it? When last
in Paris, in 1845, I did not go into the Louvre,
nor did I visit a single picture gallery.

"I sometimes indulge a vague dream that I
may paint again. It is rather the memory of
past pleasures, when hope was enticing me on-
ward only to deceive me at last. Except some
family portraits, valuable to me from their
likenesses only, I could wish that every picture
I ever painted was destroyed. I have no wish
to be remembered as a painter, for I never was
a painter. My ideal of that profession was,
perhaps, too exalted—I may say is too ex-
alted. I leave it to others more worthy to fill
the niches of art."

To salve the disappointment of the Capitol
decorations his friends raised a handsome sub-
scription for a historical canvas of like scale.
He began on "The Signing of the First Com-
pact on the Mayflower," but all zest for such
work was gone. He dropped the project and
honorably repaid the subscribers with interest.
In 1864, being seventy-three, he had "many
yearnings towards painting," and made the en-
deavor to draw once more, but found his eye-
sight hopelessly defective. In his later years
the only evidence of his former accomplish-

ment is the handsome little skull with which he habitually "dead-headed" his telegrams.

His own judgment, that he failed from holding too exalted an ideal of his profession seems not far amiss, but he possibly did not realize the full tragedy of his own case. Like Haydon and many another he was a victim to Sir Joshua's dictum of the transcendency of the historical style. Unhappily the devout readers of the "Discourses" while taking the teaching at face value, omitted to supplement it by studying Sir Joshua's actual practice and the ground of his great repute. His vivacity and distinction, his graceful artifices of composition, his rich and learned color, in short his eminently decorative quality, were so many sealed books to them. Instead they entertained a delusion which he was personally far too shrewd to cherish, that by an effort of the will one could re-create the mood of the great masters of the Renaissance. Besides there was unfortunate ambiguity as to who the great masters were. For Morse, Ribera was one of the most admirable. So a whole generation of ambitious souls, the Wests, Corneliuses, Girodets, and Hayezes came up with the delusion that one could wish himself into the grand style. Watts, with a clearer vision of the old Italians,

in a manner did it. But most of the more am-
bitious spirits were wholly oblivious of the
truth that decorative skill must underlie all
monumental painting. The man who can
decorate a space may go on as far as his
powers permit. History and the grand style
are open to him. To attempt history without
first mastering decoration is to court sure dis-
aster. While Morse was still plastic he might
have learned the true way from Delacroix, had
he had the eyes to see him, as La Farge did
later. But Morse saw Delacroix too late and
probably with disapproval.

As it was, Morse voluntarily forewent a
sure and honorable career. He was a por-
traitist of no common order. In imaginative
painting he reached a passable academic com-
petence. For the asking he might have had the
repute and prosperity of his older and younger
contemporaries, Washington Allston and Dan-
iel Huntington. He was clearly their equal in
seriousness and imagination, and in skill dis-
tinctly their superior. In my opinion he at-
tained about the artistic development that his
powers and the conditions permitted. When
he deserted art for the telegraph, some just
instinct told him that nothing but repetition was
ahead. Of his own painting, after his great dis-

illusionment, he thought far too poorly. He
was a sterling and skilful portraitist, one of the
soundest and withal most brilliant practitioners
of his time. His modest place in the history of
American painting is a perfectly sure one. He
will not be forgotten, and his eventual repute is
likely rather to rise than to fall.

[1923.]

III

GEORGE INNESS

GEORGE INNESS

American painting started with portraiture, and in the work of West, Stuart, Malbone, Jarvis, Harding, and Morse early attained real distinction. The portrait easily multiplied itself into the group, and the group as readily became a subject picture. Thus the contemporary triumphs of Benjamin West, Washington Allston, John Trumbull, and Henry Inman rested on historical painting in the traditional grand style. The theoretical basis was the "Discourses of Sir Joshua Reynolds," the technical basis, the practice of the English or French academies. The whole movement was a brilliant importation which failed to root itself and soon faded.

American landscape, on the contrary, was of humbler origin and native. It grew out of topography, as it had earlier in England. Seaports, ships, civic improvements, country places, were sketched and commemorated in engraving. The work was rude but honest. Soon draughtsmen of fairly professional competence like the partners Alvan Fisher and William G.

39

Wall published colored sheets and entire albums of our scenery. Meanwhile the writings of Washington Irving and of Fenimore Cooper had cast the glamour of legend about both our wild and cultivated sites, and the cult of Bryant's and of Wordsworth's poetry had added to legend and naïve love of nature the sanction of religious mysticism. By 1830 the artistic current was setting from the grand style to landscape. It had the interest of being exclusively and intensely a native movement.

If such an amiable topographer as Thomas Doughty stems from the English tonalists, such more characteristic figures as Thomas Cole and Asher B. Durand are entirely self-taught. They are formed before Düsseldorf and Barbizon have gained sway, they grow in strange obliviousness of the contemporary glories of Constable and Turner. Thus the Hudson River School may be rather a poor thing, but it is emphatically our own, and it presents to the student at least the charm of modesty, seriousness, and primitive sincerity—and that in an age elsewhere given over to sophistication. It also offers the phenomenon, rare enough in the last century, of a common point of view in artist and public. It was the faith of young America in the pioneers of the Hud-

son River School that made possible the
achievement of a Homer Martin, an Alexander
Wyant, and a George Inness.

George Inness was born at Kingston, New
York, May 1, 1825. His father was of Scotch
extraction and a grocer by trade. The boy
grew to young manhood at Newark, New Jer-
sey, then not a whirl of machinery and trams,
but a sleepy little city with abundant local tra-
dition and pride. About it stretched one of the
loveliest prospects in the world, now defaced
by reeking chimneys and blatant advertising
boards—the Passaic and Hackensack meadows
with their noble rim of encircling heights.
These great marshes with their swinging
estuaries, their abundance of seasonal flowers,
have an infinite variety of charm within their
apparent monotony, and the glory of dawn and
sunset nowhere yields richer or more delicate
incandescences than it does among the reeds
and cattails that carpet this old bed of the
Hudson. Treeless or nearly so, these meadows
are bordered by gently rolling country adorned
by the finest elms, white oaks, scarlet oaks,
maples and beeches. Even New England
presents in autumn no such clamor of scarlet,
crimson, yellow, and glowing russet as does
the Orange Mountain where it rolls up from

the meadows. It was then a farming country broken into glades and hillocks, offering juxtaposition of left-over forest trees with orchard or pasture—an agreeable, intimate, half-tamed landscape, with plentiful reminders of its primitive solemnity. The love of this sort of landscape beauty is the single permanent characteristic of our most versatile and volatile painter.

George Inness shifted his sketching grounds widely. The Roman Campagna, the coast of France, and England, the Alleghenies, the White Mountains and the Sierras, the Moors of Scotland, at one time or another engrossed him. But he is always at his best in such pictures as recall the rim of the meadows of the Hackensack. For him, as for so many artists, the first keen revelation of beauty was to determine the career. When in old age he came back to Eagleswood and later to Montclair, it was with a sure instinct that his supreme and most personal effort as an artist could only be made amid the recollections of childhood.

For George Inness's education we have the slightest information. He was delicate and high-strung—an epileptic. Neither his health, his inclination, nor the circumstances of his family permitted much schooling. There was an attempt to make a shop clerk of him, but his

vivacities repelled customers. His education was to come slowly and adequately, from books and from life. He is said to have studied in a drawing school and to have worked with an engraver at Newark when but a lad. Later he worked for a bare month in 1845 with Régis Gignoux at New York. Gignoux was about nine years Inness's senior. A product of French academic training, a favorite pupil of Delaroche, he had at least shown initiative in following a pretty American girl to New York, persuading her to marry him, and making a good living for her. As the first specialist in snow scenes he retains a modest place in the history of American landscape painting. In his practice he tried to realize a happy mean between the dryness of the academic style and the apparently dangerous richness of the new Romantic technic.

It is customary to deny any influence of Gignoux on Inness. I feel, on the contrary, that Gignoux in that brief month came within an ace of spoiling our best landscape painter. Gignoux, as compared with such naïve American landscape painters as Thomas Cole and Asher B. Durand, was a professional, and conversant with all the tricks. He didn't look very hard at anything, but he knew the tree touch,

as exemplified by Hobbema, the cloud and snow touches as worked out by Aart van der Neer. Inness not unnaturally grasped eagerly at this facile lore. His early landscapes are so insincere and superficial, and withal so discouragingly accomplished, that it is hard to see the makings of a good painter in him. Such a landscape as "Early Recollections," dated 1849, Inness's twenty-fifth year, is an appalling picture for any young artist to live down. There is no trace of honest observation in it. It is built up of approved touches, recipes, contrasts, has the merit of careful composition, and in a shallow rural vein is entirely charming. No young landscape painter has a right to be as smartly competent as Inness here shows himself. He himself was soon to see the error and most resolutely to turn his back upon such cheap successes.

Compare with "Early Recollections" the river scene "On the Juniata" painted only seven years later, in 1856. It is hard to see the same mind in the two works. From being facile, nondescript, and vaguely picturesque, everything has become tense, specific, and local. In the marvellously studied trees and weeds and sedges, in the exact and exquisite notation of shadow and reflection, the picture offers all the

gifts of the eager and patient eye. And if it is rather microscopically seen, it is nobly composed. The grandeur and serenity of the idea transcends all smallness of execution.

Plainly something has happened to an artist who is chipper and ostentatious at twenty-five and reverent and humble as regards nature at thirty-two. And a good deal had happened to George Inness in the interval. He had married and gone twice abroad, sojourned in Paris and lingered in Rome. His wife had borne him a son to inherit his name and talent. Above all he had experienced a definite religious conversion under the influence of his elder colleague, William Page. Page was one of those impressive personalities which fail of complete expression in their works. A few faded portraits of a great accent tell us that Page had sat at the feet of Titian. In the correspondence of the Brownings there is a recurrent phrase for Page —"that noble Page" is repeated through the letters. One does not easily or falsely make such an impression upon such intimates as the Brownings. And the earnestness, dignity and sweetness of William Page were precisely the corrective needed by the clever and volatile Inness. Their association at Rome and at Eagleswood was most beneficial for the younger

man. Page had struggled with the severe Cal-
vinism of Andover Seminary and had finally
found peace in the singularly mathematical
optimism of Emmanuel Swedenborg.

George Inness now fed his religious spirit
from this source. He also found peace both in
the expansive sublimity of his new creed and in
its quaint logical trimness and formality. He
no longer saw nature as an attractive some-
thing to be cleverly mimicked, but as the very
vesture of Deity, the hem of which an artist
might touch only with awe. Landscape paint-
ing became no longer a mere accomplishment,
but a search for truth and an act of worship.
This mystical side of Inness's art we must con-
sider later, and at some length; meanwhile this
lovely view on the Juniata shows the endeavor
for strength and accuracy which is to mark
Inness's pictures for the next twenty years. It
is remarkable that a young American of genius
should bring back from Europe only the counsel
of fidelity to our American nature. Yet it must
be remembered that Inness was no frequenter
of galleries, while in the early 'fifties the
Constables and Rousseaus and Corots from
which he was soon to learn much were neither
in public galleries nor at all available for a
casual tourist. I have no doubt that he studied

the Claudes at Rome, and thereby fortified his
own natural gift for composition, but I am
satisfied that he studied the landscape of Asher
B. Durand more faithfully than he ever did that
of any European master.

Durand is the true ancestor of whatever is
strenuous and experimental in American paint-
ing, as his friend and contemporary Thomas
Cole is of our temperamental and poetic art.
Both, unluckily, had painted good pictures
before they had seen good pictures. Durand
had passed from the drudgery of copper-plate
engraving to portraiture and thence to land-
scape. He worked with the microscopic eye,
trying for the specific, in texture of bark and
moss, in substance of rock and earth. He loved
combinations of meadowland and wild scenery
such as the Hudson River and the intervales of
the White Mountains afforded. He loved the
equable light of clouded afternoons. He
brought to landscape the simple natural en-
thusiasm of the average cultivated American of
the time, and he painted the face of nature with
pious notation of every dimple or wrinkle. He
achieved a solid descriptive kind of prose, but
of a singularly colorless kind. In an infinity of
little crisp touches, each locally right enough,
one color annuls another and the whole picture

sinks into a featureless and negative grayness. He never sees how the whole is coming out, but reverently and hopefully labors the parts.

Thomas Cole on the contrary had a prophetic notion of the intended picture, and a positive accent. But he had too little knowledge of details and only a passable sense of color. A roamer in the wilds of Ohio and Pennsylvania, he felt the melancholy poetry of our great forested mountains. There are places so still that a bird's note is startling. Cole spread these vast forest silences upon his canvases with fine feeling and adequate skill. He is panoramic where Durand often chose the limited view. Cole's landscapes have the severe, cool note of Bryant's poetry, and it is Bryant who has written the finest and truest words on Cole's art:

"Pictures which carried the eye to a scene of wild grandeur peculiar to our country, over our aerial mountain tops, with their mighty growth of forests never touched by the axe, along the banks of streams never deformed by culture, and into the depths of skies bright with the hues of our own climate . . . and into the transparent abysses of which it seemed as if you might send an arrow out of sight."

Cole was a poet and musician as well as a

painter, a sensitive and companionable man.
He went to Europe for new subjects rather than
for new methods. He worked out a sparse
Puritan method of his own in which neutral
browns, grays and greens afforded a sufficient
harmony to accompany his grave and simple
lyrics. The gift of richness and color was
never his, and in the moral allegories into which
he let himself be drawn his defects are patent
and lamentable. Still he is the poet among our
pioneer landscapists, and this vein found the
richest fulfilment in Homer Martin.

Inness himself in his latest phase was to take
up and give splendor to the ideals of Cole, but
at the outset Inness was wise enough to see the
dangers of this panoramic picture making. In-
stead he chose the entirely sound and available
naturalism of Durand. And Inness had what
Durand lacked—a fine instinctive sense of
color. Between 1856 and 1868 we can trace
in Inness the disappearance of detail in behalf
of color effect, the growth of power in render-
ing swing and texture—the easy accomplish-
ment of all that Durand had tried so hard for
and never wholly attained.

Through the 'fifties Inness worked mostly in
New York, living in Brooklyn. His painting
steadily grows in breadth, the larger truth of

effect superseding the smaller truth of detail.
His color comes clearer and in larger masses,
his paint is often loaded and worked about—
the whole look more modern and European.
The quick progress along these lines is well
shown by contrasting with the "Juniata River"
of 1856, the "Hackensack Meadows" of 1859,
which is in the New York Public Library. It is
a less agreeable picture than the earlier one, the
contrasts are exaggerated, the simplification of
masses of foliage and herbage a little bare, the
handling of the paint, though resolute, some-
what heavy and monotonous. Something of
the virginal loveliness of the earlier work has
gone. But there is great gain in skill, and a real
growth towards unity. Already we have won-
derful edges that characterize almost unaided
the masses therein contained, and we have in-
stead of copies of weeds and twigs fine ma-
nipulations of paint that suggest such features
without impairing the general effect. Inness is
travelling the way of Théodore Rousseau and
Jules Dupré and by this time is conscious of
their value as examples.

By his fortieth year, 1865, Inness had at-
tained a complete mastery of spacious themes.
In that year he signed the great picture "Peace
and Plenty" and the even greater little canvas

"The Delaware Valley," both in the Metro-
politan Museum. In the "Peace and Plenty" he
has taken, possibly in deliberate competition, a
subject similar to Cole's "The Ox Bow." He
has introduced an infinity of rustic detail with-
out cumbering the arrangement, has saturated
the whole with harvest color and invested it
with shimmering air. The panorama misses
grandeur, but has instead a direct and hearty
sense of the charm of fat fields in harvest time.
One has only to compare with it the artificial
rusticity of the "Recollections of Childhood"
of sixteen years earlier to note Inness's artistic
growth.

But "The Delaware Valley" is a far more
important picture, as showing Inness's positive
command of effects of cloud and wind and air.
It is painted with utmost freedom, with beau-
tiful expressions for texture, nearness and far-
ness, for the rolling up of clouds, and the loss
of mountain slopes in their grazing edges. It
is worked in freely broken color in a way not
less masterful than Constable's. Above all it
has a definite unity of mood and vision—noth-
ing could be added or taken away. And this
unity depends largely on the light which invades
all forms. It is a picture of absorptions and
reflections—as if between the clouds and the

earth the light were an active spirit, transform-
ing at will whatever it touches. Thus the
painter grasps not merely the poetical motive
of unity, but also the scientific spirit of flux.
The clouds will settle and break, the rain will
fall, a new light will create a new scene.

. In view of such work as this, Inness's elec-
tion in 1868 to the National Academy seems
tardy. Doubtless the immense repute of Albert
Bierstadt and F. E. Church—painters of gran-
diose mountain scenes—stood between Inness
and the public. Their pictures were shown
amid red plush curtains before footlights, and
sold for fabulous sums. On the other hand the
prim and trim art of John F. Kensett offered a
more available attraction. His lake and moun-
tain scenes, smoothly painted, picturesquely ar-
ranged, affecting the pearliness of dawn or the
glow of evening, enjoyed an enormous popu-
larity. Kensett was a genial sociable person as
well, whereas Inness was already a somewhat
solitary and eccentric man. Plainly he bewil-
dered both the critics and the amateurs of the
black walnut era. The generally expansive
Henry T. Tuckerman writes of him, in 1867,
in "The Book of the Artists":

"Inness, in his best moods, is effective
through his freedom and boldness, whereby he

often grasps the truth with refreshing power; sometimes this manner overleaps the modesty of nature, and license takes the place of freedom; somewhat too much of the French style is often complained of as vitiating the legitimate individuality of this artist; and there is in him, as in so many of his peers, a provoking want of sustained excellence, a spasmodic rather than a consistent merit."

With the wisdom of hindsight it is easy to smile at Tuckerman's condescension towards the only capable landscape school of his time. It is harder to pardon him his failure to perceive the immense superiority of George Inness over the Durands, Kensetts, and Sanford Giffords, whom he had so unqualifiedly praised. Yet in a blundering way Tuckerman had touched the weakness of a great painter—Inness's immoderation, his tendency rather to improvise than to reflect. As a matter of fact it was the variety of Inness that bothered his contemporaries to the very end. It is an art that never wholly standardizes itself, and the art dealer and art patron alike crave characteristic pictures. Of course Inness himself was very little interested in the dealer and patron and completely engrossed with his own mystical cosmologies and his painting. In ten years of in-

tense study he had thoroughly mastered the forms of American landscape—had indeed memorized them, and had simultaneously worked out a technic as free and modern as that of his great French exemplars. Indeed it might seem as if no progress were likely beyond such pictures as the Delaware Valley group or so gracious and imposing a canvas as the "Autumn," in the Rhode Island School of Design. To Inness, however, these apparent perfections were merely so many dissatisfactions—reasons not for stopping but for pressing onward.

The extraordinary personality of the man has so much engrossed his critics and biographers that they have neglected the plain business of telling where he lived and sketched and travelled. So far as I can gather from scattered and vague evidence, he was at Medfield, near Boston, from about 1859 to 1864. There he made wonderful sketches which were elaborated into pictures for many years to come. From about 1865 to 1870 he was mostly at Eagleswood, New Jersey, near Perth Amboy, in reach of his native tidal meadows. From 1870 to 1874 or so he was in Europe, chiefly in Italy. Thenceforth he lived mostly at New York, and in his last ten years on the heights above Montclair, New Jersey. He made occa-

sional trips to England, to Florida, and to the
Sierras. As to sketching grounds, he made few
real sketches out of doors after the Italian trip
of the early 'seventies. There the sheer novelty
and loveliness of the scenery lured him into old
pursuits now no longer necessary, his memory
being stored with beautiful forms. After his
first beginnings I think Inness rarely painted
pictures in the open air. In this he differed
from his fellows of the Hudson River School
who put themselves to the most needless pains
in the interest of a quite imaginary fidelity to
nature. And as Inness grew older and his
habitual invalidism increased, nature became
rather a personal solace than a direct model,
and his pictures represented so many ardent im-
provisations upon themes long ago memorized.

The Italian trip which closed with his fiftieth
year constituted a pause for reflection. It saw
the consummation of his early practice and the
preparation for his last manner. In particular
he restudied composition with new zeal, and
within the old fine arrangements he achieved a
new simplicity of workmanship. It is as if he
had considered admiringly the untroubled sur-
faces of Claude and Poussin and under their
spell was momentarily constrained to curb
the impetuosities of his own restless mind and

hand. There is a great power and modesty about the representation of the forms in such a picture as the "Barberini Pines." Nothing is scamped, nothing overasserted. It is a massive, solid apparition with nothing of the evanescence of the Delaware Valley pictures. The balance and placing of the dull greens of the pines and the olives are impeccable. Masterly is the handling of that very difficult problem— a down-hill perspective. One or two such supreme examples of gravity and sobriety Inness was to give us, before cutting loose from representation and indulging the most fantastic visions. We find the perfect application of the Italian manner in the great canvas, "Evening at Medfield," painted like the "Barberini Pines" in 1875. We have the simplest and finest indications of the essential forms, the superb pollard saturated with the afterglow, the darkling ground with the curving path that leads the eye graciously to the grand mass of the grove. Other indications of cattle and buildings are of the finest and the whole thing swims in the deepest and most resonant evening glory—the illumined "dark air" of Dante. Such a picture in its grave and simple composition represents the application of the Italian method to memories of ten years earlier. It

does consummately what Aalbert Cuyp, Old
Crome, and young Turner had earlier essayed.
These Italian and Italianate Innesses are not
favorites—for the adequate reason that we
properly associate Inness with the scenery of
his native land, and for the poorer reason that,
representing a transient perfection, they are
not characteristic. They are after all Amer-
ica's most notable contribution to the old
masterly tradition of landscape. They would
hang better in the Louvre or the Uffizi than the
more famous late Innesses. This by way of
description and not to raise prematurely the
issue of rank between the late Innesses and their
predecessors.

From 1875 to 1880 or later a curious change
comes over George Inness's painting. It seems
mixed and confused. The color has no longer
the depth of the mature works, while it has not
attained the ineffable volatility of the last phase.
The pictures seem to lack the earlier substance
and to be aiming at an ethereality not yet fully
realized. There is a not quite pleasant sense of
ferment about them—a yeastiness in the very
pigment. On the technical side this means that
Inness has ceased to lay in the picture in brown,
and no longer proceeds by successive over
paintings. Spiritually the change corresponds

so definitely to the intensification of his peculiar personality that we must perforce turn from the works to the man himself in order to arrive at any adequate explanation.

George Inness's master ideal was religious mysticism, of which his painting was merely an incidental expression. For many years he read little but theology—not I fear the wise and moderate fathers of Latin Christianity, but the enthusiasts of the recent sects. Fortunately G. W. Sheldon, an excellent critic of the early 'eighties, has left abundant -ana in his book on "American Painters" and in an article in the *Century Magazine* for 1898. Inness, we learn, talked incessantly and excitedly on religious and philosophical subjects, and left thousands of pages of quite unreadable manuscripts on these mysteries. Quite in the Neo-Platonic tradition, he had a mystical interpretation of the numbers. One meant infinity; two, conjunction; three, potency. Four signified substance and five germination. Of his painting he once said, "I would not give a fig for art ideas except as they represent what I perceive behind them; and I love to think most of what I, in common with all men, need most—the good of our practice in the art of life. Rivers, streams, the rippling brook, the hillside, the sky, clouds—all things

that we see—will convey the sentiment of the highest art if we are in the love of God and the desire of truth." It was this love of truth that wrung from him apropos of Turner's horribly theatrical "Slave Ship" the harshest words any artist has ever used of another. He condemned that much discussed picture as "the most infernal piece of claptrap ever painted."

Often Inness's religion worked very practically. He besieged the magazines in vain with a 5000 word essay on Zola's "L'Assommoir" as a consummate plea for temperance. Generally he regarded man and nature as a partial revelation or representation of the great unity that is God—a thought beautifully expressed in a remark on one of his own pictures of falling leaves in autumn—each leaf being "a little truth from off the tree of life."

Such hints must suffice for the mysticism of George Inness. We have to do with an eccentric, with a crank if you will. His thinking lacks background of culture, is often ragged and confused. And the lucidity of his views on art is in refreshing contrast to the cloudiness of his views on religion.

He saw clearly that art does not address itself directly to the moral sense. It merely conveys an emotion (Tolstoy's view). This emo-

tion must be single, that the work of art may have unity. "The true beauty of the work consists in the beauty of the sentiment or emotion which it inspires. Its real greatness consists in the quality and force of this emotion." Again he has said, "A work of art is beautiful if the sentiment is beautiful, it is great if the sentiment is vital."

With such views, George Inness naturally despised insincere or weak painting. His favorite word of scorn for ill-constructed or inexpressive work was "dishwater," and he often applied it to his own pictures in their first stages. Mr. Daingerfield tells an instructive anecdote of a diaphanous Inness, all pearly grays and faint greens, with a pale sun. The painter regarded this faint loveliness with impatience, murmured his imprecation "dishwater," rubbed his thumb in the chrome yellow of his palette, and smeared the sharp color across the painted sun crying, "Stay there till you look white." This gesture meant repainting the entire picture, carrying all its values up to a point where the keen yellow should count no longer as color but merely as light.

The impulsive act recalls the readiness with which he destroyed or transformed his own works. He once came in excited from a thun-

derstorm, and in a few hours painted "The Coming Storm," now in the St. Louis Museum, over his own big canvas of "Mount Washington." Again, the frame maker one day sent in a frame which proved to be a misfit for a new canvas. Inness sent out for a canvas to fit the frame and finished it in a couple of hours. A purchaser sent back a delicate spring landscape to have the foreground indications of cows sharpened. After half a day of furious work Mr. Daingerfield saw on the easel "a stormy sunset, over a much-torn, surf-broken ocean," and Inness exulting over "the finest thing I've ever done," and chuckling, "I guess I touched up his cows for him."

This creative fury is characteristic of Inness. He never sat down to paint. When his right hand was for a time disabled, he readily learned to work with his left. He sometimes toiled for fifteen-hour stretches, often working on as many as twenty canvases during the long day. He effaced ruthlessly many exquisite pictures. He was ever talking of principles and ever changing them. His memory so teemed with images that the merest hint or analogy in nature released a picture—as when he looked down his little lane at Montclair and the vision

of one of his finest river prospects rose clear before him.

If George Inness, then, seems the very type of the purely impulsive genius, impulse was corrected in him by very systematic theories and habits of work. The broader relations of light and dark in a picture must be determined by the value of the sky at the horizon, which should be a middle tone between the lightest and darkest parts. Nearly all of his mature works obey this law. These relations are true to natural appearance only when there are strong reflected lights from earth or water. Generally, the procedure involves an unnatural darkening of the sky. All the same it makes for unity in the effect by diminishing the contrast between sky and earth. For that matter it was the consistent practice of the great Dutch landscape painters Ruysdael and Hobbema and Van Goyen.

Inness's theory also required the division of the picture from the bottom to the horizon into three well-defined planes of which the second should contain the motives of chief interest. All minor objects should be kept within the sky line. Pedantic as the rule may seem, it makes for unity and the rather empty and open

first plane lures the eye far into the picture and creates a positive sense of spaciousness.

More original than these precepts for composition, was Inness's endeavor to achieve the fullest harmony of tone through the fullest assertion of color. In this he approaches Cézanne's theory that where the color is strongest the form should be most perceptible. Here Inness was in the line of the most modern painting and at odds with his great model, Rousseau, and his own contemporaries Wyant and Homer D. Martin, who for the sake of unity reduced all colors to middle tones. Such a method, though legitimate enough and for certain emotional expressions perhaps inevitable, seemed an uncourageous evasion to Inness—a concession to that "dishwater" and "pea soup" which his robust soul ever loathed.

About 1880, after five years of apparent fumbling, but really of strenuous research, he worked out the method which distinguishes the "typical" Innesses of the dealers and museums. Meanwhile he produced certain lovely transitional works such as the little sketch "Pompton River," at Chicago, in which the intricate tender greens are balanced with the skill of a Daubigny. The latest method is so well de-

scribed by Mr. Daingerfield that I have only
to transcribe him, condensing slightly:

"In working upon a new canvas the subject
was drawn in with a few bold strokes, the struc-
ture and principle underlying the theme being
fully grasped, this was then stained in with due
regard for breadth and light and shade, but the
tones were not extremely varied nor was the
full power of contrast sought. The pigment
was always transparent and thinned with a
vehicle. . . . As this stain set or grew tacky,
it was rubbed or scrubbed into the canvas, lights
were scratched out with a thumbnail or brush
handle, or wiped out with a rag—always mod-
elling, drawing, developing, in the most sur-
prising manner: never at a loss for a form . . .
they seemed to shape themselves at his touch,
and the brush was spread with extreme force,
as it scrubbed until in its scratching there de-
veloped wonderful growths of grass, or weeds,
or trees. As this color tightened in the drying
the forms were sharpened . . . The picture
now being fairly set, and the whole theme fairly
pulsating with the vibrant unctuous flow of it
all, for as yet there were no touches of opaque
color, he would sharpen a few lights by scratch-
ing—perhaps with a knife, more often with the

finger nail—add a note here and there of stronger color and stop for the time."

Plainly such pictures were, as Whistler insisted all pictures should be, "finished from the first." The sparing addition of local color was a secondary process which might or might not be necessary, and on such a foundation a very little frank color would give the most resonant effects. The initial creative energy was what counted. The method of cautiously enriching a complete transparent preparation was that of Rubens. It admits of no sullying the purity of the color, rejects bold contrasts, and produces a coruscation from within the picture itself.

Thus were painted the pictures that represent George Inness's splendid afterglow—the Innesses in which solid earth melts into air, and light penetrates grass and treetops, and the world seems to throb and shiver under the kiss of the sun. One need only compare a picture of the 'sixties with one of the early 'nineties to see what has happened.

Everything has been simplified and volatilized. Any corner of nature, any motive—just the shimmer of a beech trunk in the swelter of summer, a few of the tall columns of a southern pine grove, the fountain of blossoms that is an apple tree in spring, the glooming of a dark

pool before a grove—the simplest and most usual features of our landscape are now motive enough for a great picture. Through these few and carefully placed forms the light comes and goes in waves of purest color—crimsons, emeralds, topazes, sapphires. There is a sort of struggle and clash of light and color with form —a tendency of the colored light to dissolve the form, and a contrary tendency of the form to assert itself. The result is a singular harmony—tense, exciting, a bit unstable, very unlike the serene and sustained harmonies that we expect to find in most great landscape painters. Instead we have the somewhat vague ardor of George Inness's religious mysticism —a pictorial unity not quite inevitable but a little hectic and forced. The artist no longer intimates the unity of nature, he rather insists on it, but he does so with a grand and sonorous eloquence.

In the summer of 1894 George Inness died at the Brig of Allan in Scotland. His last years were his most creative, and fame was rapidly overtaking his endeavor. He had had abundant honors, had exhibited at Paris as early as 1850 and been medalled there at the World Exposition of 1889. Three years after his death his pictures were vigorously disputed in

the auction room and now they fetch the prices
of fine Rousseaus and Corots. He is the only
American landscape painter who is generally
known today in Europe and he has received
generous praise from such historians of modern
art as Richard Muther.

It is superfluous to call the roll of the last
great pictures. The "Mill Pond," "Rainbow
after Rain," at Chicago; "Spring Blossoms," at
the Metropolitan Museum; "Sundown" at the
National Gallery, Washington; "Afterglow"
and the "Wood Gatherers," in private collec-
tions, are universally known and loved. It
seems also too early to fix his precise place in
American landscape painting. Certainly none
of our landscapists was more various and skil-
ful. I may perhaps most clearly suggest his
limitations by asking the question—What are
the great Innesses? It would be a very difficult
question to answer. All the Innesses are fine
and in their degree great, but nothing stands out
as consummately so. This is not the case with
such contemporaries as Wyant and Homer
Martin. We say confidently that the fullest
expression of Wyant's thin, elegiac poetry is the
"Adirondack Clearing" in the Metropolitan
Museum. We are in no doubt as to Homer
Martin's few masterpieces—the grand melan-

choly of "Westchester Hills," the crushing pathos of the "Haunted Manor," the supreme gracefulness of the "Harp of the Winds."

With Inness it is different—the impression is more uniformly exhilarating and all-overish. He himself would have insisted that his work must be judged strictly by the value of the sentiment. And the sentiment in the later works is a sort of abstract sun-worship—a somewhat dehumanized ideal. Towards the later glories of Turner, Inness was curiously unsympathetic, perhaps for the good reason that he saw in Turner's gorgeous improvisations many of his own defects. Like Turner he lacked patience. He lacked as well the deeply reflective quality of such born landscape painters as Jacob Ruysdael and Théodore Rousseau, while he never achieved the instinctively balanced spontaneity of Corot. George Inness ever struggled with the sore difficulty of combining subjectivity of mood with a reasonable objectivity of presentation. In his later years subjectivity ran riot. It may be then that the future will effect some readjustment of valuation in his case. I can imagine a time when for their slightness and extravagance the late or characteristic Innesses will lose a little, and the marvellously balanced

and robustly conceived pictures of the late 'sixties and early 'seventies will gain.

But these are ungenerous and perhaps unprofitable speculations. America will always remember with admiration the most flame-like spirit her art has offered.

[1927.]

IV

ELIHU VEDDER

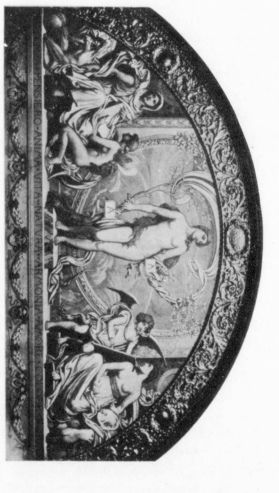

Courtesy of the Walker Art Gallery, Bowdoin College

Elihu Vedder, "Rome, Patroness of the Arts"

ELIHU VEDDER

Elihu Vedder was the last of those early American artists who were Italianate by residence and by inspiration—and far the greatest of a line on the whole more interesting personally than notable artistically. He himself was remarkable on both counts, being not only one of the great imaginative designers of his time, but also, and somewhat paradoxically, a most witty and whimsically delightful man.

All this was hardly to be expected from his ancestry. He came of a solid and much-intermarried line of Dutch stock, pioneers at Schenectady, New York. He was born in Varick Street, in the city of New York, in 1836, sent to the usual schools, and in early boyhood displayed of his future talents only a desire to make almost anything and a restless inventiveness.

His father, a merchant in the Cuban sugar trade, was mostly absent. Visits to him in Cuba, charmingly described in "The Digressions of V," must have gone far to make the future artist. There was a freer life, glory of

ponies and boots and spurs, dark-eyed little
girls who gave look for look and sometimes
kiss for kiss, slaves, pestilence, cheapness of
human life, and waving of giant palms between
blue sky and bluer sea.

Things happened, too, to make the eager
little boy face grave issues. He one day found
a beloved lodger crumpled and quiet against
the wainscot. The memory of the thing twenty
years later created one of his best little can-
vases, "The Dying Alchemist." When an old
cemetery was moved at Schenectady, he saw
come out of the ground the white bones of an
uncle whom he had never seen in the flesh. An
Aunt Sarah habitually saw visions and told them
and, having committed the unpardonable sin,
quietly awaited damnation. An Uncle Custer
went mad, but not before predicting that car-
riages would move by their own power and that
machines would fly. Young Elihu himself was
shot and nearly killed in hunting. At sixteen he
saw his mother fade and die. In Cuba he
viewed the strand where the unbaptized dead
were cast out to the sun and the buzzards.
That memory of festering rags and worse later
got into his picture, "The Plague in Florence."
Then there were always girls—encounters cas-
ual or ardent. All this meant an exercise in

seeing and feeling such as an American lad
rarely gets. It greatly enhanced what he later
called "the rich, romantic sadness of youth."

From his 'teens he began to draw, and after
a vain attempt to break him in in an architect's
office, his father faced the inevitable and put
him with a drawing master, nicknamed "Pil-
grim Matheson," from his favorite theme, at
Sherbourne, New York.

At twenty, 1856, Vedder set out for Paris,
where he drifted into Picot's class for the
antique. Some fatality kept him from, per-
haps protected him from, the current success-
ful masters, Couture and Boisbaudran, and he
missed also the new wonder of Courbet, Manet,
Millet. To the established glories of Ingres
and Delacroix he was equally oblivious. Fate
willed it that his art should be, in his own words
"home-made," but it was not precisely that, for
it was soon to possess itself of the richest of
backgrounds—that of the Italian Golden Age.

What luck led him tramping along the Cor-
nice Road to Italy he does not tell. At Flor-
ence the pedantic Bonaiuti furthered him little
more than Picot had at Paris, but at least gave
the student the example of a strenuous and ele-
vated spirit—a lesson not lost on such a young-
ster as Vedder. But his artistic education came

from Italy itself—the old masters, the villa-clad hills, the crumbling streets of old cities, the climbing cypresses on the winding roads. These things he sketched with gusto and growing skill and with a freer brush than he later commanded.

In 1861 it became impossible for his father to continue the six hundred dollars a year that had spelt Italy and liberty. After a perilous voyage from Cadiz, young Vedder, now twenty-five, anchored off New York on the day when Sumter was fired on.

Vedder's old gunshot wound, which caused the left arm to be permanently weakened, made the eagerly desired military service impossible. He settled to a bitter struggle, slept on a pallet, at times lacked food. Working for the wood-block cutters, the wages were fifty cents for a pictorial idea, a dollar and a half for a suggestive sketch, three dollars for a finished drawing on the wood. But in the lean war-time years he imagined and created "The Questioner of the Sphinx," "The Fisherman and the Genii," "The Roc's Egg," "The Lair of the Sea Serpent," "The Lost Mind." Akin to these is that handful of admirable illustrations which he made in 1865 for an edition of Tennyson's "Enoch Arden." Few young paint-

ers have ever made a more solid and brilliant début in imaginative design. The critics hailed him. In 1865 he was elected to the National Academy, being probably the youngest painter who has ever received that honor. These early canvases are among the biggest little pictures that have ever been painted. "The Lair of the Sea Serpent," with its sense of vastness and loneliness and its hint of terror and its exceptionally lovely color, has for years been one of the best seen pictures in the Boston Museum. "The Lost Mind," in the Metropolitan Museum, is one of the dozen most impressive pictures on its richly garnished walls. Vedder had achieved what no American painter before him had seriously attempted—Albert Ryder and John La Farge had not asserted themselves— an art fraught with gravity, simplicity, and noble imaginative content—as Mr. W. C. Brownell wrote many years ago, a work "penetrated with thought, with reflection, with significance."

If I could persuade the reader to turn to Mr. Brownell's essay in *Scribner's* for 1895, I could both abridge and greatly better, vicariously, my task of appreciation. As it is I shall here and there quote from it.

That Vedder should run away from such

a success and settle in Italy seems at once odd and characteristic. Various considerations prompted the decision. First, in five laborious years he had barely made a poor living—and at that had been driven into all manner of hack work. Next, as the Italian associations faded, he found nothing to replace them. He made various excursions in New England and found nothing he wanted to paint. But the true reason is well recounted in the "Digressions," in an interview with Emerson. The sage of Concord had repeatedly insisted that, nature being one, all heavens should be alike for the artist, who had better remain under that which saw his birth. To this Vedder objected:

"Mr. Emerson, I think there is a great difference between the literary man and the artist in regard to Europe. Nature is the same everywhere, but literature and art are nature seen through other eyes, and a literary man in Patagonia without books to consult would be at a great disadvantage. Here he has all that is essential in the way of books; but to the artist, whose books are pictures, this land is Patagonia. Take from your shelves your Bible, Plato, Shakespeare, Bacon, Montaigne, etc., and make it so that you could not consult them

without going to Europe, and I think it would soon be—Ho, for Europe!"

So Ho for Europe it was. There was an interval in Paris and Brittany with the William Hunts and the lifelong friend, Charles Caryl Coleman. In 1867 Vedder became engaged to Caroline Rosekrans, and the period of episodic girls ended. In 1869 he married the stately and accomplished woman who was to be his helpmate for forty years, and settled rather by habit than by intention in Italy. In the remarkable records of works of art sold between 1869 and 1883, the year of the Omar illustrations— see the "Digressions" for the list—these seem on the whole fallow years. The four children came rapidly. The little picture available for the passing tourist had to be cultivated: there was the joy of exploration and sketching in the hill towns, the pleasure of working in wood and metal, and amusingness of reviving the little painting—the *cassone* manner of the Italian Renaissance. In these years, divided between Perugia and Rome, Vedder seems to have lived on the small change of his art. Perhaps the best things are still hidden in his portfolios— for he hated to let a fine sketch go. Anyhow there are crayon sketches of magical cleverness and dexterity—an unexpected note in the illus-

trator of Omar—dating from these years, un-
awarded prizes still open to the intelligent
museum director or open-minded amateur.
And there are sketches which have the sense of
tears in them. For these days saw the death of
many comrades and of two beloved sons. To
the "rich romantic sadness of youth" was added
abundantly those real sorrows of maturity—
those tears which best water the plant of
genius.

For better or for worse Vedder is likely to
be known as the illustrator of Omar. He
learned of the quatrains at Perugia through
Henry Ellis, adept in Chaucer and in Blake.
Blake and the "Rubáiyát" gave to Vedder's
mature imagination just the shock needed to
detach new visions from the Renaissance back-
ground. Vedder never seems to derive from
one master in the sense that his friend La Farge
may be said to draw from Delacroix and from
Titian. Vedder assimilated rather the leading
principle of the Italian Renaissance than the
particular practice of any master. And that
principle was that the human body is not only
beautiful apart from any ulterior meaning, but
is also universally available and adequate for
the noblest symbolism. So in the century of
illustrations for Omar, "accompaniments" Ved-

der appropriately called them, we have grand
and elemental figures, nude or lightly draped,
which not only convey the meaning of the quat-
rains, but often seem to raise these meanings to
a higher significance. We are dealing in text
and picture with the simplest poetry of the race
—the short sweetness of life and love, the keen
but uncertain solaces of that wine which is both
drink and philosophy, the pathos of death and
parting, the mystery in life and the darker ob-
scurity beyond—in short, with these great but
generally unperceived commonplaces which are
of the very essence both of meditative poetry
and of monumental design.

To embody all this, Vedder's crayon wrought
out massive and gracious forms of men and
women, fit receptacles for all that love and life
can pour forth, as for all that death and fate
can drain away. There is passion in these
forms, with resignation and melancholy. No
painter of the century, with the single exception
of George Frederic Watts, has found such vivid
and convincing symbols for those great reflec-
tive emotions which, if we will, are ours simply
by our right as human beings. The drawings
were put through in a gush of inspiration in
twelve months of 1883 and 1884, amid the
dank, funereal laurels and cypresses of the Villa

Strohl-Fern at Rome. Unhappily they were but indifferently reproduced in the original large edition. They come better in the successive small editions, but the real publication remains to be made. Since the drawings are still kept together a real reproduction is still possible. It would not only be a signal monument to Vedder's genius, but also one of the most significant memorials of our imaginative design.

Following the Omar, came some of the best paintings: the noble and sensitive head of Lazarus, "The Enemy Sowing Tares," "The Cumæan Sibyl." Any seeing eye could read in the designs for Omar the assertion of a great gift for mural painting. Charles McKim first made this discovery and endeavored to enlist Vedder for the World's Exhibition at Chicago in 1893. The conditions of time being impossible for him, Vedder escaped from Daniel C. Burnham's joyous crew of painters and accepted a commission for a ceiling in the New York residence of Collis P. Huntington. It has been transferred since to the Yale Art Museum. He chose, as a Renaissance decorator would have done, the obvious impersonations that lent themselves to abstract handling of the figure—the "Sun with the Four Sea-

sons," in a great medallion; the "Moon and Fortune," in narrow spandrels with a winding pattern of arabesques and small nude caryatids. The whole was disposed, after Raphael's precedent, as a gracious and significant filling of chosen geometrical spaces, without such tricks and illusions of perspective as are usual in ceiling designs. The decoration was conducted with emphatic linear rhythm and without much positive color. There is a plastic quality about the modelling, and the design—as in all of Vedder's mural paintings—could be acceptably rendered in low relief and in monochrome. To this plastic quality many critics have objected and Vedder himself, in the "Digressions," seems to deplore the rather negative quality of his later color. Indeed, he used to say ruefully, and I think self-deceived, that a fine colorist had gone astray in himself.

Personally I think the objection and the regret were both ill-founded. What Vedder had to say was complete in line, mass, and composition. His idea of decoration needed only an enriched monochrome; more color, or a more realistic treatment, would have compromised the terse and logical abstractness of the method. The intimate and particular graces of painting are not valid in the field of general

ideas. Raphael knew that and so did Ingres. Thus Vedder's economy of color and incident should be regarded really as a mark of richness —of complete clarification and control of the intellectual conception.

While the Huntington decorations were going on, McKim got Vedder to do a lunette, "The Idea of Art," for the Walker Art Gallery at Bowdoin College. The year was 1894. The theme was Nature flanked by personifications of Sculpture, Architecture, and Poetry on one side, and by Harmony, Love, and Painting on the other. We have the gracious unfunctional postures of the Renaissance style, a fine contrast of types and figures, and a simple and compelling rhythm.

In 1896 and 1897 Vedder designed for the Library of Congress five lunettes representing good and bad government and their results— subjects dear to such mediæval painters as Giotto and Ambrogio Lorenzetti—and the mosaic of Minerva. He affected to think lightly of these designs, but I fancy it was a whimsical pose. The lunette of Anarchy seems to me one of the best things in the mural painting of the century. It has not only the customary largeness and rightness of design, but legitimate intellectual subtleties all its own.

The joy of ruthless destruction, of a power that has passed beyond human good and evil, could not be better expressed.

Here Vedder's work as an artist virtually closes. It had consisted of three great spurts —the early imaginative pictures of 1863 to 1865, the Omar illustrations of 1883 to 1884, the mural paintings of 1893 to 1897. For lack of training and opportunity Vedder had come tardily to his own. The great impulse toward mural painting and the waning of our æsthetic parochialism found him an old man, if a singularly sturdy one, and ready to rest on his oars. The proceeds of his mural painting went into his Xanadu, the delightful Villa dei Quattro Venti, which he built astride the saddle between the two great mountains of the Island of Capri. There and in Roman winters he lived mostly in memories, cultivated old and new friendships, wrote his delightful autobiography, "The Digressions of V," 1910, and two books of quaint verses, "Moods," 1914, and "Doubts and Other Things," 1921. The last book—beautiful in its make and illustrations—came into his hands the evening before he died peacefully in his sleep. For that I am glad, since "V" adored his own verses. He had outlived his

strength by six years, but not his wit and his musings.

What Vedder might have accomplished could he have chosen a later birthday, had he been professionally trained instead of having to train himself, had he enjoyed that small but certain and adequate income which he wistfully envisaged as the root of all artistic righteous-ness—is an interesting matter of speculation. It is the under-note of elegy in the fun and fancy of the "Digressions." As it is, it may seem enough that he was the greatest intellectualist painter of America in his day, and with few rivals among his contemporaries anywhere. With all his limitations—and painfully he knew them—he had, in Mr. Brownell's words, em-phatically expressed his own "native inclination for whatever is large and noble in form," and as well "a penetrating feeling for beauty in its full rather than in its fleeting aspects."

[1922.]

V

AFTERTHOUGHTS ON WHISTLER

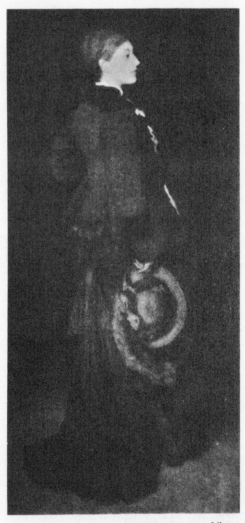

JAMES McNEILL WHISTLER, "Rosa Corder"

AFTERTHOUGHTS ON WHISTLER

A gentleman once came into a painter's studio, and in the course of chat admitted an income of fourteen thousand crowns. Before leaving, he inquired the price of a landscape and was told two hundred crowns; smilingly, he said he would call again, in hope of a lower price. On a second visit, the price was three hundred. Scenting a joke, the patron redoubled his praises of the picture and made a third inquiry. "Four hundred crowns," said the painter, "and a hundred crowns more every time you ask, and to rid myself of your importunity, and show up your stinginess, and finally, to prove that with all your fourteen thousand crowns you cannot buy one picture of mine, here goes." Whereupon the painter kicked the canvas into rags. This story is told, not of Whistler, but of one Salvator Rosa, who, more than two centuries earlier, had unpardonably anticipated many of the devices of the author of the "Gentle Art of Making Enemies."

Salvator's pictures are still in the galleries, but how little the pose he elaborately main-

tained now matters! The time will come when Whistler's symphonies and arrangements will have no advantage in mere notoriety over the reliques of stupid men. Horsley, of whose campaign against the nude was contemptuously written *Horsley soit qui mal y pense,* may look nearly as impressive as Whistler in a museum catalogue of the twenty-second century.

Already the mere wonder of Whistler is lessening. The legend which he assiduously built up is crumbling, despite the official hagiographers. Such comprehensive exhibitions as those of Boston and London tended at once to make more normal and slightly to diminish the impression of his art. The smaller anthology later presented by the Metropolitan Museum left one positively rubbing one's eyes and wondering what these battles already long ago were all about. Only a few weeks since this ill-proportioned square hall had been hung with Rembrandt, Steen, Ruysdael, Vermeer. The contrast was a bit overwhelming.

The three great portraits (what need to name the "Mother," the "Carlyle," and the "Miss Alexander?") were necessarily absent. Everything else was well represented, though one missed such a masterpiece of the early realistic days as "Westminster Bridge." For it

"The Blue Wave," a kind of sublimation of
Courbet, was a fair substitute. The portraits
were, with the exception of the etherial and
baffling "Florence Leyland," which the Brook-
lyn Museum lent, conquerors in many previous
shows. Here was that strange expression of
wistful agility, the violinist Pablo Sarasate, and
the fragile aristocracy of the poet Robert de
Montesquiou. Here was the melancholy mask
of that sorely tried and trying patron, Francis
Leyland, the æsthetic ship master. In one cor-
ner, aloof, yet conscious of you, the "Anda-
lousienne" glanced over her shoulder; across
the hall was poised in complete unconsciousness
"Rosa Corder," true Diana of Park Lane.
Her presence almost compensated for the ab-
sence of the "Mother" and the adorable "Miss
Alexander." The absolute discretion of Whis-
tler's art is in this portrait of a young gentle-
woman. Observing the pallor of the face
proudly unconscious in its setting of vibrant
browns and grays, Mr. Huneker happily read
into the whole the legend of inaccessibility—
Noli me tangere.

Beside the smaller portraits, the Japanese
manner was exemplified in "The Golden
Screen," and "Lange Leizen," the blues of
which are a feast, and "The Ocean." Of the

nocturnes and similar open-air arrangements, there were five, including the delicious "Blue and Silver—Battersea Reach" and the notorious "Falling Rocket," which cost Ruskin a farthing and several painful quarter-hours. In what, for want of a better name, we may call the English manner are the "Music Room" and the "Little White Girl." Singularly apart stood the big "White Girl," and to crown the exhibition there was a fine group of those nudes and semi-nudes in pastel which are rather obviously called the "Tanagra" series. The Museums, the Freer, Whittemore, Pope, and Johnson, and Canfield collections, among others, had given of their best. So great was the diversity of style that one was reminded of the analysis of the German critic Meier-Graefe, for whom Whistler was a case of multiple personality.

But under the evident variety of its components, the show had unity enough. A principle of ultrarefinement, of sensitiveness, and appealing charm ran through the whole. There is a Whistler manner as distinct as the Greuze mannerism. Realist, impressionist, mere prestidigitator—in all rôles, he is prince charming. The conviction grows insensibly, as one notes how many of these pictures lack the more substantial qualities of fine painting, that his art

is one of avoidance; negative, not positive.
There are certain exquisitely disciplined person-
alities to whom we yield ourselves uncondition-
ally, only to perceive later, and with a little
shock, that they prevail through elimination of
the common and wholesome asperities. This
thought we may pursue later. What is impor-
tant is to note that, save for this evasive charm,
all Whistler's work has taken on a more usual
look. Possibly the miracle of the symphonies
and arrangements depended largely upon the
background of the Royal Academy, which as-
suredly was a world to satisfy a Huxley—a
world in which miracles did not happen.

Whistler's dæmon never served him better
than in suggesting London as a residence. His
native America was plainly out of the question.
Paris, the city of Whistler's love, afforded no
appropriate stage. Had he grown to maturity
alongside Boudin, Manet, Cazin, Fantin,
Degas, he would probably have been a better
painter. This was his own opinion. But,
clearly, he would have been much less of a por-
tent. Even his wit would there have seemed not
outrageous, but merely exceptional. In the
Parisian drama he could hardly have been a
protagonist; London from the first gladly
awarded him the part of Apollyon, and trem-

bled while it hated. The result is that we have
taken his works as the cartels of a champion.
Against the murkiness of the Royal Academy
they have glowed like an oriflamme. Seen sim-
ply as paintings, they must take on a different
aspect. That, surely, is the reason why just the
shade of a misgiving now accompanies the at-
tempt to renew the old, fond adventure of a
soul among symphonies and arrangements.

It will clarify our vision if we go to the gal-
leries of old masters in the Metropolitan Mu-
seum for a moment and there take a glance at
a few superlative examples of fine painting.
Let us choose Vermeer of Delft, Hals in his
portrait of a woman, Renoir's Mme. Charpen-
tier among her children, Manet's "Boy with a
Sword." Then to the Vanderbilt Gallery, ob-
serving on the way a supreme example of
charm, Rossetti's Lady Lilith. In the long cor-
ridor, for charm and masterly execution com-
bined, let us halt before the best of the Alfred
Stevenses. As we pursue the long way back, it
will be well to lug in Velasquez. Thus we shall
have set for the Whistlers the very severest
comparisons, and I think that only a fanatic will
deny that his art, with all its winsomeness, is
distinctly of a smaller accent, at times of a
rather thin preciosity.

Let us ask a blunt question? Was there a superlatively fine picture in the memorial exhibition? The present writer is sure only of one—"The Little White Girl." Surely, no time will stale the lovely pensiveness of the mood, the dulcet quality of a workmanship everywhere perfectly assured, the dainty accord of the various whites. In comparison, the big "White Girl" is far-fetched and rapidly becoming merely odd. To paint white on white has ceased to be a marvel; in fact, it never was except in a color-blind age. Aside from this, the big "White Girl" is uncertainly balanced and uncomfortable to look at for long.

The Japanese pictures are refined to a degree, subtly harmonized, and present individual passages of the finest color. They are so evidently mere confections—self-confessed stages towards the "Little White Girl"—that their analysis may be waived.

The "Music Room," perhaps the most accomplished of the early pictures, keeps one long in doubt. It is the most strenuously complicated of Whistler's interiors. What seems to place it just a little lower than first-class is an eccentric edginess, and some lack of complete unity.

The "Rosa Corder" is so lovely an appari-

tion that I will not argue the technical reasons that make it not quite a great portrait. To a discerning eye the whole of Whistler is in this canvas. Enhance it a trifle and you would get the "Mother" or "Miss Alexander," transfer the manner to landscape, and the symphonies and nocturnes logically ensue. The essence of it is an infallible pictorial sense. The focus of that pallid face in its setting of brown and gray is perfect. Where the picture comes a little short of the best is in a too-ready sacrifice of the beauty of definition to that of unity, in a *parti-pris* of tone which makes the artist impose the harmony arbitrarily instead of extorting it from the data.

This tendency, barely discernible in the "Rosa Corder," becomes pronounced in the nocturnes. There is a thrill in most of them that makes one forget their high degree of artificiality. Cazin's moonlights, in a manner far abler, lack the glamour. Millet has done the thing with equal charm and greater majesty. Whistler invented a most useful decorative formula, which he abused a little himself. His followers have shown how much of a trick it was. His art is so personal and distinguished that European painting hardly suffices to demonstrate its insubstantiality. One may fairly judge a pic-

ture like "Symphony in Gray and Green: the
Ocean," only by comparing it with what it sim-
ulates—the color-prints of Japan. Better yet,
take landscape painting of the Chinese school.
The Eastern product is finer at every point,
more spacious, more mysterious, and, above all,
more knowing. It gets by direct and exquisite
selection from nature what Whistler got by eva-
sion. To a Japanese connoisseur most of his
work would seem superficial, and just a bit slov-
enly. And this means that, while he valiantly
shook off the cheap naturalism of Europe, he
never underwent the discipline necessary to at-
tain to the mystical naturalism of the Far East.
Artistically, he remains a man without a coun-
try.

Here he was more or less of a victim. In
his etching, his most important achievement, he
managed to keep his feet on the ground.
Doubtless, he would have done so in his paint-
ing also, but for the presence of the "enemies."
Of them he was morbidly conscious. He
dwarfed himself by resolutely being as unlike
the Royal Academy as possible. He moved in
an atmosphere of hostility tempered by adula-
tion equally excessive. He fatally lacked the
company and the criticism of his peers. The
work he did in such unwholesome isolation tes-

tifies to the extraordinary natural gift of the
man. His quality, however, was not to be
great, but to be charming.

Possibly, the "Tanagra" pastels show him
quintessentially. The refinement with which
these little figures are set within the tinted
sheet, the deftness of the spotting, the value
of the sparsely applied color, a sensuousness
that for being discreetly attenuated is all the
more effective—such are the salient qualities
of this work. It recalls, as the word Tanagra
does, the subtly coquettish flavor of Hellenistic
art. There is a hint of Correggio, though not
his vigor, and a stronger reminiscence of the
pensive charm of Watteau. Not merely in
enduing the figure with a peculiarly aristocratic
glamour, but, more technically, in adopting the
blue tints as harmonizers, the poet-painter of
Paris anticipated the poet-painter of Chelsea.

By an occasional *tour de force*—a few of
the Thames etchings, the three great portraits
—Whistler imposes himself upon us. But
we fail to note how exceptional work of this
quality is. The real Whistler is not in the
sabre stroke, but in the caress or the equally
feline scratch. It was this that made him so
readily lean toward Rossetti. In fact, his rela-
tion to the early English illustrators and paint-

ers has strangely been overlooked. Like them, he inherited much from the mannerly school of the eighteenth century. What is the title etching to the "French Set," one of his most engaging groups of figures, really like? Is it not like a superlative Stothard sketch, and even more like a Dicky Doyle? Walter Crane, as a decorator, shows qualities and defects singularly akin to those of Whistler as a painter. These analogies are raised merely to show that, normally, Whistler's place is not with the men of power, but with the men of charm. In painting he must have learned much from Gainsborough and more from Turner, who, in fact, has anticipated more robustly many of the triumphs of the arrangements and symphonies.

Withal, Whistler remains absolutely personal and apart. His art, being one of avoidance, evading certain fundamental requirements of structure, is on the whole a small one, but exquisite, idiomatic, and refreshing. An excess of languor, too great a dependence upon the hypnotic effect of the merely vague, is its defect. It heralded a needed reaction against the color-blindness of the official art of France and England, but, unhappily, it set a generation of secessionists to weaving abstract and rather trivial iridescences. In the doctrine of precious-

ness of surface, Whistler did both harm and good. To show how really hideous was much that passed for fine painting was a public service. To suggest that manipulated pigments can or should vie with the specific beauties of ceramic enamels or with Eastern weavings was to launch a forlorn hope.

On this theme of "quality" much nonsense has been put about. Simply as an agreeable colored texture no painting compares with a fine Persian rug or tile. In other words, the painter must atone in other perfections—in a masterly sense of form, in beautiful and complicated arrangements, in spaciousness, in personal interpretation of bare appearances—for the relative meanness of his materials.

Whistler met these requirements only about halfway, hence falls out of the class of great and well-rounded painters. His tact was sufficient to keep him clear of the more demoralizing implications of his own theories. Naturally, his imitators lacked the subtlety to see that the master frequently took himself in a Pickwickian sense. They lacked even more lamentably the discipline of sound early studies. Without having done their Thames etchings, they undertook their nocturnes. Where Whistler was limpid, they made a virtue of deli-

quescence. In him were the seeds of the best and the worst tendencies in modern painting. Fighting magnificently for the decorative ideal of picture-making—a truly regenerative principle—he also reduced the painter's art to mere epidermal bloom, a dangerous counsel of empty æstheticism. Hence no one can be quite indifferent to him.

Is not this according to his strictest definition of success? Nor would one gauge too crabbedly his evident limitations. He is so charming that one will generally take him at his own valuation. As time goes on, however, it will become clear that his abode in the Elysian fields is nearer the pleasant garden-houses of Watteau and Fragonard than the more imposing mansions of Turner and Velasquez.

[1910.]

VI

GEORGE FULLER

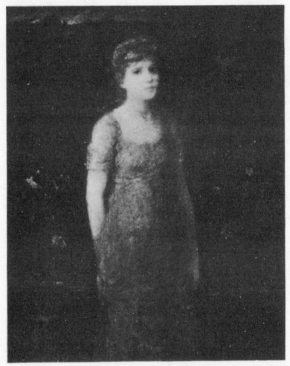

GEORGE FULLER, "Winifred Dysart"

GEORGE FULLER

Even chronologically, George Fuller's art was a twilight development. After early and relatively insignificant experiences as a portrait painter, the needs of his family drove him back for fifteen years to the paternal farm near the confluence of the Deerfield and Connecticut rivers. And it was the failure of the farming episode that restored him to painting, a man of fifty-four. The handful of pictures by which he is remembered were painted as he passed into old age. He died at sixty-two. There is something morally heroic in this art born of adversity, and accomplished almost in the face of death, but the paintings themselves tell nothing of the outwardly guiding circumstances. They are so many visions of the mystery of nature, of the fragility of maidenhood, of the hesitancies and frustrations of personalities too finely wrought for such a struggle as Fuller himself had faced.

And all this is intimated rather than expressed, and caught in a singularly uniform, almost monotonous, medium. "Brown sauce"

I hear a young and impatient reader interrupt. Yes, brown sauce, but with a saving difference, for it is not a studio recipe but a true inference from those late October twilights in Massachusetts, when the air shimmers with a luminous dust that has been crushed up from dried leaves. The simple magic of George Fuller was to grasp the quality of this hour and season, as evocative of pensive dreams.

From this quintessential moment of the dying year he distils a universal pathos. A man who sees æsthetically only the whip-poor-will's hour, and then within a narrow circle, may be a notable elegiac poet, and that Fuller was, but hardly a great artist, if we are to count fecundity and athleticism for anything. And since within his limitations Fuller is a fascinating critical problem, in attacking which I shall surely now and then fall into overstatement, let me once for all make my general estimate of him clear. I do not think any master of understatement, however distinguished, any artist whose forte is chiefly reticence, can be regarded as a great artist. It is this failure to speak out which makes Hawthorne, in every way an exquisite writer, hardly a great writer. W. D. Howells, who wrote an admirable memoir of Fuller, again is a writer who has more taste

than vitality, being withal an impeccable crafts-
man. Fuller, after all, in this devotion to un-
derstatement and half-tones is in an authentic
New England tradition which reaches from
Hawthorne's "Twicetold Tales" to President
Coolidge's enigmatic "I do not choose to run."

George Fuller was born near the lovely vil-
lage of Deerfield, Mass., a spot redolent of
history and legend, in 1822. His father was a
farmer, and from him the son inherited not
much more than a mediocre farm, a quiet pa-
tience and a love of the soil. On the side of
his mother, Fanny Negus, there was talent.
Her stock was Welsh, and an amateur of
ethnic origins would be inclined to see a Celtic
strain in the elfin and elusive art of the son.
By his fourteenth year, George Fuller's school-
ing was over, and he was a clerk, transiently,
in a grocery and in a shoe store. His libera-
tion came in a small position on a railroad sur-
vey in Illinois. Of the party was the talented
sculptor, H. K. Brown. Under his advice
Fuller trained himself as a face-painter, work-
ing eventually at Boston, Albany, in northern
New York and in the South. In his nineteenth
year he writes elatedly to his family that he
is able to raise his price from twenty to thirty
dollars. That year there was a pleasant inter-

lude at Albany with Brown and with the benign idealist sculptor, Erastus Palmer. Brown wrote Fuller as he left Albany: "Look upon your drawing and painting as your language, the medium through which you express to others your feelings." Admirable humanistic counsel which Fuller was later to ponder deeply.

From his twentieth to his thirtieth year Fuller was an itinerant face-painter, but made considerable stations in Boston and New York. His personal distinction got him good acquaintance everywhere. The habit of the world and of great books brought him an education and a culture peculiarly his own. In his art he had studied diligently Stuart and Allston. But his achievement was at best respectable, and when in 1853, his thirty-first year, he was elected an Associate of the National Academy the compliment was quite as much to his personality as to his portraiture. So he carried on, esteemed but inconspicuous, to his thirty-eighth year.

Meanwhile things went badly at the Deerfield farm. The gains were rare and hazardous; there were slowly increasing debts; some loved one was always battling hopelessly and tragically with New England's white plague. It came to a pass where the farm and the family plainly needed him, and, never a Chris-

tian believer himself, he made the art of Christian abnegation unhesitatingly. It turned out to be his own making as an artist, but this he could not foresee.

So it was in the spirit of a farewell to his art that before assuming the yoke, he gave himself a few months in Europe. His companion was that brilliant picaresque critic, W. J. Stillman. The trip, a rapid one for those leisurely times, reached from Sicily to Holland. It would be pleasant to quote from his correspondence at this time observations which show a fine and lucid taste, and a surprising degree of real education, but the scale of this essay forbids such alluring by-ways. He met Ruskin at Geneva, but was never drawn toward Ruskin's primitivism. Of Rembrandt's "Night Watch" Fuller notes: "The mystery of color and the poetic suggestiveness in a degree which has only been expressed by his masterly hand." Here was matter on which to ponder in the rare surcease of mental worry and physical exhaustion on the Deerfield farm.

By his thirty-ninth year George Fuller had taken up his work as a farmer. The next year he married Agnes Higginson. With the blessing of many children, came the accompanying cares. He did not entirely give up painting.

A simple studio building rose alongside the old farmhouse. But there was little time for pictures. He cleared thirty acres of swamp land, largely with his own hand. One must think of him growing prematurely old, already venerable with his great white beard, gazing at once wearily and intently on autumn evenings when the cliffs of Sugar Loaf rose warm and lustrous out of the brown air that filled the intervening river bottom—meditating pictures which he had no time to paint. One must also think of a simple and noble acceptance of the lot of patriarch and tiller of an ungrateful soil.

After fifteen years of it, the farm was bankrupt; there were half a dozen little mouths to feed. It was now a question whether painting would save the farm. Within his fifty-third year he painted twelve pictures; adding two earlier ones, he exhibited the fourteen, in 1876, at Boston, sold most of them, received a generous criticism, and secured a patronage which he held and increased during his remaining eight years. And when the young painters surcharged with high ideals from Paris set up in rivalry with the old Academy the Society of American Artists, Fuller was one of the very few seniors whom they honored with an invitation to their select membership. The whole

story is a little like an attenuated New England version of the Book of Job. Something of it reappears in George Fuller's upright, wistful and quietistic art.

The Job of the Bible seems to have readily forgotten his pains and chagrins in restored and enhanced good fortunes. Fuller experienced a rejuvenation, but his new art drew its character of refined obscurity from the hard intervening years. In his pictures it is always eventide. His figures do not act and have never acted. They simply exist and seek sympathy. Their appeal is discreet and muted, merely implicit. Their mood is as veiled as their forms, which shimmer uncertainly in the enveloping dusk. They live not in any world of ours, but, as Fuller once said he wanted them to live, "in a world of their own." Inevitable analogies with Rembrandt, with Whistler, with Carrière, are unprofitable, for there is no community of mood. Fuller was far less able than any of these technically kindred spirits, and, while he lacked their varying spiritual clarity, he had something quite precious and his own. It may be sensed in any one of those maiden forms that are at once mere wraiths in a luminous dusk, and nevertheless vivid apparitions to any sensitive imagination. "Winifred Dysart,"

"Priscilla," "Nydia"—these are the memorable Fullers, and to these ideal figures may be added a few portraits of similar distinction, always portraits of young people.

Before approaching the real theme, a word on the landscapes. I do not share the general admiration for them. Having a certain relation to specific appearances, they are not specific enough, and being fantastic, they are not fantastic enough. Indeed the otherworldliness of Fuller's art evidently disabled him from being a sound landscape painter in our native realistic tradition, while his temperament was too romantic to permit him to seek merely decorative conventions, and his spirituality was of a diffused type that did not readily transform specific appearances into equally concrete symbols. It seems to me that Blakelock, who was distinctly a more limited nature, saw better what Fuller wanted to see in landscape and painted it better. There are charming landscapes by Fuller. The little sketch, "Shearing the Donkey," is entrancing. I guess it to be a happy accident. The "Turkey Pasture" has dignity and more than usual richness of color, and a singularly noble sky line of live oaks. But in general the landscapes of Fuller, while very tenderly felt, seem to me inade-

quately seen. The poetry is not reinforced by any lucid rhetoric of form. The expression anticipates something of the slipperiness of recent image-making in free verse. Nothing is dense and measurable and permanent. So I think the vogue of the landscapes is really a kind of overflow from the well-grounded admiration for the figure pieces. Had Fuller not painted Winifred Dysart and her crepuscular fellow sprites, I am sure that the landscapes would have passed almost unnoticed.

To put into words what one feels about the half-dozen fine figure pieces is difficult. No description covers the case. Of what avail is it to note that these lovely figures of young women are suffused and buried in a russet and pearly mist, that they stand gracefully and hesitatingly with a breadth of vibrating gloom at either side, that they are rapt in their own musings, yet singularly appeal to sympathy, that they exist in no time and place but in a quiet effulgence of all the autumns? When one has said this, we have gained only pale generalizations for a very specific charm. Yet there is no other way, for these fair girls of George Fuller's imagination are themselves generalizations and symbols, quintessences of all that was exquisitely candid and pure in young woman-

hood as he saw it; of all, too, that was elusive
and intangible. It makes no difference whether
the apparition is named from our Colonial days
or from Roman history. It is simply a Fuller
—a reverent vision with its element of wistful
longing. Such more specific creations as "Fe-
dalma" in oriental travesty, or "The Quad-
roon," in wearied, perplexed and perhaps half-
rebellious meditation, fall out of the class. In-
deed "The Quadroon" makes Fuller look a
minor painter less from lack of gift than from
force of circumstances. The picture has a real-
ity, a formidable existence in our own world,
which the others lack. Their existence in their
own world and George Fuller's is, however,
complete and undeniable.

To be sure, the mere construction is hesitat-
ing and unhandy—much scraping out and over
painting, many changes, much ploughing the
wet paint with the brush-handle—all the marks
of a capricious and unsystematic handling. But
all this is really of the least importance. There
is no messing of the surface simply for quality;
everything ministers to expression. The admi-
rable white-line wood-engraver George Closson,
who engraved the cuts for the memorial vol-
ume, testifies that the imprecision of the work
is only apparent. Everything lent itself to the

very precise formulas of his own art, while tax-
ing all the resources of his most skilful burin.
How such effects are obtained is really no busi-
ness of the layman. His curiosity in such points
is usually at the expense of any real apprecia-
tion. It is better in George Fuller's case simply
to share that highly sublimated nostalgia with
which in advanced years he faces the lovely
mystery of the adolescence of the Yankee girl.

For the validity of his symbolism lies in the
fact that one is dealing after all with daughters
of New England. They are not portraits, but
they have an odd and inexplicable reference to
girls we have known. They are at once so
fragile and so confident, their gracefulness is
so unconscious and often so near to a captivat-
ing awkwardness. They have an air of existing
in their own right, of being unrelated to other
people or to affairs. Indeed the old cult of
American girlhood in its delicate institutional-
ism perhaps finds its best celebrant in George
Fuller. And since the cult itself has waned,
and the idol has successively changed and
stepped down from the dream-made pedestal,
George Fuller's pictures add to their intrinsic
charm a distinct pathos of distance, and a value
of spiritual documentation.

The word feminist has not the pleasantest

connotations, but in every good sense Fuller was just that, and beyond that he had very little to offer. So were two of his younger contemporaries, feminists—Abbott Thayer and Alden Weir. Thayer heroized his young women morally and mentally. Weir felt chiefly the complicated delicacies of their minds. Fuller is at once farther from and nearer to the fair girls he saw and transformed in imagination, than is either of the other two. He approached the mystery with less curiosity than either, with less desire to understand, but he gives a more complete and unquestioning homage. He has neither the somewhat stoical chivalry of Thayer, nor yet the cerebral admiration of Weir. Fuller has no desire to be noble nor yet to be discerning; he lets himself go in wistful, bitter-sweet imaginings. Autumn muses upon spring until her diaphanous form is evoked. It moves hesitantly among the dead leaves and stirs from them a veil of saffron dust which is at once a barrier and a medium of revelation.

It would be easy to take this as a classic case in the psychology of senescence, easy to be ingenious on the theme, and still easier to be disgusting. I shall hope to be neither. One does not need to cite the young maiden who warmed King David's feet; one may without reading

Mr. Galsworthy's "The Dark Flower," imagine the ordinary outgoing of every aging male towards young womanhood. But one finds the experience also in the form of a wistful and troubled homage which has in it no element of desire. There is no need of analyzing what is a matter of common observation, and, according to its quality, fit subject for the comic strip and the night club or for a high and delicate poetry. In this matter George Fuller was on the side of the angels, and they visited him familiarly, and the record of their epiphanies is in his pictures.

[1929.]

VII

HOMER D. MARTIN

HOMER D. MARTIN, "The Old Manor House"

HOMER D. MARTIN

By 1830 two main tendencies had asserted themselves in our landscape painting. With inadequate technical resources Thomas Cole had developed scenic breadth, had made visible the sober or savage poetry of our forested mountains. His art was one of deliberate selection in the interest of mood. With infinite patience and the austerity of an analytical eye Asher B. Durand set down the minute facts of our landscape. The work is descriptive and inventorial, mood being secondary to truth as Durand understood it. Our later landscape painters have followed one precept or the other, or have mediated between the two. The eventual triumph was to be with Cole, who had independently divined what was to be the point of view of the great landscapists of England and France.

It is the historical distinction of Homer D. Martin that he followed unwaveringly the tradition of Cole, enriching it with new resources and a finer sense of color and adapting it finally to more intimate subjects. It was Martin's per-

121

sonal distinction to convey more powerfully than any American contemporary the elegiac poetry of our primeval scenery, while also catching the richer pathos of sea-beaten and immemorially inhabited Normandy. This he did with reverence for average appearances and without the glamorous inventiveness of, say, Inness. Thus within a somewhat limited range, and judged by his best pictures, Martin, I think, should be regarded as our best landscape painter of the generation following Cole, and I am not sure that anyone since has really surpassed his discreet and noble deployment of his favorite themes.

His beginnings were unlikely even for the 'fifties. He was born in 1836, a carpenter's son, at Albany, New York, with a congenital astigmatism. The family were strict Methodists. They attempted to turn him from a taste for drawing by making him first a shop clerk and next an architect's draughtsman, and when they yielded to his evident vocation, no better master was available than the feeble James M. Hart. Homer Martin soon left him, and, except for a brief association with James Smillie, never again sought a master. From the venerable sculptor E. D. Palmer, from Launt Thompson, from such young friends as Edward

Gay and George D. Boughton, proud possessor
of a Corot, Martin received fellowship and en-
couragement, but his real training was in the
face of nature.

There exist scores of his early drawings.
After the timid fashion of the time these are
pencil outlines on buff paper cautiously shaded
and touched with white. The Catskills, Adi-
rondacks and White Mountains furnished the
themes. The attitude is panoramic; great
spaces are represented and, except for a cer-
tain nervous energy in tree forms, without
much skill. To a modern art student indeed
the series would seem contemptible. Yet these
austere sheets have a quality which the modern
art student rarely attains—namely studied and
beautiful composition. The point of view is
carefully chosen; the necessary omissions and
emphases are instinctively grasped; each sheet,
so far as arrangement is concerned, is a lucidly
conceived picture. In short these rather feeble
drawings constitute after all a notable training
in composition and in memorizing the greater
forms of nature. Without these early exercises
it is doubtful whether Homer Martin broken
and nearly blind could have created his noblest
forests, mountains and moorlands from memory
aided only by his own early pictures. Through-

out his career this innate concern with composi-
tion is evinced by his habit of making a new
picture out of an old one by revision and sim-
plification. He forgot nothing. His fastid-
iousness in arrangement may account for an
occasional lack of robustness in details. It is
the limitation of Claude whom, I fancy, Mar-
tin early came to know in big copper plates
adorning the walls of travelled Albany families.

The few of Martin's paintings which have
come down from the late 'fifties are so poor
that their only interest is to show that a great
talent may entirely fail to show itself in an
ill-understood medium. Slickly and thinly
painted, with the quality of a bad oilcloth, grays
out of key enlivened with poisonous passages
of vermillion, they represent the worst amateur
practice of the moment. However, from 1857,
they were occasionally accepted by the Acad-
emy, which deserves some credit for discerning
the fine arrangements disfigured by an incom-
petent practice.

In the early 'sixties his practice improves, as
a result probably of his training with James
Smillie in New York, 1862-1863. The veteran
engraver and landscape painter was no giant
in landscape himself, but he knew everybody
worth knowing in artistic New York. Homer

Martin's love of unity, expressing itself as tonality in his painting, kept him aloof from the somewhat raw polychromy of Bierstadt, F. E. Church, and early Inness, as it had earlier from that of the Harts. He must, I think, have studied the great Coles with their sombre breadth, and he probably took counsel of the popular J. F. Kensett with his crisp notations of form and his ingenious if superficial color harmonies.

At twenty-five, in 1861, Homer Martin married Elizabeth Gilbert Davis, a brilliant woman whose novels and book reviews, for the *Nation,* helped much during the thirty-five years of struggle upon which the young pair had embarked. She was his social superior, but they had almost everything else in common. Both were completely unworldly, both artists, both loved good talk, good books and good music, both were agnostics before Herbert Spencer had coined the word. On the religious side their bond was later to be strained by Mrs. Martin's conversion, under the auspices of La Farge and Father Hecker to Roman Catholicism, but she played her subsequently difficult part with entire loyalty and reasonable discretion, and the bond held.

Their future evidently lay beyond Albany.

In 1864 Martin brought wife and baby to New York, and set up his studio in the Tenth Street building already inhabited by La Farge and Winslow Homer, who were to be his only artist friends. At New York his art and associations rapidly broadened. He passed beyond the idyllism of his best early picture, "The Old Mill," 1860, and restudied his early forest and mountain themes, treating them with the old compositional felicity while adding thereto a more incisive drawing, a finer handling and a color richer and more harmonious. His art already seems complete in "Lake Sanford," one of the treasures of the Century Club. It was painted in 1870 from sketches made considerably earlier. The scene is tragically harsh. One looks across a ledgy hummock, spiky with blasted spruces, immemorially ravaged by fire and wind, to a pewtery lake beyond which dull clouds hide the distant ledges and the sky. The dark color is of the emotional essence. It seems, as Martin's friend, William Dennett, castigator of contemporary political corruption in the *Evening Post,* used to say, as if nobody but God and the artist had looked upon the scene. The picture is typical for its moment. If, as Amiel was to write, landscape is a state of mind, this was the most distinguished land-

scape America had produced, as noble as Cole's best with more conscience and precision, nobler and more selective, if less colorful and urbane, than the contemporary Innesses. And the Martins of his early New York days have often a blither note. In a canvas of 1873 painted for his friend, the late William C. Brownell, one glimpses the iridescent sheen of Lake Champlain across sunny slopes, while above the haze that veils the farther shore one finds the near-by green repeated in that blue-green, thinly covered sky which was to be fairly the trademark of the fine early Martins.

When, in 1874, the National Academy elected him to full membership, they probably were exercising rather magnanimity than artistic discernment, for Martin had become something of an outlaw among his fellow artists. Their intellectual superior, he cared little for their company. They in turn feared his extraordinary wit which, if usually genial, could at times be cutting. So his ambrosial nights at the Century Club were passed preferably with such higher journalists as the veteran Dennett and young Brownell, with the future critic of architecture, Montgomery Schuyler; with prominent physicians like Dr. Mosher, health officer of the port, or the vigorous and accom-

plished Dr. Daniel M. Stimson. In the Century the legend of Martin's talk is still vivid, but there seems to have been something untranscribable about it. The few *verbatim* examples which I managed to secure for my biography of him suggest only a ready and somewhat brittle wit. The overtones are no longer there. The charm of his talk had the perhaps valuable foil of a visage marred by a chronic eruption. His mere acquaintances say that he was physically repellent; his close friends, that the disfigurement was slight and negligible. Concerning Homer Martin men have never held tepid opinions.

In New York of the black-walnut era the Martins soon won the companionship and the admiration of the best without becoming prosperous. They both were temperamental, and indifferent managers. Her mind was on her writing and on new and poignant religious experiences, his on his painting and on convivialities more delightful than contingently profitable. Mathematically they earned the modest living they required, but the money was spent before it accrued, and, I suppose, they were never wholly out of debt. His painting, enthusiastically hailed by those who were or were soon to be our best critics, never struck the

popular and wealthy taste. Its frequent som-
breness was against it in an age very cheerful
over its own vulgarity. New riches did not
care to linger in desolate places which only God
and Homer Martin had found good. He was
suspected of painting in French and unpatriotic
ways, and, though he had painted many ex-
quisite pictures, he lacked Inness's knack of now
and then bowling over a doubting public with
a palpable and very big masterpiece. Indeed
he kept going only through the generous and
intelligent patronage of friends. In 1873 he
wrote to his friend Mosher, "It is better to be
in hell than in art."

As he carried on amid difficulties, his style
mellowed. His compositions, now cleared of
traditional details, gain breadth; his discreet
tonalities become more subtle; the brush works
no longer with alternations of exasperated
energy and heaviness, but caressingly with little
pigment; the themes are more limited and inti-
mate—brooks, the bends of slow moving rivers.
This foreordained progress was doubtless ac-
celerated by the European trip which he made
in 1876. He saw the masterpieces at London,
Paris, Amsterdam and The Hague. Unhappily
no record of these formative impressions sur-
vives except his shock over the artificialities

and sensationalisms of Turner and his joy over the tranquil perfections of Claude. At London he had the high companionship of Albert Moore and Whistler. It was the moment of the nocturnes, and I think their exquisite economy of material passingly influenced the Martins of the late 'eighties. When he returned from England, the young progressives of the Society of American Artists invited his membership, a compliment which on the material side only emphasized his unorthodoxy. He undertook hack work for *Scribner's,* illustrations of the literary shrines about Concord. This commission, however reluctantly undertaken, was highly important, for a similar charge in England was to bring him to his few years of relative ease and before his most congenial themes in Normandy.

The verdict of the auction rooms is clear that the good Martins are the Normandy Martins and those that he later made in the new style acquired in France. I do not dispute it, but I feel that the best of the American Martins are thereby gravely underestimated, and that if he gained immensely in France, he possibly sacrificed an alternative development of an even more precious sort. It is the memory of the lovely picture of 1880, "Andante, Fifth

Symphony," which evokes these might-have-beens. It is a visible tribute to the noble music, and much of it was painted while a friend played the piano partition in the studio. Here is the picture, as much as inadequate words may express it: A forest brook broadens into a shallow pool to which vague reflections of rocks and trees and broken sky lend depth and mystery. In the upper vista, boulders glint in the half-light before a screen of misty foliage. The rock-rimmed bounds of the pool and some foreground weeds are accented with great vigor, while everything in the forest above is soft and evanescent. Tree trunks loom spectrally before a general forest gloom which is enlivened by the scarlet flash of a precociously autumnal maple. The general color is extraordinarily modulated grays qualified by broad touches of russet and green. The surface is of a silken thinness and of a similarly subdued luminosity. In its contrasts of preciseness and mystery the picture obeys the Japanese law that every composition must be clearly divided into a masculine and a feminine part. Perfect tone is achieved without sacrifice of local color.

The picture exemplifies admirably a high point of momentary perfection, the culmination

of that delicate naturalism in which Martin had begun. The analogy of the stream broadening amid forest loveliness to the great Andante is by no means far-fetched. In some ways the picture is more attractive than his more highly prized later work with its broader manipulation of paint and its more systematically asserted tone. I sometimes wonder what would have happened had the public seen fit to support work of this excellence and made it possible for Homer Martin to reach his full development in his own land. All his future course was more or less accidentally shaped by the fact that the great art editor of the new *Century*, A. W. Drake, liked the Concord sketches better than Martin himself did and ordered a trip to England to sketch in George Eliot's Warwickshire. I say advisedly ordered, for Martin was in no position to decline a commission however uncongenial. So in the early autumn of 1881 he sailed for England, not as one of the half dozen foremost landscape painters of his day, but as an obscure and needy magazine illustrator.

He reknit the old friendship with Whistler and saw much of the poet Henley. His old Albany mate, George H. Boughton, now become complacently prosperous, has left an un-

gracious record of Martin's disquieting shabbi-
ness. The hospitable Edmund Gosses confirm
this impression and add that he seemed
"muffled and quite discouraged." Little was
done on the Warwickshire sketches. No paint-
ings of these nine months are known. At forty-
five Homer Martin seemed finished. It was
the coming of Mrs. Martin, in the summer of
1882, that lifted him from this slough of de-
spond. The sketches for the *Century* were
soon completed. She was promptly taken to see
Whistler, but the flutterings of the Butterfly
and her own high seriousness were antipathetic,
and the visit was not repeated.

With a little ready money from the illustra-
tions, the Martins were able to accept the invi-
tation of his old boon companion William J.
Hennessy to come to upper Normandy. After
twenty years as a justly popular book and
magazine illustrator, Hennessy had saved
enough to live abroad and paint his now for-
gotten pictures. He was a genial person, a
notable figure at Pennedepie, and he knew the
ropes. From his suggestion to settle near by
at Villerville the Homer Martins gained the
nearest view they were ever to have of the De-
lectable Mountains. It was a time of drawing
together. Both loved the place, in which men

and their habitations seemed to have become a veritable part of nature. He observed and sketched it while she wrote about it delightfully in paragraphs that are so many verbal obbligatos for his now famous pictures. To be sure they were as poor as ever, but it was easier to be poor where nobody was important or lived behind a brownstone front. They were sustained by a sense of his progress, for although he was little productive—only half a dozen large canvases can be traced to the four years spent between Villerville and Honfleur— his art was rapidly broadening, and he was regaining confidence.

Much has been written about Homer Martin's last manner, and its difference from his early style has been somewhat exaggerated. The change came chiefly to painting with a denser material, with the palette knife rather than with the brush and with a more subtle division of tones. He observed the new impressionist technique at Paris, but did not adopt it. I guess that he learned more from that master of tonality, Boudin, who was then painting in the neighborhood. What was new was the subject matter and not the attitude. As Samuel Isham has well written, "The real essentials (the feeling for the relations of mass,

for the exact difference of tone between the sky
and the solid earth, the sense of subtle color)
are the same, and under every change of sur-
face remains the same deep, grave melancholy,
sobering but not saddening, which is the key-
note of Martin's work." It should be re-
marked also that the best picture he brought
back from France was "Sand Dunes, Lake On-
tario," a theme which he had first essayed
twelve years earlier and carried through several
versions. It may also be noted that the finest
pictures which after his return from America
he made in the new technique are again on his
old native themes and with few exceptions re-
visions of compositions painted many years
earlier. Such reflections point the entirely
native and essentially intellectual character of
Homer Martin's art.

In 1886, being fifty years old, he decided to
renew the struggle in New York. He brought
few pictures back but many rich memories, and
numerous small sketches. Season by season
for seven years great picture followed great
picture, the canvases that now are the pride of
our museums and the goal of our wealthy
amateurs. Few of these masterpieces sold, and
those at a base price. Even two years after
Martin's death, and when it was already good

business to forge Martins, that fairly enlightened collector, William T. Evans, was with difficulty persuaded to buy "Westchester Hills" for a thousand dollars. Six years later he sold it for about five times the money, thereby depriving his bequest to the National Gallery of what would have been its chief ornament. Universally praised by the critics, Martin's fame brought him few dollars. By 1892 the sight of one eye had entirely failed, and that of the other was seriously impaired. Worn down at last by the endless struggle, his wife's nerves broke, and she fled for rest and support to their son Ralph in St. Paul. Six months later, driven by poverty and ill health, he followed her there.

In poverty, in a social isolation which he had never before experienced, going blind, with a cancer gnawing at his throat, Homer Martin painted four of his greatest pictures—"Criqueboeuf Church," "The Harp of the Winds," "The Normandy Farm," "Adirondack Scenery." The foe, as he wrote to a friend, was "eating the gizzard" out of him, but at last in his own opinion he had learned to paint, and that kept him up. When his wife, surmising it might be his last picture, congratulated him on finishing his noble picture, "Adirondack Scenery," he answered, "I have learned to paint at

last. If I were quite blind now, and knew just where the colors were on my palette, I could express myself." He was mercifully prevented from justifying these proud words. By February of 1897 the dull discomfort in the throat changed into a brief space of corroding agony, and on the twelfth of that month the much-worn man entered into rest unnoticed. Within five years of his death half a dozen of his pictures were sold for a total sum that would have kept him comfortably for life.

There is perhaps no moral to be drawn and no reproach to be implied. Martin's great accomplishment fell at a time when the patronage of American art was in abeyance. Our collectors were buying from France. The shifting of standards in the 'eighties and 'nineties, made all contemporary paintings seem dubious investments, and American painting peculiarly so. No dealer could confidently engage to take an American picture back at the price paid. With dead men's pictures he could and did safely do this. And the dealers morally owned the so-called amateurs. New York had sprawled all over Manhattan Island, had ceased to be a social unit. The old easy relationship between artist and well-to-do folk, which had constituted the black-walnut era a golden age, so far as the

patronage of art was concerned, had wholly
broken down. The old patrons were poorer,
the new patrons speculatively inclined and too
busy to track a poor, however talented, painter
to his unseemly lair. An artist had to be very
energetic and managing, to live in those days,
and Homer Martin was quite indolent and too
proud to scheme for success. Like most witty
men he was at once entirely lucid and some-
thing of an ironist. He never blamed the
times, and I feel that he would have agreed
he was merely unlucky in having been born with
a great painter's talent, of poor parents and in
the wrong decade.

Homer Martin once maintained among
friends who were discussing the subject of
story-telling pictures, that there was in every
picture something of this. And being asked to
prove it from his own "Westchester Hills," he
answered, "Oh, the old home has been de-
serted, and all the family has gone West along
that road." The retort was only half a jest.
The pathos of the scene does largely depend
upon the impression that these fields and slopes
and groves are derelict, abandoned by man and
not quite given back to nature. No picture of
Homer Martin is merely retinal and objective
after approved modern formulas. He was too

deeply conscious of the vicissitudes of the earth for that. There is in the Adirondack and Lake Ontario subjects a sense of the moulding or fracturing agency of storm, of the passing of fire or rain, of the furrowing of gullies and crumbling of ledges. A kind of pity for the old earth blended with awe at the immemorial processes of growth and decay is ever present. In the Normandy pictures we have the effort of man arresting and guiding these vicissitudes, and there is usually a hint of the refractoriness of the earth to such pains. His favorite hour and light are those of early evening, when, undisturbed by the shifting pageantry of the sun, one may meditate upon the uncertain tenure that man shares with mute creation. There are pictures of the early time and a few late ones, like "Sun Worshippers," in which he yields himself gladly to the intoxication of frank color and to the joy of sunlight. But this festal and candid mood is at all times exceptional. He brings usually to the observation and pictorial interpretation of nature, a definite and poetical mood full of that noble and measured melancholy, which in poetry we call elegiac. It was the mood proper to a lover of Keats and Beethoven.

Every picture of Martin, then, represents a

complex of recurrent moods, observations and memories. His tradition is the contemplative one, and absolutely alien to the instantaneous reactions of impressionism. And his habit of constantly returning to old themes is significant. Between 1874 and 1887 there must be four or five versions of "Sand Dunes, Lake Ontario," each one coming a little nearer the light poise of the remote dunes between sky and water, and each working out finer symbols of swart aridity in the forms of the foreground trees. Indeed every picture of his is quite slowly and thoughtfully elaborated as a conscious arrangement. The matter stands very plain in his own words to Thomas B. Clarke in a letter dated February 25, 1896. "As to the pictures in sight . . . in sight, that is to me, the 28 x 40" (probably Mr. Babbott's "Newport") "is all thought out except one or two cloud forms which trouble me greatly. The larger picture in which I intend to sum up about what I think of the woods" (apparently it was never finished) "needs considerable scene shifting before the curtain can be raised. . . . It might be ready for the autumn openings if I settle on the arrangements of the parts soon." Such testimony as to the wholly conscious intellectuality of Homer Martin's invention dis-

penses me from further analysis. I wish in lieu
of a formal criticism to trace the quality of the
inspiration and pictorial idiom in three con-
summate examples,—"An Old Manor House,"
"The Harp of the Winds," and "Adirondack
Scenery."

Beneath a troubled gray sky, in which a
single flash of red gives the last signal of dying
day, the old manor house stands amid a copse
of leafless, untrimmed poplars. Vacant doors
and windows are so many dark gashes in the
warm-brown, crumbling wall. The sordid
trees are swarthy and their branches give forth
a peculiar murkiness that invests the deserted
mansion. It seems as if some memory of Poe's
"House of Usher" must have been in the
artist's mind as he painted, so exactly does he
make visual the familiar words:

"About the whole mansion and domain there hung
an atmosphere peculiar to themselves and their im-
mediate vicinity—an atmosphere which had no affin-
ity with the air of Heaven, but which had reeked up
from the decayed trees and the gray wall and the
silent tarn,—a pestilent and mystic vapor, dull, slug-
gish, faintly discernible, and leaden-hued."

Between the spectator and the lonely manor
lies a lustrous, stagnant pool, marbled strangely
with confused reflections from shore and sky,

and containing more clearly the chill image of
the desolate house. Such a house and such a
pool exist at Criquebœuf, but again the convic-
tion imposes itself that this is "the bleak and
lurid tarn that lay in unruffled lustre" by the
"House of Usher," wherein one might look
shudderingly upon "the remodelled and in-
verted images of the gray sedges, and the
ghastly tree stems, and the vacant and eye-like
windows." Yet the mood of this intensely
tragic picture is not one of horror. There is
a kind of overwhelming pity in it, as if the de-
parting gleam were the sign of countless days
that had gone down in sadness; the old manor
among its sordid imprisoning trees, a veritable
symbol of all glories that have departed.

Unless it be "Criquebœuf Church," the
"Harp of the Winds" is Homer Martin's most
famous picture, as it is his most admired and
accessible. That appropriate title, which he
and his wife always used between themselves,
he declined to use publicly, fearing lest it seem
too sentimental. "But that," writes his wife,
"was what it meant to him, for he was thinking
of music all the while he was painting it." She
tells us, too, that the trees were originally much
higher, and, with their reflections in the slow
current, assumed more explicitly the form of a

harp. The change she regretted, in which I
think few will follow her, for nothing could be
more satisfyingly gracious than this file of slen-
der trees bending suavely with the curve of a
broadening river. Upstream, the light touches
the white-washed houses of a village. A slight
dip in the low sky line suggests the upper wind-
ing course of the quiet river. The clouded sky,
shot with pale bars of gold and silver over a
tenuous blue, has that peculiar diagonal rise
which gives height and movement. Silvery
gray is the prevailing tone, into which are
worked discreet enrichments of yellow, dull
green, and blue. The rough and lustreless sur-
face is remarkably luminous. A sober precious-
ness, both earthy and ethereal, comparable to
the mysterious bloom of fine Japanese pottery,
is characteristic of the whole effect. One may
note the ingenuity by which all the curves which
are arbitrary elements in a beautiful pattern in
plane are also essential factors in depth. Such
harmonizing of arabesque with spatial sugges-
tion is of the very essence of fine composition.
Better than such pedantries, it may be simply
to say that no landscape in the Metropolitan
Museum will more immediately arrest the at-
tention, and few will better endure prolonged
contemplation.

"Adirondack Scenery" is perhaps the best epitome of Homer Martin's entire achievement, being based on memories that had been turned over and refined for more than thirty years. Its direct prototype was a small canvas called the "Source of the Hudson." It is the richest in color of all the later works and possibly the broadest and most skilful in handling. The eye looks beyond gray, flat ledges over a stretch of brown second-growth, amid which flash rare scarlet maples, beyond a shallow valley and a shaggy distant ridge, to a steely lake where all the mountain slopes converge. The further ascent catches a golden permeating bloom from a dense vapor bank that recoils from the higher barrier and casts down a shadow. These vapors surge forward in a lurid and swirling yellow mass, thinning at the sides and top into the serene blue of a rain-washed sky. A peculiar and soothing gravity, proper to the vast spaces represented, is the ruling impression. One would be dull of heart indeed who could stand before this picture without a renewed and consoling awe at the secular balance of earth, air, and water which brings beauty out of ravage and calm out of strife. Nor is there anything mystic or far-fetched about the picture. Its highly generalized forms

are firm, its textures of forest, rock, and cloud, unexaggeratedly veracious. I think it would appeal almost as strongly to a woodsman as to a poet.

Unless I have grossly misread these pictures, we have to do with a most distinguished kind of imagination, with a mind keenly lyrical and meditative. The inspiration is not so much various as authentic and deep. From beginning to end of Homer Martin's painting we have much the same kind of transaction between a sensitive, clairvoyant spirit and natural appearances. What he seeks in nature is solace, suspension of the will, expansion of the contemplative self. This mood I have in passing called Virgilian. It might be well to add—of a Virgil exiled in an untamed land. The feeling is essentially pagan, and not to be confused with the Wordsworthian and mystical temper which it superficially recalls, nor with the sentimental primitivism of the Rousseauists. It is somewhat stoical, valuing nature, chiefly as a means for regaining in tranquillity the form of one's own spirit. The sentiment might be paralleled in Milton and is not uncommon in the eighteenth century poets, such as Gray, though then it sometimes implies a quite unstoical revolt against society. I find nothing of this

Rousseauism in Martin. It seems to me that his temper is quite classically poised and his real concern with the governance of his own soul. We find a similar stoicism paradoxically inter-blent with the Christianity of Bryant. One of his best poems, "A Winter Piece," a poem that curiously anticipates much recent pictorial concern with winter scenery, breathes in a somewhat simpler tone much of the mood of Homer Martin's pictures.

The time has been that these wild solitudes,
Yet beautiful as wild, were trod by me
Oftener than now, and when the ills of life
Had chafed my spirit—when the unsteady pulse
Beat with strange flutterings—I would wander forth
And seek the woods. The sunshine on my path
Was to me a friend. The swelling hills,
The quiet dells retiring far between,
With gentle invitation to explore
Their windings, were a calm society
That talked with me and soothed me.

Such a mood may sometimes be merely the evasion of a weak spirit, but Homer Martin, if wayward, was not weak. He expresses a solace that strong spirits have often felt in nature, a sentiment that has been the staple of poetry from the days of the sages of India and China, through Œdipus at Colonus and the stoics, to our own century. His vein is narrow but in

the finest tradition and of the most evident personal authenticity.

Yet, saving only La Farge and Vedder, I have never heard a painter speak in unreserved praise of Martin's work, and I have heard painters whose opinions are usually worth while declare that it is negligible. No formal rebuttal of such opinions seems to me necessary, but a word as to standards may be in order. The value of any work of art, I believe, is solely that it should communicate a choice and desirable emotion. This is true even of so-called impersonal art. In Manet, for example, quite the most objective of painters, one shares a tense and distinguished curiosity. Now the person who gets no such choice and desirable emotion from the art of Homer Martin, may, if he be assured that his sensibilities have reached their limit of education, quite properly neglect work from which he derives no pleasure. Which comes to saying that the reasonable criticism of a work of art is always of its emotional content, and so in a manner of the artist himself. It is always competent to declare that this emotional content, however strongly and consistently expressed, does violence to our own nature and is for us undesirable. Indeed any other unfavorable criticism of a work of art

seems in the nature of things superfluous and absurd.

If this very simple principle were understood, it would save much confusion. There is abroad an ultraromantic assumption that we are always bound to accept the point of view of the artist, but perfectly at liberty to object to his technique. Precisely the reverse is the case. His point of view, having all sorts of general and vital implications, we are entirely free to accept or reject, being bound merely to understand it, while the particular rhetoric of his expression, being idiosyncratic and necessary, we must accept, and the less we bother about it the better. To do otherwise is to miss the whole point. You may, for instance, attack Claude as a poor imagination, but not as a flimsy executant. Yet, many, with Ruskin, admit his poetry and deplore his tree-forms or the thinness of his pigment or what not—which is one of the more asininely specious forms of æsthetic pedantry.

With men for whom a George Fuller is primarily a feeble draughtsman I cannot argue. Let them come out honestly and say they think the sentiment is forced or cheap, and we can self-respectingly agree to disagree. And my grudge against my painter friends who decry

Homer Martin is that they do not discuss his
sentiment, but assert some weakness in his dic-
tion. He splits his pictorial infinitives or ends
his phrases feebly with a preposition, or other-
wise breaks the rules. Whose rules? I marvel
at those who know so exactly how a vision
should be conveyed which they have never
glimpsed save through what they call a defec-
tive form of expression. Yet there is a profes-
sional realm in which these technical matters
are subjects of legitimate interest. Only we
should keep in mind that such considerations
are subæsthetic and quite secondary.

Taking the work of Homer Martin on this
lower plane, it is obvious that he is not, strictly
speaking, a great painter. The zest, variety,
swiftness, and deftness of the consummate prac-
titioner he has fitfully, and on the whole, rarely.
An impeccable sense of mass and close-knit at-
mospheric balance was not his. Tryon, who,
in some respects, may be regarded as his clos-
est American affinity, was more skilful and
curious in these matters. I have sometimes felt
that Henry Wolf's admirable woodcut copy of
the "Harp of the Winds" was just a shade more
substantial and fine than the original. Yet it
is precisely the twilight and occasionally un-
sure vision of Homer Martin that we value.

And the unsureness in no wise affects what he has to say to us. Beautiful pattern, vibrating color, distinguished mood—all these things are precisely and fully conveyed. What matters it while the "Harp of the Winds" balances rhythmically in pellucid air and shimmering water that perhaps you couldn't walk on the nearer strand? The fact that you conceive the feat shows that you have missed the picture entirely.

To those who are sensitive to the gracious and highbred melancholy of Homer Martin's work, this explanation will be superfluous. To others it may be said that his alleged technical weaknesses are of the emotional essence and stand or fall with the emotion itself. He was a lover of clear thinking, and this must be my excuse for a digression that may clear up a confused attitude towards his work. He seems to me a singularly appealing type of the minor artist, the kind one often loves better than those of accredited greatness. For variety, copiousness and vitality, Inness and Winslow Homer are clearly his superiors; both of these come nearer to meeting the usual notion of a great painter, and yet I would sacrifice all their work if I might keep the "Manor House," or "Adirondack Scenery." Not because I under-

rate these large and genial personalities just mentioned, but because I believe that the future is more likely to duplicate approximately their type of vision and degree of skill.

I imagine Homer Martin's fame as compared with theirs will suffer vicissitudes. He is more aloof and complicated; they, more simply explicable and more nearly related to average wholesome predilections. They are more democratic and of our land and time, he more aristocratic and more free of the whole world of contemplation. I can imagine Homer Martin at times forgotten. I am equally certain that he will be perennially rediscovered, and always with that thrill which the finding of some bygone poet of minor but delicately certain flight brings to the man of open heart and sympathetic imagination.

[1912, 1926.]

VIII

ALBERT PINKHAM RYDER

ALBERT P. RYDER, "Moonlight by the Sea" *The Author's Collection*

ALBERT PINKHAM RYDER

The usually dependable stork sometimes quaintly loses his bearings and drops his precious burden in unlikely places. This happened when James McNeill Whistler was born in Lowell, Mass., in 1834, and when Albert Pinkham Ryder arrived in Mill Street, New Bedford, Mass., on March 19, 1847. Whistler did not fail to protest against the stork, on grounds both of geography and chronology. To a would-be fellow townsman and contemporary he declared that he would be born when and where he chose. Albert Ryder never quarrelled with the date or place of his birth, and though it is hard to reconcile his lunar poetry with his upbringing, he shows certain traces of his origin. His people for several generations back were Cape Codders from Yarmouth—mechanics, shopkeepers, seagoing men. Ryder was himself what is called on the Cape an "independent" person, hard to move, immune from outside pressures. Well-meaning friends at different times tried to lure him into comfortable quarters and to induce

155

him to produce regularly and be prosperous.
Ryder's answer was to lock himself more
tightly in his Eleventh Street attic. No Cape
Codder will be driven or even much urged. To
the chagrin of long-suffering patrons, Ryder
often kept a promised picture in hand for a
score of years. Concerning a client who had
been gradually trained to patience, he once re-
marked, "Lately he has been very nice about it,
only comes around once a year or so." The
precise humorous inflection will be more readily
grasped on the Cape than anywhere else in the
world.

Cape Cod too is a haunted region. Spiritual-
ism swept over it in the 'thirties and 'forties.
And the abundant new ghosts found already in-
stalled the spirits of the victims that Captain
Kidd slaughtered over his buried treasure.
The pines around Tarpaulin Cove have seen
the pirates, the British and the Yankee pri-
vateers dropping anchor opposite their sweet
spring. And the soft, humid air of the Cape
entraps more moonlight than any air I know,
and then the tiny sand dunes loom gigantic be-
tween the moon path in the sea and the veiled
sky. And the little fish-houses offer spectral
walls and blue-black mysteries of gaping door-
ways. Such were the visual memories of

Ryder's stock. It proved a sufficient artistic in-
heritance, and in his later years he willingly
went back to confirm and enhance it.

Albert Pinkham Ryder came up in the de-
cency of old New Bedford, graduated in due
course from the Middle Street Grammar
School, and began to paint. Most of his
juvenilia have perished. Indeed we are as
badly off for his first steps as we are for those
of the average old master. One or two pieces
that I have seen suggest in their sirupy brown-
ness the influence of Albert Bierstadt. A re-
pellent, metallic painter in his Rocky Mountain
vein, Bierstadt was a mildly attractive land-
scapist when off his guard. He dealt in lumi-
nous browns and yellows after the fashion of
Hobbema as understood at contemporary Düs-
seldorf. Every well-regulated New Bedford
home is still likely to have a Bierstadt of this
livable type. He was one of the wealthiest and
most prominent citizens of the town and per-
haps the most highly considered American
artist of the 'sixties. Ryder's developed style
may be considered as merely an intensification
of Bierstadt's minor vein, the yellow-brown
being carried down towards black, the timid
veiled blue assuming a green resonance. Pos-
sibly certain tawny pictures of large size lying

in disrepute among the dealers are really the
early Ryders. They are at any rate what the
early Ryders should be if his point of de-
parture were Bierstadt. It is a ticklish critical
question which I cannot presume to settle.
Moreover, its artistic importance is rather
slight.

Young Ryder came to art and indeed to life
sorely handicapped. His great frame had been
poisoned through vaccination. In particular
his eyes had been so weakened that any strain
tended to produce ulcers. Naturally he drifted
into an owlish sort of life, wandering off into
the moonlight at all hours and avoiding the
glare of the high sun. The physical and moral
solace of these moonlight strolls is a chief emo-
tional content of his pictures. Indeed the forms
of most of his compositions can be directly
traced to such memories. His trees in their dis-
tortions and bold pattern are merely the wind-
blown dwarf oaks of the Cape seen against an
evening sky; his misshapen hulks are those ob-
solete carcasses that darkle on that little grave-
yard of ships, Crow Island; his misty stretches
of calm water in moonlight washing the feet of
shadowy dunes can be seen at South Dart-
mouth. Even the rare bits of stately archi-
tecture in his pictures suggest the late Geor-

gian porticoes and belfries and gables along
County Street. All his life long he assiduously
reinforced his particular type of vision, but I
think he added rather little to the visual mem-
ories of adolescence. Likewise the element of
glamour and peril in his sea pieces grows out of
New Bedford. Her hardy sons pursued the
whale to the ends of ocean. Ships came back
bleached and battered, mere wraiths. The
little schooners plied to George's Banks
through leagues of treacherous shoals and
baffling currents. Ryder never attempted a
literal record of this, nor of anything, but the
spirit of adventure and hazard in his work
found its nourishment along the New Bedford
wharves. His scudding ships are wholly
fantastic, yet very like some hard-clammer's
skiff staggering up towards Fort Phœnix
before a souther, its bellying, tiny spritsail at
once deformed by the urging blast and full of
moonlight.

In a precious autobiographical fragment Al-
bert Ryder tells us how the vision of his art
suddenly came to him. He began by studying
the great masters, naturally in engravings, and
copying them.

Like many old Yankee families the Ryders
produced just one money-maker, and he loyally

helped out the rest. William Davis Ryder
came to New York soon after the Civil War
and set up the eating-house of Ryder and Jones
at 432 Broadway. It prospered. By 1879
William was proprietor of the Hotel Albert
in West Eleventh Street. The rest of the
family followed his fortunes to New York. In
1871 we first find Albert Ryder with his father
Alexander registered at 348 West Thirty-fifth
Street. They were only waiting for brother
William to move into larger quarters at 280
West Fourth Street. That was the family
home for many years, until 1879, when Wil-
liam moved to 16 East Twelfth Street near his
hotel, and Albert Ryder set up his studio.

Doggedly the old father tried to do his bit,
and not too successfully. We find him in 1871
running a restaurant at 36 Pine Street. Evi-
dently it was a bad venture, for within a year
he is registered as a milk man. That lasts a
year or two. In 1877 he is superintendent, sex-
ton, of St. Stephen's at 35 Howard Street.
That job again lasted little more than a year
and was the old man's last activity. By that
time perhaps William had managed to convince
the patriarch that it was in the financial interest
of all that he should forego the luxury of self-
support.

For two years from 1871 Albert Ryder is described in the directories as an "artist." Doubtless this is the period of his association with William E. Marshall, the portrait painter and engraver. Marshall had made solid studies with Couture, and was a serious craftsman. Ryder was possibly rather an assistant than a pupil. This we may surmise from the scrupulousness with which in 1873 he registers himself as a "student" when he enters the school of the National Academy of Design. Since neither the training of Marshall nor that of the Academy is reflected in Ryder's work I pass both briefly. His position as a student of the Academy gave him the chance to exhibit a landscape called "Clearing Away" in the exhibition of 1873. In 1876 he showed a "Cattle Piece" and thereafter contributed with fair regularity. He tardily became an Associate in 1902 and was soon promoted to be an N.A., in 1906. The sojourn with Marshall invites exploration. It raises the probability that Ryder painted portraits which have been lost. One such was seen and described by Sadakichi Hartmann about 1900. He writes of it in his "History of American Art."

"The first glance told me it was a man in American uniform, after that I saw only the

face, the tightened lips, the eyes; it was as if a soul were bursting from them. . . . This portrait immediately gave me a keener insight into his artistic character than any other picture. Everything was sacrificed to express the radiance of the innermost, the most subtle and intense expression of a human soul."

About 1876 the Scotch connoisseur and dealer Daniel Cottier discovered Ryder. He and his partner James Inglis thenceforward counted for much in whatever small prosperity Ryder ever enjoyed. Cottier's influence was great with the few æsthetically aspiring New Yorkers of the moment. He promptly showed Ryder's pictures alongside those of Abbott Thayer and Francis Lathrop. When in 1877, the Paris-trained insurgents founded the Society of American Artists, Ryder was among the first to be invited. It showed liberality for these apostles of dexterity to choose a man whose methods were as fumbling as his imagination was exquisite. Ryder very faithfully exhibited with the Society and became an academician with the rest at the time of the merger in 1902. His few artist friends, Alden Weir, Charles Melville Dewey, Albert Groll, and Alexander Schilling were in the new movement. The few critics who deigned to notice his early efforts

admitted his force of invention but gently deplored his lack of fidelity to nature. Indeed a chiding paragraph on Ryder and Blakelock was almost ritual in sound criticism of the day.

In 1881 a miracle of liberation befell Ryder. Up to his thirty-fourth year he had lived as a semi-dependent, with his family. The solitude and disorder which were the very necessity of any creative existence for him had been impossible. Now he set up his own studio in the old Benedick on Washington Square East. It was then new, an effrontery of unwonted height with its six stories, a sinister symbol of an impending emancipation of American bachelorhood from the semi-domesticity of the boarding house. There Ryder worked for ten years and there I am confident three-quarters of his pictures were conceived. Thereafter he had three attic studies, all portents of dire disorder, in Greenwich Village. He lived as a shy recluse, building up in his later years a small group of fervid and patient admirers who assured him such modest prosperity as he wished and as his dilatory habits permitted. His final year was one of invalidism and during it he was tenderly cared for by his friends, the Fitzpatricks, at Elmhurst, L. I. In their house he died in 1917, being seventy years old. His creative period

was brief, maybe from 1880 to 1895 or so, from his forty-third to his fifty-eighth year. The habit of retouching and the necessity of repairing his pictures, which were painted in a most perishable technique, kept him in occupation when he was no longer a creator. It is no exaggeration to say that the last twenty years of his life were largely devoted to patching up his early work. Thus it is generally idle to ask when a Ryder was painted. When "Henry Eckford" (Charles de Kay) wrote the first generous and adequate criticism of Ryder, in the *Century* for 1890, he had seen all the great Ryders except the "Jonah" and the "Race Track" picture and the "Siegfried." These were in hand before Sadakichi Hartmann's visit about 1900. By then the creative impulse was pretty well exhausted. Probably there never had been enough physical energy to inform the great frame, or enough will to carry through a career, and as Mr. Sherman, Ryder's best biographer, suggests, Ryder declined to repeat himself even when repetition would have been lucrative. He remained a shy and secluded bachelor, content with a few intimacies and his dreams. He made three brief trips to Europe in 1877, 1887, and 1893, but was uncomfortable in travel and nearly impervious to the old masters.

He is said to have proposed to a woman he had
never seen, but whose violin playing from a
neighboring studio had enraptured him. He
read deeply a few great books, his Bible, Chau-
cer and Shakespeare. At the opera he occa-
sionally drank freely of the Teutonic myths
through Wagner's music. He willingly com-
posed for his pictures rhymes and sentiments
which have a Blake-like simplicity and appeal.
He remained all his life a great child with no
views except about his own art. The Institute,
Barbizon, Manet, and Monet successively revo-
lutionized American painting in his time. Like
Dante, he kept out of movements, making "a
party by himself." Unconventional, he had
no quarrels with the conventions. Many still
remember him as an old man, very gentle, shy,
and charming. His head was too small both
for his great body and patriarchal red beard.
How he looked may be seen in Alden Weir's ad-
mirable portrait of 1894. It conveys some-
thing of the Yankee amenity of the man, and is
more truthful than Kenneth Hayes Miller's
better known and more obviously impressive
effigy. Altogether Ryder belonged to the spo-
radic genus of dreamers. They turn up every-
where to our æsthetic delight and sometimes
to our practical distress. They decline to be

classified except in terms of their own prefer-
ences, and on their own conditions.

Of the great Chinese painter Kao K'o-ming
is written: "He was a lover of darkness and
silence; he loved to roam about in wild coun-
try and gaze abstractedly for a whole day on
the beauties of mountain and forest. Then,
when he returned home, he would remain in
some quiet room, shut off from all thoughts and
cares, and allow his soul to pass beyond the
bounds of this world."

This eloquent passage from Dr. Giles's
"Chinese Pictorial Art" very well expresses the
relation of observation to creation in Albert
Ryder. He was a lover of the mystery of twi-
light and moonlight, but he has left no sketches
from nature. He roamed about and in his own
words "soaked in" the scene. Of his one hun-
dred and fifty paintings more than half are
landscapes or marines. Of the landscapes
three only depict an actual locality. If we in-
clude sheep and cattle pieces among the land-
scapes, the list rises to fifty. Of little figure
subjects, generally a single woman's figure with
a literary suggestion, there are thirty-three.
Mythology and symbolism claim eleven pic-
tures, and here are his masterpieces. There
are two or three oriental scenes, two little com-

positions of nudes, and one extraordinary still
life of a dead canary. Two-thirds of the pic-
tures are tiny, less than a foot in largest dimen-
sion, the biggest are still small, perhaps three
feet in greatest measurement. Perhaps no
artist has won such fame for so little manual
labor, and again few pictures show such un-
remitting work of the mind.

The little marines and landscapes can only
be treated as a class, and as the preparation for
the higher flights they should be first consid-
ered. Let me describe the one I know best,
"Moonlight by the Sea," for the good reason
that it is under my eye as I write. It is number
153 in Mr. Sherman's catalogue. The little
oblong is exactly divided by the warm brown
of a sand dune and the blue-green light of an
evening sea and sky. The dune sweeps down
from the left in an S curve, which is extended
to the right in a bit of level land. The land
and the sky-sea part of the pictures are equal
reciprocals, each having about the form of a
row-boat rudder. Any unpleasant evenness in
the division is immediately effaced by giving the
vaporous sea a value much darker than the sky.
The sea is worked with dry little touches of
pale blue over a red ochre preparation. The
warm ground comes through at the horizon,

carrying in warmer tone the brown of the earth into both sea and sky. Towards the land there is a faint yellowish moon path. A level mist over the horizon cuts a moon at the middle. One gets in faint lemon yellow an aerial illusion of a very long building with a low dome.

Above, the sky shades off into greenish blue, lightly glazed and streaked throughout with warm brown. All this seems to have gone ahead fast. It is a lovely bit of tonality, cold and positive in the glimpse of sea, warm and mysterious in the veiled sky. The scene gets its validity largely from the quality of the shaded edge of the dune. Nothing could look more fumbling on near view or be really more skilful. It hardens where needed, escapes the sky, showing bits of the reddish preparation, occasionally interlocks with the level brush strokes in the sky. All this means irradiation and the sufficient rounding over of the mass, and it lends great scale to what in actuality was a small motive.

So far we are still, I think, in the first intention of the artist. Remained the task of enriching the somewhat monotonous brown mass of the earth. Where the dune curves a little too sweetly into the water is set the sharp prow and bowsprit of a stranded sloop. The back-

ward raking mast supports a rag of silvery triangular sail, at this stage the brightest spot in the picture. We have the needed angular contrast to the simple curves of the design, and the interest is moving forward from sky to earth. Next a little of the very pale blue of the water is flicked across the foot of the dune in indeterminate short strokes. It gets some warmth from the brown and seems a faint, narrow band of moonlight stealing over the dune. At the end of this strip is a little fish-house facing the sea. It is lighter and warmer than the ground and a little of the blue moonlight comes up on its foundation. Such touches of light are carried sparsely out towards the foreground.

The intention is now to locate the interest under the dune, for two red cows at the right and a heavy stake at the left of the foreground, though boldly put in with the palette knife, are also subordinated. They constitute an enrichment of the level stretch, but are visible only when you search for them. Such low visibility would be quite impossible in nature.

At this point the interest of the picture wavered between the silvery sail and the fish-house. The last touch, which made the picture, will have been to diminish the size of the sail

and to paint in a new gabled house facing the spectator. The front glistens with moonlight under what seems warm reddish-brown thatch and around a mysterious dark doorway. Nothing explains the redness of the roof. It is chosen simply as the focus of all the warm values of the pictures. And the moonlit front, which becomes brightest light and focus of all the lights in the picture, is painted in no expected color, but in a sharp if also pale lemon yellow. The new fish-house is slapped in without much relation to the old one, which almost disappears behind it, and of course there could be no such gleam or deep red roof lines in a building that faces directly away from the moon. In short, while the great relations all rest on observation, or rather on very fine memory, and the whole thing has the "air of drawing" which Ryder modestly claimed for his work, the determining details are treated with complete freedom, disregarding probability and even possibility for some higher law of the picture itself.

I need only add that the paint is mixed with a heavy varnish, the picture being a series of glazes. Over all, more varnish has been floated, which has developed a large but handsome crackle. The whole thing has the ma-

terial preciousness of an enamel or lacquer. And with these purely decorative preoccupations so marked, it has a paradoxical richness of mood. Everything that soothes and awes one when a veiled moon rises at sea and the mystery reaches landward is expressed on the little eight-by-ten-inch canvas.

Similar qualities are in all the landscapes and marines. Always the great simple design, always the fundamental contrast between a blue-green sky and a darker sea or earth, ever the subtle enrichment of the darks and the working of the surface into a lustrous enamel. In the marines the pattern of the sky often furnishes the chief interest, a fantastic sail serving merely as a contrasting accent to the dense leaden clouds with sharp yellow borders where the moonlight breaks around them. Generally the faint light comes out of the picture. Nearly without exception, the work has been repainted and revised, features moved about and added until the final effect is reached. Very exceptional is such a masterpiece of simple untroubled composition as "The Wreck," which seems to have gone through by first intention.

Many of these pictures are marred by deep fissures. Some have faded almost into irrecognizability. Ryder used varnish upon var-

nish, as Whistler often did, with the same disastrous results. Retouches were often made in light upon a dark ground. Poorly grounded canvases or panels without a ground were too often used. I have seen a noble design painted on what looks like a small bread-board. The soft wood has drunk up the pigment till only a wraith is left. In short Ryder disregarded all technical considerations in the endeavor to get his pictorial effect and his lustrous enamel. During his lifetime he had to restore perhaps half of his paintings, and very few will survive our generation undiminished. On the whole the marines seem likely to stand best, having less underpainting of brown, and by a rare good luck the half dozen masterpieces, with the exception of "The Flying Dutchman," are painted in a fashion that promises reasonable duration.

While Ryder touched in the figures in his great compositions with great energy and expressiveness, his little single figures seem to me the most negligible side of his work. They have their poetry often, as in the charming creation "Passing Song," which was emphasized by the artist's own rhymes, but they are as a class ignorantly done. Ryder had never studied the body as he had moonlit landscape, and the

slovenliness of the work goes far to detract
from the value of the sentiment. They lack
that distinguished "air of drawing" which his
landscapes and marines have so markedly. Ex-
ceptions are the noble descending Pegasus in
the Worcester Museum and the two very in-
tense if almost over-sweet versions of Jesus re-
vealed to the Magdalene.

Perhaps the greatest Ryders are "The Flying
Dutchman," "The Jonah," "The Race Track,"
and the "Custance." Many would add the
"Siegfried." It has steely coruscations worthy
of a Greco, and in mere pattern is consummate;
it conveys most energetically its sense of doom,
and is just a little melodramatic. The "Jonah"
is the best exhibition piece, marvellous in the
way in which is carefully built up a boiling of
great waves, superb in the relations of the
laboring boat and the heavily darting great fish,
most skilful in the way in which the mere arms
and head of the sinking prophet dominate the
picture. One sees it all as if from a neighboring
boat, shares as a participator in the sublimity
and terror of the moment. Tintoretto himself
could not have bettered it. Even more beauti-
ful in its rich blues and lilac grays, and even
more distinctive as a composition is "The Fly-
ing Dutchman." The mere work is simpler and

stronger, the towering of the phantom ship above the doomed skiff magnificently asserted, the mixing up of spectral sails and driving tempest clouds most effective. It is tense and lyrical where "The Jonah" is dramatic. The sheer glory of the vision captures the old castaways in peril of death. Again much of the effect comes from our being drawn bodily into the picture. We see the vision precisely as the men in the foundering boat see it, sharing their dread and exhilaration.

"Death on the race track" has a place apart, for we can trace its origins both in life and art. The occasion of this great symbol was the suicide of a waiter who used to serve Ryder in his brother's hotel. The waiter had a sure tip from the famous Dwyer stables and put all his savings on Hanover. Ryder, who was in his confidence, tried to dissuade him. Returning to the café of the Hotel Albert after the race and missing the waiter, Ryder learned that Hanover had lost and that his unlucky backer had shot himself. Thus the great picture of a skeleton horse and rider galloping about a dusky and forsaken track grew simply out of Ryder's shock at this tragedy of gambling. As he cast about for a symbol, there flashed in his memory the conqueror death in Old Bruegel's

picture of the plague, which he had lately seen
at the Prado. He sets the withered, speeding
figures of horse and rider at the turn of a
gloomy track, and the thing becomes a universal
symbol. Death rages in a dead world, his vic-
tims have been reaped, and still he rides and
ever must. It is the most concentrated crea-
tion of Ryder's genius, and the chief motive is
directly borrowed from one of the most diffuse
pictures in the world. Ryder's genius lies
largely in daring the obvious association of
Death with the solitary track. It is the most
child-like and right putting of two and two to-
gether. It makes the activities of death, which
in Old Bruegel's masterpiece were as compli-
cated and interesting as that of a field-marshal,
seem as monotonous and mechanical as they are
sinister. It is a new note in *macabre* design.
Incidentally it is instructive to recall that Velas-
quez and Titian in their glories at the Prado
never affected Ryder's art, whereas the homely
and drastic art of Old Bruegel stuck in memory
and lent itself perfectly to one of Ryder's most
personal inventions.

Perhaps the loveliest of all the Ryders is the
"Custance." Under hesitating clouds—gener-
ally in Ryder clouds have determined pattern
and set—a great boat rocks gently and discloses

the pale face of a young girl who lies with a baby on her breast. The water laps and curls gently about the clumsy barque and is full of tranquil moonlight. The little forms in the boat, since its gunwales and shadowy depths form a sort of dark nimbus, dominate the scene extraordinarily. Ryder is incomparable in the art of directing the attention where and as he wants it. A benign sea and sky are pictorial value for that Divine protection which Chaucer emphasized in "The Man of Law's Tale." One feels that the boat

> "dryvynge alway,
> Som-tymë, West and som-tyme North and South
> And som-tyme Est, ful many a wery day,"

is bound for a happy port.

If the greatest Ryders are those that enlist legend and human interest, their difference from the little landscapes and marines is after all merely one of degree. The essential poetry is ever the same, the difference being only that of emphasis or accent. Any scrap of an angry sea with the big winds equally driving metallic clouds and a laboring sail through the moonlight conveys hardly diminished the glamour and peril of "The Jonah" or "The Flying Dutchman," while any one of a score of tiny

nocturnes distils the enveloping peace and high serenity of the "Custance."

The imaginative content of Ryder's painting is so direct and elemental that any verbal transcript becomes at once a hopeless competition and a sort of impertinence. Most of his critics have wisely taken refuge in analogies. Mr. Duncan Phillips has cited illuminatively the eerie quality of Coleridge in "The Ancient Mariner." Less happy is the almost stock parallel with Monticelli and Blakelock, both men of tone not of contrast, and of slighter inspiration. A little better is the customary allegation of Thys Maris and George Fuller. But they too are more tonal, more subtly psychological, less profound and general. Charles de Kay has more perceptively indicated a real kinship with Millet.

"Not by the way he paints or the subjects he chooses but along more intricate channels of resemblance, by his humble boldness, if one may be forgiven the seeming paradox, by his imagination, seriousness, and childlike temperament." Sadakichi Hartmann very aptly recalls the marvellous Virgil woodcuts of William Blake. For me, this is the nearest shot of all, and I may add that a still closer affinity is Blake's best pupil, the painter and etcher,

Samuel Palmer. His was a similar intense and simple poetry, a kindred love of the great relations between earth and sky, a common desire to enrich the darks to the limit of lucidity, an identical patience and thoughtfulness, the same twilight preferences. Add to this the small scale of the work, and a generalized sweetness and serenity, and the parallel approaches completeness.

Albert Ryder may or may not have known the Palmers. It is probable that the Cottiers often showed them, and it would be hard to persuade me that Ryder did not know and study the lovely etchings and drawings for Virgil's "Eclogues," which were published in 1883 after Palmer's death. Palmer's letters on his own practice would form an excellent commentary on Ryder's methods. Palmer writes to his son: "Somehow or other, let a design be never so studiously simple in the masses, it will fill itself as it goes on, like the weasel in the fable who got into the meal-tub, and when the pleasure begins, in attempting tone, and mystery and intricacy, away go the hours at a gallop." Again he writes to Hamerton of his drawings, "They take a long time for the very reason that I am longing to see them done, and know that the

shortest and only way is to aim at no mechanical finish and to put only touches of love."

Compare Ryder's sayings, "The artist should fear to become the slave of detail. He should try to express his thought and not the surface of it. What avails a storm cloud accurate in form and color if the storm is not therein. A daub of white will serve as a robe for Miranda if one feels the shrinking timidity of the young maiden as the heavens pour down upon her their vials of wrath. . . . The canvas I began ten years ago I shall perhaps complete today or tomorrow. It has been ripening under the sunlight of the years that come and go. It is not that a canvas should not be worked at. It is a wise artist who knows when to cry 'halt' in his composition, but it should be pondered over in his heart and worked out with prayer and fasting."

I have no desire to press unduly parallels that may be only coincidences. Yet nothing could be more Palmer-like than Ryder's greatest landscape, that owned by Miss Bloodgood. The elevation of the feeling, with a certain elation in it, the harmonious organization of the clouds with the lights and darks of the rolling hills, even the accent of the tiny forms of men and animals could best be matched in Palmer's

designs for Virgil and Milton. I need hardly add that if Palmer seems to me the more accomplished, Ryder seems to me the greater artist. In pure composition, in the right adjustment of economy and richness, in the capacity to make completely and unerringly his precise pictorial point, no artist of his time excelled him, and very few of any time.

[1917.]

IX
WINSLOW HOMER

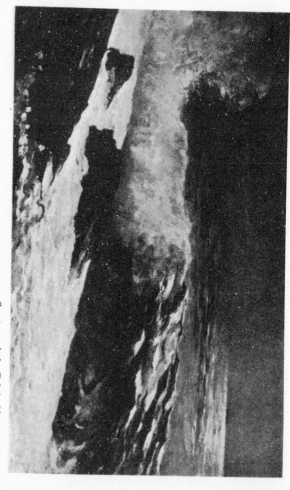

Courtesy of the Toledo Museum of Art

Winslow Homer, "Sunlight on the Coast"

WINSLOW HOMER

Since for many years I had admired the pictures of Winslow Homer, just this side idolatry, I hate to acknowledge that the first glimpse of the memorial exhibition at the Metropolitan Museum made me wince. It seemed impossible that so many fine works by one hand should be so discordant. Here were so many openings in the wall, but the vistas revealed no principle of harmony. Except for a uniform energy in the work, these pictures might be the product of several men of different ages and training. Here was a man who apparently faced nature with no preferences and preconceptions, and set himself to study almost impersonally her dynamic phases. Plainly, it was the struggle of men with the sea, of the waves with the land, the slow, powerful heave of tropic seas, the poise and buoyancy of boats among threatening billows, the battling of trees with the tempest—in general, a world of ceaseless strife and motion that engaged Winslow Homer's imagination.

What is baffling in his art is the absence of

183

formulas. He seems to have had no liking
for this or that form of color emphasis, no
habits of the hand, no desire to unify or atten-
uate the rawness of the thing seen. He faces
nature with a kind of ruthless impersonality.
He repels while he attracts, is distinguished in
virtue of a magnificent commonness and a wil-
fully prosaic probity. He gives a keen and
paradoxical sensation that I have encountered
nowhere else in art except in the superb and
more civilized brusqueness of Édouard Manet.
And again in Winslow Homer one frequently
sees the great single contour, the direct asser-
tion of color and plane, the general primitive
aspect that the post-impressionists affect with-
out attaining. Had he only consented to be ec-
centric in color, he might have anticipated the
notoriety of Gauguin. As it was, Winslow
Homer kept to his studio at Prout's Neck, in
view of his beloved sea, and painted with advice
of no one, in oblivion of praise or blame.

A kind of primitivism is of the essence of this
art. Here is a self-schooled man, free from
transatlantic influences, who paints as if Düssel-
dorf, Barbizon, and Giverny had never been
heard of. Christian Brinton, in an interesting
essay in *Scribner's Magazine,* has celebrated
this Americanism of Winslow Homer. And,

indeed, in impetuous scorn of conventions and
adoration of energy he may be regarded as the
most American of men. Yet I feel that the
isolated position of Winslow Homer makes him
something more or less than American. Ob-
viously, no other nation can claim him; but did
we really possess him, or does he by an excep-
tional and wholly individualistic superiority
dominate us? For me he does not fit easily into
our American scheme, as Frederick Remington
did, but quite disconcertingly evades classifi-
cation, after the fashion of Walt Whitman.
And of the two, Whitman was more of our
sort, if only for his diffuseness and enormous
easygoingness. Nothing of this in Winslow
Homer. His mode is concise and tense. Some
taciturn trapper or skipper reckoning with nat-
ural appearances might paint like this.

These pictures have no look of things that
are composed or meditated in a studio, but of
thi gs that vehemently occur amid the clash of
waves and rapids. In this memorial exhibition
of some fifty pictures, two or three quite excep-
tionally have great charm, but without this
demonstration I should have supposed it impos-
sible that so many fine works should have of
charm just nothing. It may seem a pity to
begin our analysis with negations, but this con-

scious asperity is the central quality of the man, and from it grow both his greatness and his limitations.

Take his last work, the unfinished picture, "Shooting the Rapids, Saguenay River." A sweep of inky gray gives the heave of a treacherous chute down which races a birch-bark canoe. Guides at bow and stern strain to keep clear of the rock which reveals itself in a heavy spurt of yellow foam. In the centre a sportsman braces himself with that exhilaration which is just a little qualified by fear. The whole thing is gaunt, powerful, emphatic; the mere indication of the tense distorted faces of the paddlers is caricature of a striking type. It is, let us say it frankly, very ugly, and quite unforgettable. What the artist wanted was clearly the assertion of the heave and rush of the rapids, of the strain of the figures, and for the rest he contented himself with an approximate notation of the local color. And this means that the picture was not conceived in what we call beauty, but in energy that implied nothing more harmonious than nature herself. Had the finished picture attained charm of color or rhythm of line or mass, these qualities would have been secondary and imputed, and it is difficult to imagine that anything charming could or would

have been superimposed upon these repellent
sooty preparations.

Now recall Whistler's truest paradox that
the fine picture is finished as soon as begun, re-
veals, that is, at every stage some principle of
harmony and arrangement, and a very serious
shortcoming in Winslow Homer's vision and
method will be apparent. He is often harsh be-
yond the needs of his particular form of expres-
sion. Observe those masses of white paint—
most perishable of pigments—that indicate the
uprush of waves shattered on the rocks. That
procedure suggests very well the massiveness
of the ocean's attack, the formidable hydraulic
fact, but how little it suggests the color of such
translucent columns or the subtle weaving of
festooning curves between sky and sea! In
short, while the artist's business, generally
speaking, is to make things more orderly than
they seem, Winslow Homer, for the sake of
anarchic force, has made them less orderly.
And here again one recalls Whitman, who, not
satisfied with spurning the trammels of verse,
created a rhetoric looser than that of prose.

The analogy does less than justice to the
magnificent lucidity of Winslow Homer. And
I have felt freer to emphasize his sacrifice of
the rhythms of form and color to expression of

force, because the sacrifice was evidently a conscious one. The harmonies did not escape him; he evaded them. How lovely is the darkling blue and green in the wave depicted in "Sunlight on the Coast"! How filmy and fairly calligraphic the drift of spray to the left, how pictorially satisfying the slow roll of the steamer athwart distant billows! The whole thing has a sober, saturated radiance that we shall rarely meet except in the water-colors. Beautiful in tone, again, is the "Banks Fishermen," with a dory splendidly poised above a net shimmering with herring. Their metallic lustre dominates the accessory blues and grays of the picture, and a red buoy balanced in green water is a fine note of contrast. Again the coppery flesh colors and leaden hue of the sea in the strange canvas, "Sunset and Moonrise: Kissing the Moon," are keenly original and effective. The whole composition—the grim heads that rise abruptly from a dory lost in the trough of the sea, the crest of a wave that licks up to the cold disk of the moon in a sky of slaty violet—all this is most personally invented; much less the cross section of reality than it seems.

But it is evident in this and many other pictures that color had no preciousness to him intrinsically. It was a powerful language that

told of the motion of things, and rendered facts
of farness and nearness, nothing more. Colors
to him were instruments, not friends and foes.
Of that sense of arbitrary fitness and harmony
which is the mark of the great painter he had
nothing; and if harmony appears in his pictures,
we may fairly suppose that it was not invented,
but caught fresh from nature. The thought
occurs that one who recked so little of the
beauties of color should perhaps have worked
in monochrome. And the gaunt silhouettes of
Capes Trinity and Eternity are here to suggest
what he might have done in this manner. The
titanic scale of the subject he has captured, and
with a little more richness and variety in the
grays and a pleasanter surface quality, what is
a superb study would be a masterpiece.

Yet if Winslow Homer had eschewed color,
we should be the poorer. His parsimonious
palette, based solely upon realistic intention, is,
after all, highly symbolical of the coldly de-
structive seas of the north and of the sturdy
folk who cope with the ocean for their liveli-
hood. Moreover, it is instructive to see what
truth and vigor of color construction can exist
apart from tone. That is almost a new chapter
in the technique of painting, and it paradoxi-
cally links the primitive artist Winslow Homer

with such musical anarchists as Richard Strauss and Dubussy, who have discovered that musical construction need not imply overt melody or harmony.

The last twenty years of Winslow Homer's life were spent in relative seclusion at Prout's Neck, Maine. With occasional flights to the deep woods or the West Indies and Florida, he settled down to two subjects: the sea gnawing at the land, and sea-folk struggling with the sea. The actual clash and fury that shapes the edges of the continent he painted with a force and energy attained by no other artist. It is unnecessary to specify pictures of this type. There are not many of them, for he was a slow worker, but they constitute possibly the most generic achievement that American art has to show for itself.

Yet the masterpieces are possibly elsewhere. The best of Winslow Homer's fishermen are seen with a simplicity and largeness that is instinct with style. The most famous picture of this sort is, of course, the gaunt moonlit face of the lookout who rings eight bells. Of equal quality is the picture of the same title, with two figures, which Mr. Stotesbury lends to the memorial exhibition. Here we have the great contours and generalized modelling of Millet,

and a true sense of the physical littleness and spiritual might of those hardy men who go down to the sea in ships. Such pictures are more concentrated and less subject to defects of color than the more famous marines. There is in them a hint of manly admiration, the impersonal creator is caught off his guard, and a severe beauty gets into the work.

No estimate of Winslow Homer can be a fair one which fails to take into account the fact that he began as and in essentials remained an illustrator. The Civil War liberated him from hack work in a lithographer's shop. Besides war sketches for the wood block, which brought him fame, Winslow Homer found time to paint *genre* pictures of army and negro life. He displayed the knack of the journalist draughtsman and something more. A single study, showing negro soldiers lolling on the sunny side of their tent, is in the present exhibition. It has character, and the sky is beautifully painted. The National Academy of Design showed an uncommonly keen sense of merit when it elected him an associate in 1864 and the year after promoted him to full membership. In 1867, being thirty years old, he made the prescribed visit to Paris, whence, unlike thousands of his colleagues, he returned unscathed.

For a matter of ten years he roved widely in the forests of Maine and Canada, in the still wild Adirondacks, in Florida and Bermuda, producing more sketches than pictures, and still continuing the *genre* vein that was proper to him as an illustrator. Some of his best work of this sort, fish leaping at the fly, tenting scenes, etc., transcends the stock illustration for the sporting press only by its energy. A picture like "Snapping the Whip," with its line of romping schoolboys, shows how undistinguished his vision was as late as 1876. Close inspection of it will show a fine and masculine workmanship. The hand is ready, but the mind still hesitates and does its seeing casually or at second hand. A study of the illustrations which he made abundantly for *Harper's Weekly* between 1867 and 1877 would reveal at once the solidity of his self-discipline and an unexpected versatility. He could have been great as a *genre* painter had he chosen. It was not till his fifties that we begin to get pictures of the quality of "Banks Fishermen," 1885, "Undertow," and "Eight Bells," 1886, and it was still a decade before the conviction began to spread that we had a great painter among us. It was a sojourn in Gloucester in 1878 that initiated him into the life of seagoing fishermen, and his

finest pictures are more or less reminiscent of this period.

An interesting and not quite explicable episode in his development is his work done at Newcastle, England, between 1881 and 1883. It has an amenity nowhere else appearing in his art. It seems as if England mollified the wanderer. There are even odd suggestions that the sentimentalism of current British painting may have reacted ever so little upon his stern manner. The English sketches have a peculiar flavor. How account for that admirable monochrome of a lugger, lent by Mr. Drake, in which sit peasant girls with the classic poise of goddesses? Ingres would not have set them down with a subtler line, and Frederick Walker would not have conceived the subject very differently.

Within a few years Winslow Homer was in his retreat in Maine, and his work had already assumed that harshness which was to be his characteristic to the end. What caused this swift and radical reaction from the sweet new style acquired in England is a critical problem of some difficulty. We have no right to pry into the causes of that carefully guarded seclusion at Prout's Neck. Indeed, there is a sufficient obvious cause in the man's hatred of

crowds and love of the sea. As for the change of style, it may rest upon the strange objectivity of the man. Where there was atmosphere and picturesqueness he painted it, where it was lacking he scorned to prettify the crude reality. The case may be as simple as that. And yet I fancy the intimates of Winslow Homer could, if they would, give us a more psychological explanation. In any case, I would not press the point of objectivity, for Winslow Homer was much more the conscious personal artist than he seems, his devices being merely unusual and well concealed.

On several occasions, notably at the Pan-American Exhibition at Buffalo, Winslow Homer chose to be represented by his water-colors. Doubtless he felt in them possibilities of harmony lacking in his larger works. In these water-colors, many of which were made in sub-tropical seas, rules absolute simplicity of statement. They are exhilarating from their calculated audacity. A few sweeps of the brush, an added accent or two, and a blue expanse of quiet sea spreads out before you, or the lush tangle of Everglades, or the lustrous shambling forms of half-nude negroes luxuriating in sea and sunshine. Of the series devoted to American fishing and camping scenes Mr.

Huneker has somewhere said with a certain in-
nuendo that they will be liked by those who like
the subjects. The observation merely under-
lines the artist's proud habit of abstracting
himself from his work. Yet the water-colors
show a powerful and very likable accomplish-
ment. They never attain the finer and more
mysterious harmonies, but they are sonorous in
a fashion foreign to the oil paintings. Most
of the water-colors betray a very definite illus-
trative intention. A capital instance is the
study for "Hunter and Hound." The hunter in
a canoe has caught a buck by the horn; the
swimming animal drags the boat downstream
while a hound paddles desperately in pursuit.
The determination of the hunter, the slip of the
boat over the water, are admirably expressed.
Strident whorls of white indicate the great rip-
ples that enfold the struggling beast. It is a
remarkable vision of energy unqualified by any
desire for arrangement. And here it is instruc-
tive to note the considerable changes made in
the oil painting. The crudity of the delinea-
tion has yielded to a certain mystery. To the
left the river turns in and affords a vista. In
short, though the compositional changes are
slight and in a manner obvious, they show the
artist seeking a greater unity through complex-

ity, working, that is, in the spirit in which good pictures have always been made.

It would be interesting to review the water-colors in the memorial exhibition, but it is better to take collectively those brilliant studies which catch the radiance and slow potency of tropic seas, the swing of moored boats in the shallows, and the battling of sailing craft with the gale. There is an extraordinary sketch of palms searched and shaken by the hurricane. For technical mastery nothing equals the sketch "Homosassa, Florida," in which two simple washes do duty for the sunlit front of jungles in foreground and middle distance, while a single murky wash of purple slightly accented suggests the whole complication and mystery of the inner forest. I suppose a painter would unhesitatingly stake the greatness of Winslow Homer on a few of these consummate sketches, and they are indeed among the unprecedented things. They recall vaguely certain triumphs of the Japanese in similar themes, but the American work is swifter, more potent, less schematic. I cannot imagine that work so in-dividual and invigorating will ever be for-gotten.

To anticipate the verdict of the future on Winslow Homer would be a presumption, yet

this much may safely be said: that he bulks large today partly because of the debilitated estate of American painting during his lifetime. Whenever painting has resumed a normal force and expressiveness, his peculiar merit of energy will inevitably seem less rare, while in better times than ours his defects in arrangement and tone may well be judged more harshly. Meanwhile his memory deserves the most generous admiration from his contemporaries. If he narrowed himself and sacrificed merits that seemed cheap to him, it was for the sake of truth and intensity. He seems to have had little music in his soul, but he had a blunt and forceful way of saying what he meant. Unquestionably, he has deepened the common vision of our sea and forest and their folk. In short, he did about all that a potent individuality, isolated, unsustained by a sound tradition, can do in our day. A more fortunate age that has arrived at vital formulas may perhaps find his work a shade anarchical, brusque, and incomplete, but such criticism, I believe, will be tempered by profound admiration for a great spirit. The stark apparition of Winslow Homer may remind some future critic that in the off days of art in America we lacked not

so much great personalities as a social tradition to give them support and an æsthetically enlightened remnant to afford them companionship.

[1911.]

X

THOMAS EAKINS

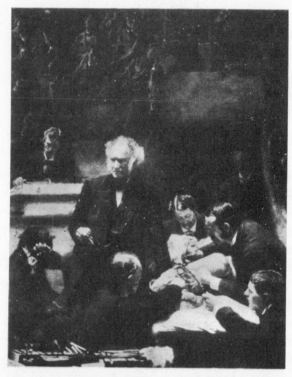

Courtesy of Jefferson Medical College, Philadelphia

THOMAS EAKINS, "The Gross Clinic"

THOMAS EAKINS

Born in 1844, Thomas Eakins had about ten years' seniority over that group of Paris-trained painters which includes Beckwith, Brush, Cox, Blashfield, Sargent and Weir. And Eakins was also a good ten years younger than such pioneers as William Hunt and John La Farge. These chronological facts and the contented obscurity with which he lived out his life in his native Philadelphia have prevented Eakins from being considered with the group to which æsthetically he belongs, and of which he was unquestionably the greatest member. Thus, though a pioneer of the Paris style in America, he never received pioneer honors. That heartening conspiracy of praise which it was the good luck of the founders of the Society of American Artists to enlist, had no Philadelphia branch by which Eakins might benefit. Indeed it did not even occur to the Society to invite to its membership that painter whose career had been singularly prophetic of its own ideals. Quite tardily, in 1902, the National Academy did elect Eakins. He re-

ceived his modicum of medals and awards, but he had no press, and desired none. Philadelphia had no equivalent for the promptly reported revels of the Tile Club. The grubby mansard of Eakins's house, his only studio, never entertained the danseuse of the moment. To be sure he painted many celebrities, but they were Philadelphia celebrities.

No anecdotage enlivens Eakins's memory. That report of fellow students at Paris which makes young Sargent and young Weir still vivid is in Eakins's case entirely lacking. We know that for some years before 1870, after preliminary studies with Leutze and Schuessle, at the Pennsylvania Academy, he studied with Gérôme at the École, and with Bonnat, that he was wandering in Spain during the Franco-Prussian war, that shortly after his return to Philadelphia he taught drawing and painting at the Academy, and when a venial and even humorous indiscretion ended this connection, he continued to teach in the Independent Art Students' League till within a few years of his death in 1916. We know that he studied anatomy profoundly. Everything about his work tells of the tenacious student and intrepid thinker. And the work also tells of certain masculine propensities. He loved the prize ring at its spectacular moments,

the swish of the sweeps of a racing shell, the light swiftness of oversparred racing craft on quiet waters. So far as I know, he never painted a horse, but he was a horseman and modelled fine horses for great monuments at Trenton and Brooklyn. For the *décor* of the artist life he cared just nothing. His own great portraits, many of which he painted for friendship or for practice, gradually overran his comfortable, nondescript house, converting it into one of the most curious and personal of museums.

Great moments in painting, everything that we associate with Manet, Monet, and Cézanne, fell within his activity and observation, and we can only guess what he thought of them. His practice ignored these movements, changed little from his young manhood, and he never took the trouble to record his opinions, or possibly even to form them. One thinks, in contrast, of Thayer and Weir each painfully remaking a style, promptly repudiating the manner that served Eakins for a long lifetime. All this suggests a certain massiveness and immobility in Eakins, a certain narrowness, if you will, but it also shows wisdom and lucidity. In the way of style Eakins had from the first what he needed. As a portraitist and *genre* painter

in that old tradition which delicately balances the claims of character with those of specific appearance, he knew his strength to lie. The new problems were not his problems, and although a few colorful landscapes prove that he could have gone forward had he wished, the old conventions perfectly served his genius, and he held faithfully to them. This gave him a gaunt, left-behind look and secured him only that grudging and qualified recognition which eager youth accords to an old-timer. Such neglect seems not to have mattered to him. With a few stanch admirers, mostly old friends, he carried on in his sixties much as he had in his thirties. In our day we have rarely seen so intelligent an artist so early and fully integrated. Indeed I recall no parallel except Renoir for so untroubled and consecutive a career, at perhaps the most agitated moment the art of painting has ever known.

The style which for a lifetime sufficed for Eakins's talent, seems, barring a partial survival in portraiture, as dead as the dodo. Yet it is a style that took two or three centuries to produce, and it is still worth analysis. It may be assumed that the youth who passed from Schuessle's classes to Paris, about 1866, was already an able linear draughtsman and

brought with him what Paris still regarded as
the beginning of pictorial righteousness. This
is only an inference from Eakins's pictures, for,
curiously enough, he almost never made draw-
ings, unlike his contemporaries, was not
tempted by etching, began his work ordinarily
on the canvas itself, and painted such prelimi-
nary studies as were necessary with the brush.
In short, while his taste was old-fashioned, his
procedures were quite modern. He thought
only in terms of paint. In contrast, one may
recall the portfolio of fine pencil studies that
would underlie any considerable painting of his
master, Gérôme. At Paris the style of the In-
stitute had already subdivided into a more
linear and a more painter-like tradition. In
the direct succession of the Empire style was
Gérôme. He thought of everything in line,
with color as a secondary grace. His ideals,
naturally with personal modifications, passed to
America in Kenyon Cox, George de Forest
Brush, H. O. Walker, and Robert Vonnoh.
Alongside the straight orthodoxy of Gérôme,
there flourished a tolerated liberalism, with
Bonnat as its prophet. From Couture down,
the more liberal official painters, without break-
ing doctrinally with the Empire style, had been
seeking a more flexible and painterlike prac-

tice. They consulted the museums. In Spanish painting particularly they found precedents for richer surfaces, greater luminosity, and a synthesis that made for unity. Bonnat and Ribot were working along these lines, while Whistler was ready to conduct similar experiments more audaciously in England, and Eastman Johnson, with inspiration chiefly Dutch, had already introduced something similar in America.

Essentially a painter spirit, Eakins naturally turned to Bonnat and the liberals. A few academies from the Paris days still preserved in the Eakins house are like more supple Bonnats. Indeed these studies have so much of the richness and discreet luminosity of Courbet's flesh painting that one must suppose Eakins perused the great heretic on the sly. This type of painting is so unduly discredited today that it needs a word of championship. It accepted a set of historical conventions which seem to me still sound. Everything, being done in the studio, showed the generally reduced light and sharpened contrasts of indoors. Illumination was effected not by precise registration of closely allied tones but by selected and strong contrasts of light and dark. This chiaroscuro was the means of creating form.

The necessity of strong contrast tended to eliminate distracting hues and to base the palette on black and white. Great care was taken with the blacks and whites, which thus got a kind of color value. Frank color was generally admitted only as a spot, a flash of red or gleam of blue justified by a costume or accessory. Something like this convention had served Rembrandt and the little Dutch masters, Velasquez and the Spanish realists; before them, Caravaggio; and after them, Chardin. It was the dark manner always competing with the equally conventional florid and colorful tradition of Rubens. Today such pictures from auctioneers to æsthetes are shrugged off as "dark pictures," which only means that it takes a certain amount of time and patience to read them, as it took time and patience to paint them.

Of course there is no merit in painting dark or in painting bright. Either way, the best and the worst pictures have been made. But the painter who wishes to linger over his theme, facing it in many moods, enriching it from repeated observation and reflection, correcting and reshaping as he goes—such a painter will quite logically be a dark painter. To say what he has to say he must liberate himself from the inexorable tyranny of the fugitive appearance

and from the perplexities of an ever shifting light. He must content himself with wide approximations to appearances, just enough to give credibility to the mental images in which he deals. Such a painter today is hardly regarded either as an artist or even as a respectable craftsman, but that is due to the cheap contemporaneity of most modern taste and to the great delusion of a constant progress in the craft of painting.

All that is just in the prejudice against dark painting is the intuition that a stupid painter may impose himself more readily that way. This may be true but it is also true that it is harder to paint a great picture by the dark conventions than by the bright, nature and the luck of appearances and decorative novelty cooperating less in the effect. It is the conviction that Eakins's dark pictures are paradoxically great which has retained him the respect of a youth which dates the birth of painting from Cézanne. And the more imaginative even see, that being what he was, a profound student of his fellow men, he could no other than adopt and retain the methods proper to the painstakingly intellectualized work of art.

Possibly Eakins was really at his greatest in *genre* painting, but since portraiture was his

life work, we should begin with it. An Eakins portrait is very largely conceived, but without parade of handling; and very minutely detailed, but without any smallness. The main balance, the cardinal articulations, the characteristic mass, are surely and strongly felt from the first. He saw what distinguishes anyone from a distance, before the features come into play. Here lay his specific genius. Whoever knew one of Eakins's sitters would easily recognize him at a hundred-foot remove from the canvas, simply by the way of sitting, standing, or walking. No amassing of details, and Eakins added them relentlessly, ever effaced or attenuated this first vivid apprehension. Now to catch a sufficient approximation to these larger facts of appearance is of course the common gift of the caricaturist, but I believe no one can transcribe such facts accurately and expressively on the scale of life unless he knows their cause. And here Eakins through profound anatomical study had attained the knowledge of those greater dynamic peculiarities which give to each of us his unique look and bearing.

And as Eakins multiplied details, he did so in a hierarchy of organization. Nothing was felt separately as unrelated to the larger structure. Hence the more details are added, the

closer knit is the whole. And the details are expressed in an entirely painter-like way, as flecks or patches of tone which give the plastic suggestion. The feeling of the brush is everywhere, it never hardens into a pencil. For this harmonious union of breadth with minute detail there are few precedents or analogies. In every way the closest is the early portraiture of Velasquez. The critics speak of it in the same terms of carefully guarded praise that you will find in the scanty critical writing about Eakins. And indeed I am willing to concede that whatever verdict is fit for Velasquez in his early maturity is approximately right for Eakins throughout. In both cases we have to do with extraordinary expressions of character without positive charm or felicity of mere handling.

Generally Eakins's sense of character is somewhat tragic. There are notable exceptions—the two concert singers (at the Pennsylvania Academy and at his house) in their full-throated vitality, the splendid lolling nudes in the "Bathing Pool," the lean athletes in the prize ring pictures, the brawny rowers, the noble nude woman in the "Nymph of the Schuylkill." But in the main Eakins liked to paint and did paint men and women strong

though ravaged by the years, somewhat warped
and furrowed by much action and thinking. In
a few portraits, as that of his friend, Arch-
bishop Wood, he dwelt upon the mellowness
and benignity of old age, but he preferred to
read character in terms of effort and fortitude.
This Spartan mood was repugnant if not mys-
terious to an age that eschewed the tragic, or
tolerated it only if attenuated by an alien urban-
ity. It was the moment when "The Lady of
Lyons" passed for high tragedy while "La
Traviata" was a favorite opera. In such days
the lucid bleakness of Eakins could not be liked,
and when approved, was approved hesitatingly
or coldly. He was a fine draughtsman, but a
mediocre painter.

This point of view was most elaborately ex-
pressed by that excellent critic, Samuel Isham,
from whose "History of American Painting"
I quote, premising that Isham bracketed Alfred
Q. Collins and Eakins, as portraitists with a
formidable grasp of character but without ease
of charm of execution.

"In the same way Eakins, with a like grasp of the
personality of his subjects, and an even greater en-
joyment of the picturesqueness of their attitudes and
apparel, yet fails of the popular appreciation that he
merits because of his neglect of the beauties and graces

of painting,—not the beauties and graces of his sub-
jects. No one would wish his sitters more modishly
clad or more self-conscious. Their interest lies in
their personality, and that is excellently given. The
drawing is the most searching and delicate, the figures
are well constructed and stand with notable firmness
on their feet, and every line of face and raiment has
character. The artist seems to say, 'Here is the man,
what more do you want,' but the paint is apt to be laid
on inelegantly. There are vast expanses of back-
ground that are thin or dry or muddy or cold. The
eye longs for beauty of surface, richness of impasto,
or transparent depths of shadow, and the lack is the
more felt because the artist has shown that when he
will he is quite competent to give them, but they do
not come naturally."

How this whole passage evokes a pathos of
distance! Only twenty-five years ago you could
write of the beauty of painting, and everybody
would know just what you meant. It all lay
in *cuisine,* and the proof of the pudding was the
eating. You sampled it, like little Jack Horner,
by putting in your thumb and pulling out a
plum. If the plum were not well textured, lus-
trous, discreetly iridescent, you condemned the
pudding. To consider the total concoction of
the pudding—culinary preconceptions that
might call for an unalluring sort of plum,
would have been to intrude alien literary issues
into a judgment purely æsthetic. It was won-
derful to live in such certitudes. I who speak

have done it, and perhaps Mr. Isham may really be congratulated in failing of that full measure of years which would have brought him to a moment when beauty of painting, namely the artist's *cuisine,* save to one or two die-hards, means just nothing at all.

A joyous historian once remarked to me of the Three Fates of the Parthenon that they were "not very cuddlesome." He did not regard it as a serious criticism of Phidias. To Mr. Isham it did seem serious criticism to regret that an austere genius should not paint voluptuously. Today it would be impossible to persuade any amateur that an Eakins would be better if it were painted with the richness of a Chase. I need only add that the alleged defects in Eakins's practice would only be apparent if you looked for them in corners. The whole picture always has its inevitable rightness, metallic, if you will, but complete and profoundly impressive. The artist rarely wishes to charm you, was seldom charmed himself; he wishes to understand fully, to see clearly and to show clearly, and this he invariably does. One must simply accept a certain grim nobility and ruthless directness as proper to the man and inherent in his message. Perhaps the greatest of the very mixed bene-

fits that Modernism has brought in its train is the habit of judging pictures as wholes and not from arbitrarily chosen extracts.

Any fine portraitist is perforce a historian, and Eakins's portraits give the fullest record that exists of the intellectual travail of our old American stock in the 1870's and 1880's. It was a period when there seemed to be an abyss between thought and action. The men who were seaming the land with railroads, bordering the rivers with mills, wresting coal, oil, and metals from the earth, harnessing electricity, applying chemistry to great industry—these men seem wholly detached from our tradition, constituting a new and baffling race of their own. None of them so far as I know was painted by Eakins. They would not have sought him. A kind of æsthetic simplicity about them drove them to popular and flattering portraitists when they had time to be painted at all. For the rest, few of them looked their admittedly important part. There were exceptions, captains of industry who lived broadly and generously and achieved a fine and personal culture. I would go far to see an Eakins portrait of J. J. Hill or of Sir William van Horne. But this was not to be. His

sitters were artists and intellectuals, and there he wrote his indelible chapter.

It was in a singular sense a moment of hesitation. Darwin, Huxley, Herbert Spencer and Matthew Arnold were novelties, presenting urgent problems with which thinking people had to cope. Everything in belief and much in practice had to be radically reconstructed, with a dire off chance that only destruction was possible. There had been no time to think it through, nor yet to adopt the defeatist policy of letting it alone. Eakins's personal attitude in this matter I do not know, nor is it important. It is enough that he saw and caught the stigmata of such thinking in his most characteristic portraits. The few complacent sitters of Eakins were priests, and these as a class are his least interesting pictures. His gift was to understand a generation, seeking dimly to find itself, and saddened by an uncertain quest.

If the historical value of his single portraits is great, this value is at its maximum in the two big pictures of surgical clinics—"Dr. Gross's Clinic," at Jefferson Medical College; "Dr. Agnew's Clinic," at the Medical School of the University of Pennsylvania. Here Eakins is venturing in a field magnificently occupied by the early Dutch painters and vulgarized through-

out the last century by the official painters of France. There is no question on which side Eakins belongs. You must parallel him not with Roll and Gervex, but with Hals and Rembrandt, and he does not too much suffer under the comparison. Between Eakins's two topically similar masterpieces there is a spiritual abyss. It is the difference between the old and the new surgery—surgery as legerdemain and surgery as science. In the "Gross Clinic" Eakins caught imperishably the very last of the old, for Lister had already published his discoveries.

With the enthusiasm of a beneficent magus, Dr. Gross presides over the oddest sort of witches' kitchen. Eager young men clutch about the gashed thigh. A woman in the operating circle hides her face. There is a general black fustiness, everywhere frock coats and white linen, sometimes blood-stained. A great surgeon retains the garb and capacity of a gentleman even when he operates. So doubtless did Amboise Paré. Behind and above is a mystery of faces, clear only that of the clerk who rigidly keeps pace with act and word. There is a separate study in the Worcester Museum for the head of Dr. Gross, and it is amazing how the mere posture implies the whole pic-

ture. He is wise, sad and determined. He
has staked his skilful hands against death or
decrepitude, but the event is uncertain, remains
a God with whom possibly neither he nor the
patient is on terms, and a fate which he cannot
control. Skilful he has been, and forgetting
the blood that crimsons his fingers to the
knuckles, he poises his hand and tells as he may
where his skill lies. It is a portrait of Dr.
Gross, everything else, despite resolute second-
ary portraiture throughout, being incidental.
He is a prophet among his disciples, and his
act seems not one of routine, but a gesture
implying a miraculous deliverance. It is a very
great picture. Rembrandt's "Anatomy Les-
son" seems to me inferior to it in taste and con-
centration. It was painted in 1875, when
Eakins was forty-one, and it did not meet its
predestined gold medal till twenty years later,
at the St. Louis Exhibition.

With "Dr. Agnew's Clinic," painted some
fifteen years later, we step into another world.
There is no sense of urgency or inspiration.
Instead, the beauty of an orderly ritual. The
white-clothed surgeon stands apart with the
nonchalant confidence of a military commander
in his trained force. Three surgeons work
deftly and quietly about the half-exposed body;

a trim nurse stands by. The formidable array
of special cutlery that we note in the fore-
ground of the "Gross Clinic" is absent. One
just sees the edge of a modest instrument tray.
The surgeon is no longer an inspired magus
working his miracle in a dire emergency, but
merely the principal actor in a well-knit drama.
He no longer bets just his skilful hands against
death, but a whole body of knowledge and a
corps of capable assistants. There is no weep-
ing relative in the circle. Science has learned
that the weeping relative is as septic as the gen-
tlemanly frock coat, and has banished both.
There is nothing grim about the scene. The
mood is rather serene and cheerful. Nobody
but Eakins has so keenly felt the tense beauty
of a modern surgical operation—a spectacle as
lovely in its fashion as a solemn dance, and for
the same reason, that it rests on an exquisite
order.

Merely on the technical side this is an ad-
vance on the "Gross Clinic." The atmospheric
envelopment is finer and more reasonable, the
audience of medical students, including many
admirable portraits, is at once more fully real-
ized and better subordinated. But I think the
"Gross Clinic" with its sinister intensity is after
all the greater picture, evidently not so lucidly

seen, but more impetuously imagined. Either
picture would suffice to make an enduring fame.
Modern painting affords no worthy parallels.
Besnard, in the "École de Pharmacie," with all
his ability, is far less penetrating. For our
analogies we must go back to the Dutch cor-
poration pictures and to the anatomy lessons
of Keyser and Rembrandt; and Eakins, if his
dexterity is less, is on the same high plane of
insight and interpretation.

The single portraits of Eakins are as various
as the sitters. Style they have abundantly, but
it is scrupulously subordinated to character, and
has to be looked for. I suppose he has lacked
his due fame largely from the fact that his
handling is never an earmark. There is noth-
ing about a fine Eakins' portrait that gives the
tyro the joy of saying offhand, "There's a good
Eakins," as he would say, "There's a Chase, a
Sargent, a Whistler." You would say instead,
"There's a very serious portrait." In short in
a generation that sorely overvalued brilliant
handling, Eakins simply offered nothing that
could be talked about or written about, and was
naturally neglected. Today, I trust, we are
more interested in what is expressed than in the
rhetoric of expression, and Eakins is coming
into his own, for no portrait painter of his age,

whether in America or Europe, has left a more various and speaking gallery of thinking and feeling fellow mortals.

The very variety of these portraits makes any such generalization as I have attempted in an earlier page misleading and inadequate. What common denominator will fit the sombre gravity of "The Thinker," in the Metropolitan Museum, all grave blacks; the resolute frailness and delicacy of Miss van Buren, in the Phillips Memorial Gallery, with its bleakly lovely flash of silvery blue; the sprightly somewhat cynical assurance of Dr. Agnew in his white surgeon's jacket, at the Barnes Foundation; the slouching geniality of Walt Whitman; the crisp and almost inhuman detachment of the great physicist, Professor Rowland; the fine dandyism of J. Carroll Beckwith at his easel; the superb vitality of the Concert Singer, the stolid confidence of the little girl, Ruth, already assuming her defensive mask against a none too friendly world, the exquisite subhumorous quality of the young woman, Clara, with the grand oval of a face worthy of a Juno? Plainly these achievements can only be hinted, but the hint may be sufficiently verified and extended by consulting the illustrated catalogue which was published by the Metropolitan

Museum for the memorial exhibition of 1917.

It may still be argued that Eakins might have cared more for richness of painting and for composition. The answer would be that these pictorial graces are usually indulged at the expense of true portraiture. Only Velasquez in his maturity seems to have achieved fastidious arrangement and handling without waiver of the pristine veracity of his conception. Indeed the notion that a picture is a world made by the painter after his heart's desire has in portraiture a limited application. A portraitist of Eakins's kidney felt rather that the world of each portrait is primarily that of the sitter, that in each case it should be investigated and ascertained, and by no means predetermined on stylistic grounds. In portraits conceived with this severe probity, the personal style of the painter will all the same transpire, but rather as an intangible, a precious moral aroma, than in lusciousness of handling or measurable compositional ratios. It is entirely unprofitable to compare Eakins with those poetizing or caricaturing portraitists who are primarily painters and decorators—little brothers of Titian, Vandyke or Frans Hals. He is of another sort. It is safe to predict that his place is assured in a line of portraitists which after all

includes Antonello da Messina, Il Moro, Raphael, Hogarth, Copley, David and Ingres.

In *genre* painting Eakins is so uniformly urbane and so positively charming that his lack of recognition in this field is amazing. Released from the formidable responsibility of painting portraits, dealing often with sports he loved or with intimate scenes at home, or, exceptionally, with whimsical evocations of the past, these little pictures offer no obstacle to appreciation. Yet he sold few of these little masterpieces. Most of them are still in his widow's possession or have passed through her generosity to the Pennsylvania Museum. The only one that was publicly visible during his lifetime, the admirable "Chess Players," in the Metropolitan Museum, was his gift. These pictures were his recreations, and he let it go at that. Why they did not sell when the Eastman Johnsons, the E. L. Henrys and the early Winslow Homers readily found purchasers is mysterious to me. Possibly Eakins rarely took the pains to exhibit them. Sure of a modest living from his teaching, selling pictures was about the last of Eakins's concern. It was enough to paint them.

Eakins was about twenty-eight when on his return from France he painted the rowing pic-

tures. He sent back to his master Gérôme
"John Biglen in a Single Scull," retaining for
himself a replica which is still in the Eakins
house. Both master and pupil had reason to be
proud of the picture, for it is very plainly told,
having, withal, an unaffected greatness. In a
shell cut sharply at the ends by the frame the
brawny form of the champion is arched for-
ward ready for the catch, the wrists still
dropped in feathering position. The nose of
another shell just enters the picture from be-
hind. Far beyond is the hazy farther bank of
the Delaware, a shade lower than the rower's
head. The dull blue expanse of river is trou-
bled only by the long eddies from the last
stroke, gently breaking the reflection of the
figure and the shell, and by a couple of distant
white sails. Everything is homely and specific,
yet singularly grand. And this largeness of
effect is chiefly due to the way in which the burly
form, its heavy curves contrasting with the dom-
inant horizontals, between two of which it is
held, imposes itself against the vast level of the
river. And the picture has in a high degree a
grace then novel and only beginning to be talked
about, an envelopment that catches the very
feel of that sultry mist which hangs over the
surface of our slow-running tidal rivers. Not

greater but more charming is "The Pair-oared Shell" driven powerfully through the shadow of a massive lustrous bridge pier towards broken rapids and a near-by wooded shore. Here the distribution of great masses of light and dark in a simple and noble geometrical arrangement is both lovely and impressive. A few fresh and jolly pictures of small sailing craft, of this same time, afford a relief for the tension of the rowing themes.

Of 1874, Eakins's thirty-first year, is the portrait of Professor Benjamin H. Rand, now in Jefferson Medical College. It is as much a magnified *genre* picture as a portrait, with the interest impartially distributed between the fine bearded head, the sharply lighted microscopes and papers, and the pet cat arching a luxurious back against her owner's solid left hand while a light paw reaches for the right hand heavily resting on the paper. Already we find that indefinable air of a witches' kitchen which was to be fully realized in "Dr. Gross's Clinic" of the next year; and already we discern the formula upon which the later subject pictures were to be built, a carefully chosen form strongly illuminated in foreground amid a barely penetrable obscurity. Upon a similar principle of contrast are constructed such masterpieces as "The

Zither Player," "The Chess Player," "The Home Ranch," the two versions of "The Nymph of the Schuylkill," the two prize ring pictures. It was the formula that had earlier served Caravaggio, young Velasquez, Rembrandt and Terborch. For that *genre* painting which seeks rather intensity of character than kaleidoscopic variety of appearances the convention seems permanently valid. One is not far from it in the superb "Card Players" of Cézanne, where the same principle of concentration rules. Here it is instructive to compare the admirable contemporary narratives of Winslow Homer in which a concern with specific ambience sacrifices mental to physical reality. Indeed the right use of established formulas may seem to be the fine wisdom of all great artists, as it is that of all men who with delicate intelligence lead the good life. Such a course relegates mere experimentalism to its due and minor place whether in art or life, resting, as such a progress must, on the conviction that discovery is best reached through a preliminary review and recovery.

Of the pictures painted in this convention "Salutat" is the more thrilling and "The Nymph of the Schuylkill" the more charming and satisfying. In the prize ring picture, the

firm body of the champion tingles from the toe
barely touching the floor to the upraised right
hand; the homely and entirely natural poses of
the towel-man and sponge-holder behind are of
singular nobility; the background of applauding
sportsmen, including portraits of Eakins and
his friends, though seen in half-light, is admi-
rably realized, but there is a baffling lack of
unity. Perhaps it is as simple as that the two
secondary figures are more interesting than the
main figure, or that there is too much light
behind the boxer. In short, one is inclined to
believe that the picture would have been better
had there been a greater sacrifice of naturalism
to the convention.

No such reserves apply to the grander ver-
sion of "The Nymph of the Schuylkill," which
seems to me entirely perfect and worthy to be
named with the great Terborchs or with Rem-
brandt's "Little Susanna." The motive of an
artist working from a nude model has of course
served for scores of the most tedious or vulgar
Salon pictures. In no case could Eakins have
stooped to such banalities, but he was fortu-
nate in getting a hackneyed theme in a delight-
fully fresh and unexplored form. In the leg-
endary of Philadelphia one learns that when
William Rush, carver of figure-heads, wished to

cut in wood the local nymph, finding no worthy
model at a moment when the professional
model hardly existed, "a celebrated belle of the
time consented to pose." One wishes that
legend had handed down her name, for she was
a free spirit before freedom had become fash-
ionable with her sex. The sittings took place in
an old house still shown on the river bank
within sound of the quiet running of the Schuyl-
kill, and Mrs. Rush kept the "celebrated
belle" in countenance with the sanction of her
presence. I fully grasp the impatience of a
sophisticated reader with these anecdotal, or,
if you insist, sentimental preliminaries. But
they are really of the pictorial essence. It is
Eakins's sensitiveness to these considerations,
which is implicit in all the arrangement and ex-
ecution, that makes the little canvas at once
so great and so delicious.

The noble form of the model blooms out of
the dusk. The back, partly turned towards the
spectator, is invested with a heavy and little
modulated shadow while a superb blotch of
light establishes the front profile of the
entire figure. The figure itself, massive and
graciously equipoised, the left side being free
of the burden, has no seductiveness, but rather
a beauty into which sex hardly enters, recalling

the rare female nudes of early Greek sculpture. The seated form of Mrs. Rush, knitting, balanced by a fine confusion of the model's clothes on a chair, constitutes a picturesque half-circle in which the model stands or from which she seems slowly to rise like a Venus Anadyomene from her great shell. In the far corner, left, one sees the sculptor dimly, but realizes how carefully he studies his stroke before striking the big chisel set on the ankle of the statue. In the other corner is one of those bizarre features which Eakins, for all his sobriety, loved, the chalked outline of a figure-head on the wall with scribbled notes in chalk. Here is just a touch of that witches' kitchen quality which dominates earlier pictures. The slight bit of color conceded in a generally monochrome scheme, a bit of grayed blue in the fillet and a touch amid the mass of clothes, is very effective, while the whites and blacks are so modulated as to give a richness of tone, which I think no one would exchange for more positive color. Of course the greatness of the picture rests on an all pervading thoughtfulness. There is some sense of a solemn rite about it. The celebrated belle so carefully balancing the folio which simulates an urn could shift from the dusky room on the Schuylkill to the procession of urn-

bearing maidens on the Parthenon frieze, and
not find herself an alien. In such a picture, the
entirely familiar meets the unexpected to create
an effect of grandeur which has its overtones of
glamour and even of a latent humor.

No review of the other *genre* pictures is pos-
sible. "The Negro Boy Dancing," the singing
"Cowboy"—carried off with the gusto of a
Hals, "Spinning," many another—all show the
same grasp of the pictorial moment, the same
sure and simple emphasis. Let us pass rather
to the masterpiece of them all, "The Swimming
Pool." The subject is nothing but six naked
men and boys on or about a rude stone pier
which juts out before a grove, with a glimpse
upstream to a rising meadow, closed by woods,
which cut off all but a patch of sky. The pyram-
idal group is as formally composed as any
Renaissance picture, with contrast of forms
tensely erect or lolling and relaxed, with lovely
connecting gestures, everything studied and
complete. But, by a singular grace, nothing is
far-fetched or forced. Every pose, every ges-
ture, is what might be seen. By a happy chance
any confused group of bathing men might fall
into this monumental order without anyone
dropping a hand or turning a head. The in-

gredients are casual and natural, the whole stately and monumental.

Of the principle of discovering beauty by selective observation of mere appearances there could be no finer example, and of course this was ever Eakins's road to beauty. The picture is not built on the usual formula. The light comes well forward on the pier, and more than half the surface is rather bright. The shadowed pool is not rendered with the richness and variety of color that was already in vogue about this time, about 1898, but Eakins gives after all the look of the scene to an eye focused on the figures and taking the riverscape for granted. This was an old-fashioned procedure. It was the momentary fashion to let outdoor light disintegrate the nude. Hardly any good painter except Renoir dared to stand out of the mode. In the nature of the case, it is hard to see why a figure should lose all interest as a figure simply because it is out of doors, or, withal, why specific illumination should seem the only admirable attribute of nature. Cézanne was soon to teach us better. And indeed has any picture come nearer to Cézanne's own program of "doing a Poussin after nature" than does "The Swimming Pool"?

Thomas Eakins's genius was that of the

observer and discoverer. His aim was ac-
curacy and truthfulness, his habit a self-efface-
ment which was proud or humble, as you choose
to look at it, but in any case rested on a devout
acceptance of the thing seen. His art then con-
sisted in study and a delicate probity. The
personal transformation, which every good
artist makes, was in his case confined to well-
pondered omissions and discreet emphasis of
the residual vision, in a very creative act of
taste. This same inherent taste and culture
saved him from the lure of unfit novelties, kept
him from restless experimentation, led him
surely to such established conventions as were
akin to his thinking and feeling. Thus there is
a massive and appealing wisdom in all his work,
a value of interpretation which time will not
efface. Amid the whirlwind that stirred the
art of painting to its depths during his activity,
he held his tiller true. No painter of his time
better deserves Leonardo's praise for that
artist whose judgment surpasses his mere dex-
terity. The time abounded in painters whose
dexterity surpassed their judgment. Most of
them are already forgotten, while Eakins's
fame, which has never yet received its due cele-
bration, mounts steadily.

[1929.]

XI

THE ENIGMA OF SARGENT

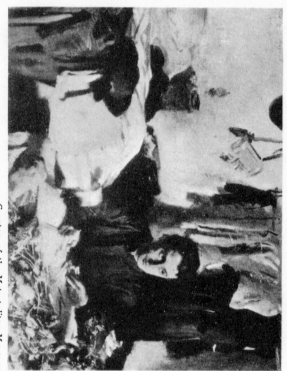

THE ENIGMA OF SARGENT

In reading very carefully Mr. Downes's life of John Sargent, I have been followed by a curious sense of frustration. It is evident that the accomplished art critic emeritus of the *Transcript* has assembled about all the material at hand, clear that he has written with the conviction of admiring acquaintance, but the man behind the painting completely eludes me. There is a baffling amount of widely differing opinion about Sargent: he was a sardonic prosecuting attorney, he was an honest and disinterested student of appearances; he was a heartless virtuoso, he was a loyal and considerate gentleman; he was one of the best painters of all times, he was a showy and shallow executant. And for all these contradictory views there is a perplexing variety of evidence. Nor do my own casual meetings with him and seeing his pictures for a matter of thirty-five years help me to simplify matters.

One recalls agreeably the nice, burly, Anglified American gentleman, entirely simple and affable when you took him as such, stiffening a

little defensively when you took him as an artist. One recalls pictures as masterly as work as they are as human interpretation, others merely assertive and clever, still others showy and flimsy, again others objective and breathlessly faithful to the look of things; mural paintings overingeniously archæological, others highly decorative in an archaistic way, others highly undecorative in a melodramatic way, a few highly decorative and as deeply felt, some mildly decorative and hardly felt at all. Then one thinks of the water colors so marvelously seen and executed, but so little felt, and alongside of them of a landscape like "Lake O'Hara," profoundly seen and as deeply felt. The whirl of these paradoxes, while confusing, is also consistent. One has the spectacle of a first rate gift producing rarely at its height, but dealing often in the second rate or worse.

Mr. Downes's well-sustained eulogy naturally helps little to explain a paradox of which the eulogist seems unaware, but his ample collection of facts is serviceable as are the many cuts which quicken old memory of their originals. Evidently the life and work of any artist if closely questioned should betray any apparent mystery of his genius. Let us approach the enigma of John Sargent along these lines.

He was born in Florence in 1856, his father
being of the New England Brahmin class and
his mother a Philadelphia patrician. It was
she who passed on to him a passionate love of
music and painting, the father contributing that
physical tenacity which plays a large part in any
artistic success. John Sargent thus came up in
an atmosphere of expatriate gentility, shifting
his casual schooling and more continuous efforts
as a draughtsman, as considerations of health,
economy, or convenience moved his parents
from Florence to Rome and Nice. Reading
good books and learning languages by contact,
he had a far better education than falls to most
painters. However, I think he never wholly
outlived the irreality of his upbringing. To
think of life in terms of comfort and voluntary
contacts may befit old age, but it is a poisonous
programme for youth, as weakening the heroic
sense of duty and reducing the exercise of the
sympathies, which are really best fined and
trained in compulsory contacts, to a kind of
selective dilettantism. A great artist may well
end, Goethe-like, as a citizen of the world, but
no great artist has ever begun as that, and John
Sargent was not to prove an exception. High
seriousness is a homemade product. In short
his morale was limited to that of the nomadic

American of culture, and that necessarily qual-
ified his whole view of life, and naturally his
attitude towards his art.

In seeking Carolus-Duran at eighteen, young
Sargent merely found confirmation of defects
and qualities already established. The ideal
of the studio was a vivid but superficial curios-
ity towards appearances; the technical pro-
gramme, the production of cleverly manipu-
lated passages of paint to suggest any sort of
attractive epidermis in nature. Everything
was studied as so much still-life. Whatever
of a moral or physical sort might be within the
epidermis was not the painter's concern, did
not really interest him. That larger drawing,
which is really a psychical taking possession of
any subject-matter was not so much neglected as
completely unknown. Indeed only Puvis, Car-
rière, Fantin, and Degas—Cézanne had not
emerged—possessed it at the moment in
France, with Watts and Alfred Stevens in Eng-
land, and Thomas Eakins and Winslow Homer
in America. It is interesting to guess what
Sargent might have become had he sought, in-
stead of Carolus, one of these large seeing
masters, but I am inclined to agree with Mr.
Cortissoz that in Carolus's atelier Sargent
found precisely the training that befitted him.

The method there pursued had indeed its undeniable merits. It was grounded in a discreet revival of the sumptuous low tonalities of the Venetian and Spanish schools, in emulation of the bold yet learned manipulation of their great masters. It employed the safe and tested earth colors, avoiding those ephemeral stridencies which the synthetic chemist was putting at the disposal of the contemporary Impressionists. So reasonable and handsome a way of working was welcomed by the cosmopolitan youth who was by his capacity as an expatriate American of culture free from all the perilous curiosities and aspirations of the new radical schools. Within four years Sargent had fully mastered the method, exhibiting at twenty-two in the Salon of 1878 the excellent little canvas "Oyster Gatherers of Cancale," now in the Corcoran Gallery. It has much charm and alertness with a quiet and just sense of life and movement, and a sober pearliness in the illumination.

For more than twenty-five years Sargent occasionally produced little figure pieces of this sort, and the group constitutes the most satisfactory and untroubled expression of his personality. "The Sulphur Match," "Venice in

Gray Weather," "In the Luxembourg Gar-
dens," the two "Venetian Interiors," "The
Spanish Courtyard"—every well-informed art
lover knows and likes these pictures, for their
elegance, for their sober perfection of tone and
handling, for a clear and simple evocation which
is free from insistence. Their entire accessibil-
ity is their charm and perhaps their limitation.
Anybody can see them. But just anybody can-
not see Degas in similar vein. It requires su-
perior vision. Sargent's complete and elegant
accomplishment in this vein seems to me to re-
sult in a certain emptiness when the scale is en-
larged as in "The Boit Children" and most of
the other portrait groups. However, simply
these little figure pieces would entitle him to be
regarded as one of the best minor painters of
his time, keeping him in grateful memory with
such painters as Alfred Stevens, Frank Potter,
and Tarbell.

As a portraitist, Sargent during his lifetime
evoked the widest difference of opinion, and a
critic will do well to cling so long as he may
to what little unanimity there is. I suppose
that everybody will agree that the "Carolus,"
the "Lady with a Rose," the "George Hen-
schel," the two Marquand portraits, the Homer
Saint Gaudens, and most of the Wertheimer

portraits, with the "Coventry Patmore" and
the "Lord Ribbesdale" and the "Ian Hamil-
ton," together with the Mrs. Augustus Hem-
ingway, the "Major Henry Lee Higginson,"
the "Joseph Pulitzer," and the group of the
Four Doctors are not merely among the best
portraits of our times, but also compare very
favorably with the finest portraits of the past.
I should not expect anybody but some Modern-
ist who disbelieves in portraiture to differ from
this view. Naturally the list might be consider-
ably extended, but I feel the additions would
soon be sharply contested. Personally, for in-
stance, I find the much-admired "Beatrice
Goelet" and the "Honorable Laura Lister"
neither better nor worse than the similar pic-
tures of little girls by Millais; I think the
groups of aristocratic young women in the eigh-
teenth century tradition far-fetched and tedi-
ously assertive; I loathe the "Ellen Terry" ad-
miringly and am only mildly amused by the
fabulously clever "Carmencita"; I think "The
Boit Children," despite the adorable sepa-
rate portraits, unpleasant in scale and feebly
realized as a space. Naturally no authority is
claimed for such prejudices. They are men-
tioned at all merely to show the wisdom of ap-
proaching Sargent through the group of about

twenty admitted masterpieces of portraiture.
Let us seek whatever principle of unity there
may be among works quite various in handling,
running from very sober treatment in the tradi-
tion of Carolus to the most audacious pyro-
technics.

In the first place these are all "sympathetic"
Sargents. One feels that he cared more for
the sitter in every case than for his own adroit-
ness in divination or his own skill in rendering.
Except in the case of the "Asher B. Wert-
heimer," the most ill-wishing critic could not
say that Sargent had played the "prosecuting
attorney," and here the critic would be wrong,
for the Wertheimer is a high act of apprecia-
tion of the shrewdness and vitality of its sub-
ject. One has in every case an extraordinary
virtuosity modestly subordinated to a congenial
task of interpretation.

Next these are all early Sargents. Most of
them were painted before 1898, and none of
them later than 1903. These in short are the
sort of portraits that engaged the enthusiasm
of Sargent's most friendly and perceptive
critics, Henry James and Alice Meynell. Be-
yond 1903 there are very few memorable Sar-
gent portraits, and many bad and flimsy ones.

It seems to me that a certain obvious importance of these chronological facts has been ignored. We have the very peculiar fact that the man who was regarded as the greatest portraitist of his day did all his best work by his forty-eighth year and at fifty-five was sick of the task. Sargent had exhausted prematurely a vein which a Velasquez, a Titian, a Rembrandt, a Raeburn, a Stuart, cultivated and enriched so long as their hands could hold a brush.

What an artist quits is his own affair, and while quitting portraiture, Sargent remained immensely busy at mural decoration and water-color sketching in his last fifteen years. But for an artist of great and established achievement to go off badly is not entirely his own affair. The case wants explaining. I shall not forget the somewhat appalling revelations of the memorial exhibition held in the Metropolitan Museum. With half a dozen portraits that seemed fit company for the Halses, Rembrandts, and Velasquezes, and Vandykes in neighboring galleries, there were many of which to speak little is charity—figures that stood ambiguously or toppled out of their frames, speciously painted stuffs with no body inside, beautifully painted heads with nothing

below the neck, much nondescript and some poor color, many pictures that seemed oddly out of fashion—a look that a first-rate picture never gets. Generally speaking the showy portraits were the bad portraits, the "Mrs. Swinton" being the type, with its brittle and hollow workmanship, its entire absence of any reasonable grammar of painting. It was there to show that Sargent was occasionally painting very badly near his best time, 1897.

To seek the reason for this paradox through those twenty triumphal years in London from 1884 is a task as difficult as ungrateful. Yet one may guess at the effect upon a very sensitive and self-conscious nature of such excesses of praise and blame as cheered or howled before the Chelsea door of a cultured and expatriate young American in his early thirties. He was one of the greatest portraitists of all times, he was merely a clever exhibitionist; he was a profound interpreter, he was a shallow and heartless virtuoso enriching and amusing himself at the expense of his infatuated sitters. Doubtless he pretended to himself that all this did not matter, but here and there it stung him so far that he broke a habitual reticence, to counterattack what seemed to him to attaint

his character as a gentleman. More serious handicap, he had to live up or down to an early fame as the cleverest painter of a very clever age. It is the heavy penalty of cleverness that the clever person must conduct a continuous performance. To live up to such *tours de force* as "El Jaleo," 1882, and "Carmencita," 1899, was to live in overstrain. Both pictures are masterpieces bred of peculiar experience, of nerves tingling at the sinuous fury of the dance or at the splendid insolence of a Spanish she-devil in repose. The brush moves with the swiftness and certainty of a conductor's baton, evoking a visible music at once strident and superbly rhythmical. But Sargent was expected to be as excited over the aigrette of a British matron or over the towering late-Victorian shoulder sleeves of a reigning belle. He played fair with them. When they gave him something to think of while painting, he gave them his virtuosity and with it his insight and his sympathy, and when they gave him nothing, he honestly gave them what most of them wanted and were paying for—his mere virtuosity.

So I imagine the apparently ideal life in London, with its successful defence against

unfit contacts and its rich companionship with fellow artists, musicians, men of letters, and understanding women was less satisfactory to Sargent than it seemed. Without developing either the constant insight and deep human respect of the great portrait painters or the sound perfunctory habits of the merely good portrait painters, he was harassed between two almost equally sinister reputations, that of superhuman virtuosity, and that of a malign "prosecuting attorney." So he remained chiefly a virtuoso who, like Hals and Rubens before him, painted many brilliant portraits, and, as admiration or affection moved him, a few portraits that are great.

By a circular route we have come back to our starting point that the great Sargents are the "sympathetic" Sargents. By this I do not mean that the sitters are likable, though often they are, but that they vividly enlisted Sargent's interest, that he thought much about them while painting them. Surely the "Marquand," the "Wertheimer," and the "Coventry Patmore" are not precisely likable effigies, nor is the amiability of the marvelous "Four Doctors" their most salient characteristic, but in every case we have personalities potent enough to arrest even an expatriate American of culture. Nor is

"Mme. X." really likable, but she is so alive in
her steely perfection that one cannot see her
with impunity. Perhaps Sargent's extraordi-
nary sensitiveness is best shown by simply com-
paring "The Lady with the Rose" and "Mme.
X.," recalling that less than three years sepa-
rate the two portraits. One woman is painted
with some magical distillation from flowers seen
at dawn through the dew, the other welcomes
and challenges the merciless light from raucous
avenues; one is fully intimated with manifold
respectful modulations, the other is fully and
emphatically uttered in a single *élan* of male
admiration. And both pictures are quite per-
fect.

Before leaving the "sympathetic" Sargents
we do well to note that some of them enlist his
greatest virtuosity. It is concealed in many,
particularly in his valedictory to great paint-
ing, "The Four Doctors." The structure of the
fine heads is so unobtrusive that it seems as
if anybody must have painted them that way,
and the really noble, spacious, and highly
studied arrangement seems almost casual. The
"Major Higginson," too, owes nothing of its
massive and benign existence to any overt han-
dling. One never thinks of the workmanship;

one thinks of the man. But the "Marquand,"
the "Patmore," and the "Wertheimer" are as
brilliant as the "Carmencita," be it said with
brilliancy of precise, emphatic, and understand-
ing elucidation and without a shred of personal
display in it. For the "Carmencita" so much
cannot be maintained.

The relation of sympathy and interest which
underlies all of Sargent's finest portraits evi-
dently did not depend upon the intrinsic worth
or interest of the sitter. It depended rather
upon some mysterious and possibly capricious
rapport. Sargent could do an inadequate
Roosevelt, Woodrow Wilson, and President
Eliot; an indifferent Booth and Irving. All of
which goes to show either that he lacked the
portrait painter's temperament, or more likely,
that, having it, he soon lost it. How, we may
hardly surmise. Possibly a too long and diffi-
cult inner struggle against adulation, abuse, and
boredom may account for much. Few painters
have been thrust so early into so ambiguous a
notoriety. In any case, the great portraitist in
him died young, emerging now and again post-
humously in a few of the water colors and
charcoal drawings of the later years.

So, measured by the standard of consistent
performance, the general view that Sargent

was the greatest portraitist of his times seems exaggerated. Watts, I feel, painted many more fine portraits, so did Fantin and Thomas Eakins. And the best portraits of Sargent seem to me less enduringly good than the best of Degas and Carrière and Augustus John, while Orpen's equally brilliant practice is far more evenly sustained. I do not press such comparisons; they are possibly unprofitable. As a portraitist, Sargent seems to me to have suffered from his natal cosmopolitanism, and from the absence of any pondered and settled attitude towards his art and presumably towards life. He was the fine flower of the Parisian dilettantism of Théophile Gautier and Carolus-Duran, and great only when he transcended his æsthetic origins. In many fields he was immensely able and intelligent, displaying a versatility which suggests some lack of inner centrality. Possibly he was too much in the fashion of his day and without that degree of detachment, that capacity for seeing in the aspect of eternity, which the greatest artists never lack. Hence a considerable abatement of his present fame is to be expected. But his best portraits, both for beautiful vision and workmanship, are his sure gage against that

oblivion that quietly waits for the merely clever artist in any field.

In the early summer of 1890, in his forty-fifth year, Sargent was charged with the decoration of the upper hall of the Boston Public Library. The subject was to be the history of religion. This work was his most absorbing interest for his remaining twenty-five years, and it never was quite finished. It is one of the ironies that those architects, McKim, Mead and White, who were chief promoters of our mural painting, generally designed their monumental halls first, and often called the decorator to irrevocably bad conditions. They never designed an interior less fitted for monumental painting than that which was assigned to John Sargent. The long corridor was cut in two symmetrically by a big skylight above, and asymmetrically on the floor by the well of a staircase and its parapet. There remained available for the mural painter the two shallow barrel-vaulted alcoves at the ends, three big lunettes on either side and, below them, sadly isolated spaces on the side walls proper.

Within these limitations, Sargent was to do about everything that was possible. It worked out as three quite separate series: the two alcoves and the six lunettes. That a painter

of Sargent's fine critical intelligence should
have accepted so unpromising a task and
worked at it so loyally requires explanation.
There is evidently implied a great zeal to do
mural painting. Next the very difficulties may
have challenged one to whom difficulties were
supposed to be merely opportunities. Again
Sargent himself was the fine flower of a mo-
ment that, insisting on fine parts, had largely
lost the sense of fine wholes. Good writing
consisted wholly in fit words and fine phrases,
good painting meant only fine passages. It is
possible that Sargent at first welcomed condi-
tions that limited his task to the creation of
so many fine episodes, and only too late faced
the problem of unification. Talking with him
just after the lunettes and long vault were fin-
ished, I felt that his prodigious endeavor had
not unnaturally produced an amiable self-de-
ception. He had worked so hard to produce
unity that he saw more unity than there was.

For four years Sargent worked at the first
part of the decorations in the vast studio which
he and Abbey shared at Fairford. There were
trips to the Levant to saturate himself with
the feeling of the old paganism. The contrast
between the works proceeding at opposite ends
of the Fairford studio is suggestive. Abbey

was working out an idyllic and reflective sort
of poetry in the Grail series, with retrospective
and Tennysonian references; Sargent, largely
guided by Flaubert and the actual monuments,
was seeking to revive as spectacle the beauty
and horror of the old beliefs. So in 1895 he
set up the lunette which represents the Jews
trampled by the strange gods of Egypt and
Assyria, the adjoining vault heavily occupied by
Moloch and Astarte,—cruelty and lust, with
the broad frieze of aspiring and agonizing
prophets below. In the lunette and vault Sar-
gent intended to represent the Confusion of Re-
ligions, and here the intellectualism that some-
what vitiates all these decorations appears
clearly. Evidently confusion may become a
pictorial or decorative motive only on condition
that it be brought into order, in which case
it ceases to be confusion. Sargent was aware
of the paradox, for he compromised. The
lunette and the vault may be considered as half
in order, equal concessions being made to the
intellectual theme of confused religions and to
the requirements of decorative arrangement.
Naturally the effect was ambiguous. The tend-
ency was to praise it ambiguously as a distin-
guished sort of novelty, and to reserve genuine
praise for the entirely understandable frieze of

prophets. The prophets were and are resolute academic studies. Without decorative unity, they had dignity and an interesting portrait character. Today they seem chiefly old-fashioned and the least effective part of the decoration. The promise lay in the chaos above the prophets, with its real inventiveness, despite its archæology, and its very personal color scheme, gold dominating sullen reds, as of glowing iron, and tenuous blue greens. To make a very splendid and wholly novel decoration nothing was needed but a finer and more formal ordonnance, and this was supplied some eight years later in the "Dogma of the Redemption" which adorns the opposite wall. Its vault and side panels were set up some fourteen years later, in 1916, and here is the perfect fulfilment of Sargent's talent as a mural painter.

Before designing the "Dogma of the Redemption," Sargent made a special trip to Spain, where he felt much of the spirit of mediæval Christianity had survived. There he made profound studies of a class of paintings, the great Catalonian altar backs, which at that time were little known even to professional historians of art. These strange paintings of the fifteenth century combine extraordinary realism in figure painting with the most sumptuous deco-

rative abstractions. In a panel of Jaime Ver-
gos you will see a face modelled with the knowl-
edge of a Masaccio looking out from a nimbus
of embossed and engraved stucco covered with
gold. This art has a peculiar æsthetic effect.
It is at once completely actual and completely
otherworldly. Could an art based on the best
realistic teaching of the Paris Schools attain
otherworldliness by careful assimilation of the
decorative conventions of early Catalonia?

Such was John Sargent's problem, and he
solved it triumphantly. About the sculptured
Christ rules a beautiful geometry of design.
The three identical figures of the Trinity above
glow somberly from behind their twisting ban-
deroles in gilded relief with that red of cooling
iron which we have observed in the earlier lu-
nette. The motive of the Trinity fills the arch.
Below the geometry is less insistent in the row
of angels bearing the implements of the passion.
The two patterns are connected by the figure
of the Crucified Christ with Adam and Eve
lashed to His pierced sides. Nothing is
archæological except the arrangement, which
after all rests on principles which have no date,
and the decorative conventions. In figure
painting and sculpture Sargent uses all his re-
sources. Here there is nothing of Nazarene or

pre-Raphaelite anæmia, everywhere splendid
vitality, specific form, even something of the
nineteenth century sense of the model. This
is true of the angels, and they are perhaps Sar-
gent's most beautiful creations. Again what
would otherwise have a beaux-arts quality,
gains aloofness and a sort of spirituality
through the abstract splendor of the gold, and
here are repeated those same thin, greenish
ceruleans which we first saw in the diaphanous
veil of Astarte.

The mood is one of intellectual understand-
ing and reverent sympathy. Sargent could not
be expected to believe that Euclidean theology
which he so clearly visualized, but the man of
historic imagination knew how nobly seventy
generations of mankind had lived and died
under the dogma of redemption. Sargent
found no place in his scheme for the religion of
the Renaissance, feeling it justly an anti-reli-
gious age. To complete the vault and short
side walls of the alcove he passed directly from
the Middle Ages to the seventeenth century
and the Counter-reformation. In the notable
omissions involved, his tact was complete.
Protestantism, while it offered a sufficiently
pictorial history, provided few symbols and less
mythology, was unavailable for any compre-

hensive decorative scheme of which mythology and symbolism were the essence.

Above the two Madonnas on the side walls, he disposed the vault formally about great rectangles presenting the Annunciation and the Crucifixion, the smaller ovals and quatrefoils containing scenes from the life of the Virgin and of Christ. Within these narrow and formal bounds moves a passionate life. Sargent has caught perfectly that appeal to emotion with which the Church met the Protestant appeal to reason. He has assimilated the great painters who have expressed the new fervour— Sodoma, Baroccio, El Greco. But the inventions are his own, and the greatest of Sargent is in such little spaces as those which contain "Christ on the Mount of Olives," "The Visitation," the Boy Christ rushing into His Mother's Arms. The method is new. Everything is veiled and shimmering with broken light; it is as modern as a Besnard. But the formal gold mouldings and minor ornament including the heraldic symbols of the evangelists bind the Baroque vault into a perfect unity with the end wall. Unlike the end wall, which is sympathetically understood, the vault is deeply felt. Here is a paradox, for intellectually Sargent must have been as far from the religion of St.

Ignatius Loyola as he was from the theology of St. Bernard. But Sargent was temperamentally as much a musician as a painter, and his emotional self responded to a form of religious expression which without irreverence may be called nobly operatic.

Fortunately this alcove may be viewed as a unit. It is, I think, Sargent's greatest achievement, that in which he most fully gave all of himself. Technically it has a place by itself as the only modern mural painting that equals in material splendor that of the early Middle Ages and Renaissance. On the spiritual side it is replete with Sargent's perceptive intelligence and warm sympathy and intuitional scholarship. In a moment the chief spiritual product of which was the historic imagination, this is a highly representative work. It is a reconstruction not through archæological data—Abbey was proving the sterility of that in the Grail series in the hall below—but through the invention of symbols fit, though of our time, to express the soul of a time long past.

Were it a question of giving up the alcove of the "Dogma of the Redemption" or all the portraits, I should give up the portraits. Fair equivalents for them could be found; their absence would not essentially change the prospect

of the painting of the turn of the century. But
there is no equivalent for Sargent's finest deco-
ration, and its absence would deprive us of a
capital document for our times.

The desired contrast between the pagan and
Christian ends of the long hall remained liter-
ary and was decoratively unachieved. In the
six great lunettes representing the Apocalypse
and Millennium, Sargent adopted a new
method, or rather returned to the approved
method of the schools. Blond nude bodies,
rather flat modelling, much unifying blue and
blue gray, some gold to echo the formula of the
alcoves—everything is technically right and
able. Gold braidwork about the vaults and
around the dreadful skylights, much of it done
by Sargent's own hands, does its best to make a
decorative unit. The invention of the lunettes
is alert, gracious and always ingenious, the
mood pleasantly theatrical and quite unreal.
There was nothing of the prophet in Sargent,
and he paid off these prophetic themes, as he
paid off many of his sitters, simply with his
manual skill.

Not much more can be said for the great
decorative series in the Boston Museum of Fine
Arts. As an expression of Sargent's athleti-
cism and general fine judgment this great suite

with its relief sculpture and ornament is re-
markable. One is astounded that any man in
the late sixties could in a short time turn off
so creditably so great a task. Everything goes
along safe and established lines without very
heavily taxing invention or attention. Sargent
once remarked to me that all any decorator
could do was to make a place look better than
it did before, and this modest ambition was
agreeably fulfilled in the Museum. The com-
positions greet the visitor pleasantly without
arresting his entrance and exit unduly. To
the historian of art they will be chiefly inter-
esting as proving that the early twentieth cen-
tury could occasionally produce a mural painter
with the executive capacity of a Pietro da Cor-
tona or a Luca Giordano.

Concerning the two big World War panels
in the Widener Library, Harvard University,
silence is kindest. Sargent had lived the war,
had sketched at the British front. It was all
too near him to be symbolized. He should not
have undertaken a task which could only event-
uate in forcing his vein and in patriotic melo-
drama.

Reviewing Sargent's career as a mural
painter, we apparently get quite a different im-
pression from that which Sargent the portrait-

ist yields. We find a reflective, scholarly spirit brooding retrospectively, and greatest in its more mediated efforts. It is a spirit also capable of amazing improvisations, and technical display, but æsthetically insignificant in this phase. It seems as if the cosmopolitan and expatriate with no tangible home in the present found a home for his imagination in the long endeavor of the race towards a righteousness and knowledge not of this world.

Such was his inward avenue of escape. The exit outward was sketching in the face of nature, the dearest pursuit of his last twenty years. In 1903 was published, with an introduction by Alice Meynell, a splendid folio of more than fifty plates after Sargent's portraits. With a very few exceptions it contains all his best portraits, and may fairly be regarded as his lasting monument in this field. Such was his own view, for thenceforth so far as possible he avoided portrait painting, made mural decoration his serious concern and sketching in water color his chief recreation. Though well short of fifty, he had earned his right to go his own way. Not to mention his four or five knighthoods and his membership in half a dozen academies, and a collection of gold medals formidable from mere weight, Sargent

had behind him what for most artists would be a life work. He felt he was losing his touch in portraiture, Mr. Downes tells us. However that be, he had surely lost his interest, and doubtless felt justly that in portraiture nothing but repetition of past triumphs was possible. Despite the "Four Doctors" and the "John D. Rockefeller," this was broadly true.

In water color sketching he developed an extraordinary technical skill. If there were trials and failures, as is to be supposed, he destroyed them. And about the water colors there was not the bitter debate that had raged around the portraits. The aquarelles had a uniformly good press and were bought by scores for our American museums. According to one's standards, these water colors are the most wonderful performances or the most negligible. Possibly they are both. In technical quality, in clean and dextrous application of the pure wash, they are amazing and exemplary. In discovering simple formulas to suggest the most various textures and illuminations they are stupendously intelligent. If the task of the water-colorist be merely to catch the obvious and superficial look of things, there are no better water colors. If, however, his task is to evoke larger truths of nature's structure and essential organization,

these sketches are of small importance. Like the poorer portraits, they are hollow—all outside. From the first I have felt their brittleness, their lack of anything like distinguished mood or interpretation. Their positive quality has always seemed to me to be restricted to their sure and expeditious execution and to the gusto that accompanies it.

All these immediate convictions were emphasized when for the first time I saw, in the Metropolitan Museum, the Sargents hung within sight of other fine American water colors. Not merely in confrontation with the Winslow Homers—dire juxtaposition for any aquarellist—but also in comparison with good average sheets of Gifford Beal, Paul Dougherty, Childe Hassam, John Marin, the Sargents as a group sunk into the gallery walls, lost color, lost validity. There was nothing behind the surface of the paper. It was a somewhat melancholy reflection that through a confusion of fashion with artistic merit, hundreds of such sheets were in transit from museum walls to museum portfolios and ultimate oblivion.

Naturally among a thousand brilliant misses there are a few hits, and these generally are not brilliant. For the water colors as for the

oils the rule holds that the good Sargents are
the sympathetic Sargents. The little outdoor
portraits as a class are admirable, finely felt
and unaffectedly executed. The men in a hay
mow, the girls fishing, the numerous studies of
his friends as they sketched with him, the burly
apparition of himself on a hilltop—these are
the fine Sargent water colors. And in these
expressions of friendship he usually keeps in
abeyance a color sense as audacious as uncer-
tain, falling back upon the safe and simple
harmonies of his early figure studies in oils.

It is unfortunate that the water colors have
been so egregiously overrated. Only rarely en-
listing the serious side of their painter, as the
chosen escape of a great talent, they have their
own interest. They also furthered certain re-
markable achievements in outdoor painting in
oils.

Throughout Sargent was a great talent in
which genius was sporadic. It took genius, if
chiefly of a technical sort, to paint that ex-
traordinary study in sheer illusionism, "The
Hermit," in the Metropolitan Museum. Amid
the cross-lighted confusion of a forest one
gradually makes discoveries—a gaunt hermit,
two gazelles. The eye is not led, as in most
pictures. It wanders in some bewilderment

among shafts of sunlight, never quite coming to rest. Kenyon Cox in "Artist and Public" writes discerningly of this picture. The scene "is rendered as one might perceive it in the first flash of vision if one came upon it unexpectedly. This picture is better than Sorolla— it is better than almost any one. It is perhaps the most astonishing realization of the modern ideal, the most accomplished transcript of the actual appearance of nature, that has yet been produced."

"The Hermit" was painted about 1910 when the "modern ideal" was setting elsewhere, and Kenyon Cox's words were written in 1914, when the flood tide of a new Modernism had become torrential. "The Hermit" is likely to survive successive Modernisms if only for the good archæological reason that it is the consummate expression of the leading ideal of its moment.

During the World War Sargent trudged along the miry British trenches and made a few little sketches of such simplicity and power that one feels a great illustrator may have remained unrealized in him. It is a view which the mural paintings at Boston support, and it awakens a regret that Sargent called so rarely on what was a remarkable capacity for invention. The

Spartan episode of the trenches may well have weakened a heart that before long was going to refuse to serve his stalwart frame.

In 1916, having finished the Library decorations, John Sargent summered in the Rocky Mountains. Amid the grandeur of that scenery and in the unwonted relaxation of camp life he conceived and largely executed a handful of superb landscape sketches in oil and the large picture of Lake O'Hara. It is another of those surprises which his generally standardized production presents bafflingly from time to time. Great in scale and feeling, of American landscapes of this century only Abbott Thayer's "Monadnock," Albert Ryder's fantastic landscapes being obviously out of the comparison, seems to me to equal it in grandeur. It is very American in mood and even in general look, with odd affinities with Bierstadt's heroic landscapes. It has of course a sombre loveliness of color and a sense of moving mists and waters that Bierstadt never commanded or even perceived. It has dignity without either constraint or exaggeration and a rare felicity of workmanship without display of cleverness. I am glad to leave this the final impression of John Sargent's art.

This isolated masterpiece may recall our

initial guess that Sargent's work as a whole may be inferior to his native gift, and that there was a distinct frustration in his career. The causes for this I have already suggested in his youthful experiences, Paris training, and in the exaggerations of praise and dispraise that early troubled a sensitive temperament. It has been no pleasure to me to counter the *élan* of indiscriminate admiration that has followed his death. Yet a chief business of criticism is to distinguish between what is merely fashionable and successful and what is great in art. This I have tried to do in Sargent's case, simply bringing together views which are already on record and which were expressed when Sargent's vogue was at its height.

Whatever was possible for an expatriate American of culture, trained by Carolus and rising to fame in the London of the 'nineties John Sargent abundantly achieved. It was an achievement bewildering in its variety and ability, but in the main uncentral and impermanent. I summon one of Sargent's closest friends to explain why.

Henry James once wrote of the cosmopolitan C. S. Reinhart words that express much of his own case and more of that of his lifelong

friend John Sargent. The quotation may save me a summing up.

"Does the cosmopolitan necessarily pay for his freedom by a want of function—the impersonality of not being representative? Must one be a little narrow to have a sentiment, and very local to have a quality, or at least a style; and would the missing type . . . yet haunt our artist—who is somehow, in his rare instrumental facility, outside of quality and style—a good deal more if he were not, amid the mixture of associations and the confusion of races, liable to fall into vagueness as to what the types are?"

[1927.]

XII

EDWIN AUSTIN ABBEY

EDWIN AUSTIN ABBEY

The career of Edwin Abbey is at once very simple and quite baffling. He was born in 1852 in Philadelphia of New England stock. His vocation as an illustrator developed early, and, after a modicum of schooling in letters and art, he became a general utility man for the Harpers in New York. Those were the old wood-block days. To go into that mill of faking, redrawing, and being redrawn—all in a hurry—might have ruined a much better artist than nineteen-year-old Abbey. Instead, he underwent the drudgery unscathed and with profit. Soon he got better work, like the illustration of Dickens's "Christmas Stories" and of Frank R. Stockton's "Rudder Grange." By twenty-three he had passed out of apprenticeship and poverty and had developed his peculiar gift for the illustration of such old English writers as Herrick and Shakespeare. In this quick progress the great Victorian book illustrators, Houghton, Pinwell, and Millais, were his guiding lights. But he grew into a style quite different from theirs, less austere and

more colorful. The multiplied small lines are beautiful as such, but they readily merge themselves into tone. Probably like Blum and Pennell he had in mind the brilliant pen-drawing of Fortuny. It was fortunate that the new photo-engraving processes were coming in, for such drawings simply defied the best efforts even of the meticulously patient woodcutters of the 'seventies. Doubtless the love of definition and of antiquarian detail sufficiently accounts for Abbey's technique as a pen draughtsman. He wanted not indications, but complete little silvery pictures, and he made them deliciously. Very likely the example of such French pen draughtsmen as Meissonier and Vièrge and of such etchers as Gaillard and Bracquemond counted for something, as may the early work of George du Maurier. In any case Abbey eschewed the precedents of such powerful, summary pen draughtsmen as Charles Keene and Tenniel, though he greatly admired them, and chose a manner in which delicacy and reflection and graciousness were to count for more than strength.

Already Abbey had developed that conscience of an antiquarian which was to govern all his work. He buys eighteenth century costumes and furniture regardless of cost, and when

originals are unattainable has copies made. Yet never an archæologically minded designer showed greater ease. The more pains he took the more graceful was the result. This initial paradox runs through his entire production.

Upon the Bohemian days in New York at the old University Building, and upon the high jinks of the newly founded Tile Club Mr. E. V. Lucas, the official biographer, expands with gusto. This companionable note accompanies Abbey to the end. When he moved to England the best doors went ajar for him forthwith. And no one better deserved friendship. He took pains with it. For years at Morgan Hall he held a cricket week, playing an intrepid duffer's game himself well into middle life and entertaining his entire eleven with unstinted cordiality.

In 1878, being not yet twenty-six, Abbey, having survived perilous farewell feasts from Harpers and the Tile Club, sailed for England with the contracts for half a dozen of his most famous books in his baggage. In England he was to spend most of his remaining thirty-three years as most industrious of artists and most accessible of country gentlemen. In 1882 appeared his first book, "The Songs of Herrick."

It was quickly followed by such charming masterpieces of illustration as "The School for Scandal," "The Quiet Life," "She Stoops to Conquer," "Old Songs," and the perhaps less uniformly successful Shakespeare illustrations. Within twelve years he won his first place among illustrators, had begun timidly to paint in oil, and had married, doing all these things cautiously and well.

In all but the matrimonial venture nothing but repetition was now to be expected. On the contrary, he soon was to cease illustrating and to win an equal prominence as an historical and mural painter. When in 1890 Charles F. McKim commissioned Abbey to do the Story of the Holy Grail for the Boston Public Library he exercised an extraordinary faith and insight. Abbey seemed essentially a little master, a maker of delicious illustrations, an adept at a rather small and idyllic type of water color. Abbey girded himself to the task, assembled a twelfth century armory and wardrobe, and in twelve years the series was complete. Meanwhile, he had astonished one Royal Academy after another with the most vigorous historical narratives, "King Lear and His Daughters," the "Courtship of Richard Crookback," and had painted great decorative idyls like the

"Song of Fiammetta." In 1896 he was elected
an Associate of the Royal Academy and in 1898
a full Academician. In 1902 he was chosen to
paint the Coronation picture, and this seems
almost a prerogative as a Philadelphian, for
had not Charles R. Leslie painted Queen Vic-
toria's coronation?

The Boston decorations are not the greatest
work of Abbey, but they most completely repre-
sent his artistic ideals. He set himself learn-
edly to re-create the century of Robert de
Borron as he had to revive the age of Gold-
smith, Herrick, and Shakespeare. He was new
at decoration and later admitted that the Grail
pictures were too elaborate. They are indeed
rather charming and romantic as episodes than
lucid and compelling as a series. In their ideal-
ism is just a taint of irreality. His very pro-
cedure of painting from made properties and
endeavoring to reproduce the look of so remote
a time seems, however upright, artistically er-
roneous. There is an æsthetic statute of limi-
tations for archæology. The materials rea-
sonably exist for re-creating the look of the
seventeenth century, but not for the twelfth.
Herrick, I think, would feel fairly at home with
the Abbey illustrations and Shakespeare not
too much a stranger, but Frederick Barbarossa

would feel utterly *dépaysé* in the delivery room
of the Boston Public Library, nay indignant, for
he might suspect caricature of the world he was
defending against the Paynims. On the con-
trary, he or St. Francis would accept St. Gene-
viève's world as Puvis spread it on the walls
of the Pantheon without benefit of archæology.

In short, the only artistically available past is
the past that can be visualized in imagination.
Such visualization cannot be effected by col-
lecting data and translating these into proper-
ties and arranging and painting the proper-
ties. The imaginative visualization—Raphael's
Greece, Rubens's Rome, Poussin's Arcadia—
will have a kind of mental and sufficient reality,
whereas the archæological reconstruction will
have at best a Wardour Street illusion of real-
ity. No completely intelligent artist has ever
made Abbey's mistake, for instinct warns him
that the land of legend can only be glimpsed
with the mind's eye. Howard Pyle, who was
much the better mediævalist, once wrote asking
Abbey whether he really saw his settings or
only "saw them in his nut." Abbey wrote re-
provingly, and considerately left the letter un-
posted, for posterity, that he really saw every-
thing, never realizing that it would have been
better to look in his "nut" for them.

This he did tardily in his last great task, the decorations for the State Capitol at Harrisburg. Here everything is simpler and more coherent. Abbey realized that in certain spaces history was impossible and allegory and symbolism imperative. He once cited Raphael's "Jurisprudence" in the Vatican as the ideal of what a noble decoration should be, and the work at Harrisburg echoes that conviction. It is noble and effective, rightly audacious in mixture of reality with symbolism, as in the lunette, the "Treasures of the Earth," with the geniuses of science hovering over actual toiling miners. It is conceived heroically throughout; no American mural painter save La Farge and Vedder and Sargent has done anything as fine. Where it lacks is in scale, freedom and gravity; everything is magnificently thought out, but it is not quite seen.

This great task wore Abbey out. He died in 1911, aged fifty-nine, and the world was the poorer by a very great gentleman and a very distinguished painter. Edwin Abbey seems a case of an exquisite little genius promoted far towards but not quite to greatness by an indefatigable industry, probity, and intelligence. Abbey could do nothing badly. Had the am-

bition seized him, he would have painted an
entirely creditable Last Judgment. He would
not precisely have failed had he illustrated
Dante, but nature plainly intended him for an
illustrator of Sheridan and Herrick. He is
most delightfully himself in the lovely draw-
ings for "Old Songs" and "The Quiet Life."
Posterity will remember him vividly by these
things when it has to consult its guidebooks to
make sure who created the decorations at
Boston and Harrisburg. He was one of the
great nostalgic talents, true *confrère* of his
friend Austin Dobson. The nostalgic artist
must somehow make a home for himself, and,
when made, he leaves it with some peril. Abbey
found his real home in the England of our
great-great-grandfathers and so wholly pos-
sessed it that no eighteenth century English
illustrator gives an equal conviction of the more
gracious realities of that age. He is more real
than the documents he so intelligently con-
sulted. That in venturing far from his true
domain he not only did not meet disaster but
even achieved measurable success is an impres-
sive tribute to his industrious and flexible talent.

Indeed, the exemplary value of this rich life
so fully and genially celebrated by Mr. Lucas is

precisely that it shows how far an artist may go with a limited allowance of genius, if only his store of grit, patience, taste, intelligence, and perseverance be large enough.

[1922.]

XIII
KENYON COX

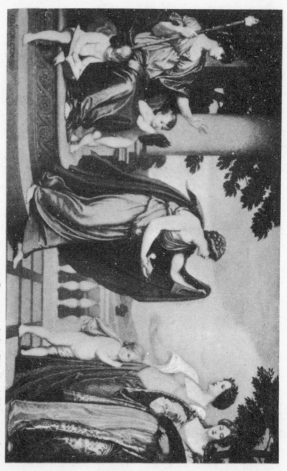

KENYON COX

To estimate the personality of a man with whom one has had relatively short acquaintance may seem impertinent. Yet any criticism is perforce an estimate of personality, and that of Kenyon Cox was too masterful not to have a public character. When hardly out of the École des Beaux-arts, a struggling young artist in his late twenties, Kenyon Cox began to be a legend and a portent. People admired him and feared him; in his regard, no one thought of being lukewarm. He was one of that group of modernly trained young men from Antwerp, Munich, or Paris who perturbed and eventually dominated the old National Academy through the transient rivalry of the Society of American Artists. The treatment these honest reformers received is one of the mysteries of the history of American taste. Without difficulty they got social and critical approval, everything but purchasers. For a generation, under the tactful coaching of the dealers, the collectors of New York had bought dearly the "conscientious nudes" of Lefèbvre and Cabanel, not to

mention Bouguereau. Why they should have ignored the equally able academies of Cox is not easy to fathom. Why the critics should have cavilled at these very skilful exercises of Cox, while applauding the precisely similar achievements of his Parisian exemplars, is again mysterious. Perhaps it seemed right for Frenchmen to indulge a taste for the academic nude, but wrong for an American. Or with a subtler epicurism the connoisseurs of our by no means naughty 'nineties may have felt that a conscientious nude, like a cask of sherry, needs a sea-voyage to make it desirable. However that be, Cox, like most of his artistic contemporaries, was driven back on teaching, writing, lecturing, illustrating, meanwhile, in neglect, laying the solid foundations for future success as a mural painter.

In neglect but not in obscurity. As a teacher in the Art Students' League and committeeman or official of the Society, his influence carried far. He was an embodied conservative conscience, a stalwart and dreaded champion of the great traditions of painting, a dangerous critic of successive new schools and fads, a formidable foe of every sort of sloppiness. The times were fairly sloppy, so he was not popular. It was a lot which he accepted, because he was

thoroughly honest and fearless, and because it
was the condition of his loyalty to what he be-
lieved the great tradition. His death must
have caused relief if not rejoicing among the
wild-eyed inspirationalists of Greenwich Vil-
lage. For them he was an uncomfortable per-
son to have around.

Cox came of extraordinary ancestry. His
mother was the daughter of Doctor Finney, the
great evangelist, and first president of Oberlin
College. His father, Jacob Dolson Cox, had
an amazingly various career. He was a Civil
War major-general in the field, and later one
of the best historians of the war; governor of
the State of Ohio; and later senator and con-
gressman; secretary of the interior for Grant,
forced out of his place for resisting land-grab-
bing; president of the Wabash Railroad and of
the University of Cincinnati. As if that were
not enough, he was a lawyer, an admirable book
reviewer for the *Nation,* a renowned microsco-
pist, and had an uncommon knowledge of
cathedral architecture. With all this versatil-
ity, he was a man of most stable competence
and of highest integrity. To be born of such
a father is a patent of intellectual nobility.

Kenyon Cox was born in Warren, Ohio, in
1856. The rich and pleasant scenery upon

which his eyes opened was the subject of one of his rare landscapes, a beautiful picture called "Passing Shadows." His formal education was much hampered by illness, though in such a family as his the training of home was the best of educations. His chieftain father came back from the war to find the tall lad in bed. From his ninth to his thirteenth year he was bedridden, at times in peril of his life, and periodically under the surgeon's knife. To this deprivation of the usual activities of boyhood one may ascribe a sort of bodily ungainliness, oddly contradictory of the robust pattern of his mind. On acquaintance this paradox worked as a charm.

From early childhood his calling as a painter was manifest, and from his fourteenth year he was allowed to take drawing lessons. At twenty he sojourned for a rather unprofitable year in Philadelphia, at the Academy School, and at twenty-one, 1877, he sought the land of painter's promise, and Paris. Beginning with the master most in vogue, Carolus-Duran, he left him in a year for the severer tutelage of Gérôme. From 1879 to 1882 he was an exhibitor at the Salon. He returned to New York in that year, being twenty-six years old, was immediately elected to the Society of Amer-

ıcan Artists, and soon became prominent in its
schools and councils. He had pursued with pas-
sionate conviction the academic study of the
nude at Paris, and continued it in New York
against the difficulties we have already noted.

With the plain man's disinclination to hang
the academic nude in his home, I have consid-
erable sympathy. He is naturally offish toward
what he suspects is an exercise or a show-piece,
and at best a hussy without clothes. The New
Yorkers of the 'eighties and 'nineties, perhaps,
deserve less blame for their uncovetous ad-
miration of Cox's very able exercises than for
the snobbishness with which they bought en-
tirely similar and by no means better academies
only because these were made by European
artists. Cox was really preparing himself with
dogged grit and intelligence for his ultimate
work as a mural painter. One sees in these de-
signs the struggle for freedom through disci-
pline. And half a dozen of these nudes he
hardly surpassed.

A discerning person might have inferred this
from his delightful and too little known illus-
trations for Rossetti's "Blessed Damozel,"
1886. Meanwhile he achieved a few figure
compositions, such as "Moonrise," which will
be more valued as time goes on, and did occa-

sional portraits of character and distinction. In some fifteen years of purposeful effort, without attaining vogue, he attained what is more difficult—personal authority. Then his chance came as a decorator, at Bowdoin College, in the Appellate Court, New York, at the Columbian Exposition, Chicago, and in the Congressional Library.

In these new and unproved activities, as he has himself written, his development was characteristically slow and thorough. The color he had learned in the Paris schools and the habit of representing the model rather literally had to be foregone in favor of colors and forms suitable for intricate compositions and great wall spaces. His whole practice had to be renewed in the light of the great masters of monumental design. Too robust to seek the solution of bleached tones, with the followers of Puvis, he turned to the Venetians, Titian and Veronese. Since Rubens and Vandyke probably no artist has studied them more penetratingly. He believed that their richer forms and colors and intricate rhythms in depth were more suitable for our modern ornate buildings than the paler hues and simpler forms based on the primitive masters of fresco. In his practice, as later in his writings, he scouted the idea that mere flat-

ness and paleness were in themselves decorative
necessities or decorative merits. I have often
heard him laugh at the current notion that
Veronese or Delacroix or Paul Baudry lacked
monumental quality in comparison with Giotto
or Ingres or Puvis. In such a view Cox stood
almost alone. Though the unobservant took
him as a formalist, he really was the foe of too
narrow formulas whether old or new.

From the year 1900 or thereabouts Cox's
decorative style assumed more urbanity and
sureness in design while his color grew richer
and more unified. I have not had the good
fortune to see Cox's best decorations in place,
but I did see the growth and promise in such
works as the lunette "The Light of Learning"
at Winona, Minnesota, when it was being fin-
ished in New York. Its beautifully calculated
rhythms are both easy and noble, its color
resplendent. Even more ingratiating are the
little lunettes for the Iowa State Capitol.
There are fine decorations in the court-house
of Wilkesbarre, Pennsylvania, and mosaics and
wall paintings in the State Capitol at St. Paul.
For these learned and gracious designs I doubt
if Cox ever got approximately due credit out-
side of the pages of *Scribner's Magazine*.

It is fair to say that the few competent news-

paper critics are naturally embarrassed before
the absurdity of judging a mural decoration in
the studio. The appraisal naturally belongs to
the art critics where the decoration abides.
Unhappily, regions that can very well afford
mural painting cannot afford critics, so many
of our most noteworthy mural decorations
never receive adequate criticism at all. Kenyon
Cox had even worse luck in the grudging char-
acter of the mention he did get. He had been
too long an Aristides, and the critics usually
slurred him without intelligence. I present
with only the comment of my own italics a pas-
sage which illustrates the journalistic formula
for judging a Cox. It was written, it doesn't
matter by whom, on Cox's "Marriage of the
Atlantic and Pacific" at St. Paul. "One might
have wished, *despite the beauty of design in-
herent in his work,* that Mr. Cox had chosen a
less formal method of treatment."

Kenyon Cox was an art critic himself for a
matter of twenty-five years, and it is safe to say
that in all that period of work, and often of
hack work, no sentence like that ever dribbled
from his pen.

He early won his spurs as a writer by becom-
ing a staff reviewer for the *Nation.* To *Scrib-
ner's* as well he was a frequent and welcome

contributor. From 1905 begin his remarkable
books collecting his periodical essays or em-
bodying his lectures: "Old Masters and New,"
"Painters and Sculptors," "The Classic Point
of View," "Artist and Public," "Concerning
Painting." It was an unusual type of criti-
cism—forthright, clear, emphatic. It drove
straight to main issues, avoiding subtleties and
by-paths. It was so clear and accessible that
it was easy to underestimate its literary merit.
I have heard the work dismissed as obvious.
Such a judgment misses entirely the athletic
compactness of Cox's English as it does the
fine energy of his thought. There never was
a greater error than to dismiss him as a cold
person; he loved and scorned tremendously.
Right-mindedness was a passion with him.

On the positive side Cox has left us un-
surpassed appreciations of Veronese, Corot,
Millet, Holbein, Saint Gaudens. These essays
seem to me already classics in a field in which
classics are few. The various studies of Rem-
brandt and that on Michelangelo add some-
thing to these well-worn themes. Whatever
theme he touched he enriched. Leonardo da
Vinci, Raphael, Vermeer of Delft, Puvis—
much bewritten as these masters are, Cox sup-
plied fresh points of view. It is not safe to

neglect even the shorter essays and notes, most
of which were taken over from the *Nation*. On
Whistler and Burne-Jones, for instance, no
one has written with more justice and dis-
crimination.

Again, on the constructive side, Cox treated
the whole matter of the education of the artist
and of the right relation of artist to public.
Here, against the headlong individualism of the
day, Cox took his stand on the side of a tradi-
tional and social art. The idea that the artist
could find all necessary warrants in himself he
rejected as sure to lead to eccentricity. To
such barbarous self-assertion he opposed the
Classic Spirit. "It is the disinterested search
for perfection; it is the love of clearness and
reasonableness and self-control; it is, above all,
the love of permanence and of continuity. It
asks of a work of art, not that it shall be novel
or effective, but that it shall be fine and noble.
It seeks not merely to express individuality or
emotion but to express disciplined emotion and
individuality restrained by law." Such doctrine
was naturally poison to young people who with
neither knowledge of the past nor vision of con-
tinuity nor respect for law were trying to slap
their souls rapidly on canvas. What could they
make of the great half-truth, "The only study

that has ever greatly helped the designer is the study of design as it has been practiced before him"?

On the all-pervasive Impressionism, the success of which within its proper limits Cox generously acknowledged, he wrote: "Impressionism, which makes light its only subject, and ruthlessly sacrifices clarity and structure in the interest of illusion, is acceptable in inverse proportion to the essential beauty and interest of the objects represented." For the rest he felt that the handling of the Impressionists was often brutal and ugly and hindered the attaining of a modern technic.

To note the limitations of Cox's manly and pondered criticism is, perhaps, to repeat the error of the scribe who at once admitted that one of Cox's decorations was beautifully designed and in the same breath wished it quite otherwise. Cox necessarily missed certain finesses of appreciation which one finds in such all-viewing masters as William C. Brownell and John La Farge. Being almost impeccably right, as it seems to me, he was sometimes right on terms of an artificial simplicity. His intense perception of general principles sometimes colored unhappily his particular judgments. He so loathed muddle-headedness that he insuffi-

ciently admitted that irony of life by which a quite wrong-thinking person may act rather well, while an artist with false ideas or none in evidence may do very beautiful work. He was so resolute in condemning what seemed to him subversive theory that he sometimes swept under the indictment rather notable works. Thus he did scant justice to Rodin's real greatness, it seems to me, largely because Rodin had unwittingly demoralized the young generation of sculptors.

But despite all these reservations the bulk of Cox's critical writing seems to me sound and hearty and permanent. To read contemporary criticism after fifty years is usually to thank God that we are not as other critics were. I don't think Cox will give much basis for this kind of complacency, say, in the year 1968. I believe his occasional reader then will rather marvel how so much fighting energy and conviction could be combined with so catholic a taste and so delicate an insight, and will marvel the more that these books with their fairly eighteenth century ease and lucidity could have come out of the welter of the early twentieth century.

From the competent, Cox never lacked honor. He was chosen an associate of the

National Academy in 1900 and a full member
in 1903. He was medalled by the Salon, the
National Academy, the Architectural League,
and at the recent world expositions. He had
honorary doctorates from Oberlin and Dart-
mouth and was an early member of the Amer-
ican Academy of Arts and Letters. He be-
lieved in organization and authority and
worked indefatigably in conservative propa-
ganda on the lecture platform or in the drud-
gery of art juries and committees. He had
force and discretion, was a natural leader. No
doubt, had occasion served, he would have led
a brigade in the field as competently as his
father did. His failure to gain from young
students the confidence his lay contemporaries
gave him was due to the fact that his teaching
countered sharply the restless spirit of the
times. Indeed, few of the art students of the
'nineties had historical background enough even
to know what Cox was driving at. For such
isolation there was balm in the fact that he was
able to nurture a delightful painter's gift akin
to his own in a wife and a son.

Dying at sixty-two, Kenyon Cox's career as
a painter snapped in the years when an artist
of his reflective type is just coming to his own.
Every mural design was finer than the last, his

practice was gradually measuring up to his
high and arduous theories. Hence there is
especial tragedy in his cutting off. What he
had done up to his fiftieth year seems merely
preparatory to great mural design, and it is
only within ten years that he had been doing
work that relatively satisfied his ideals. Hence,
considerable as the work is, it is fragmentary
as compared with what it might have been had
strength and long years been granted to him.
His was a painstaking and gradual develop-
ment like that of certain of the old masters—
Dürer, for example—whom he loved. Such
artists rarely give the full measure of them-
selves in their painting. So I feel it is with
Cox. Whether in his pictures or in his writings,
the future will have difficulty in realizing the
massive and brilliant integrity of the man who
is gone.

[1918.]

XIV
ALDEN WEIR

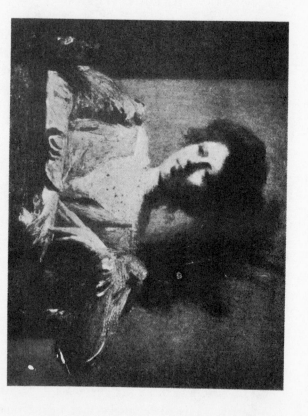

ALDEN WEIR

The late Alden Weir carried into American painting a quality of æsthetic conscience akin to that of Mr. Howells, and Henry James in his early phase. To make a precise and delicate record of observation was his aim. Whether his theme were a New England factory village, a bunch of roses, or a finely bred American girl, he sought to tell the true truth of the matter. While insisting on its main characteristics, he neglected none of its shades and overtones. Thus his painting, while technically austere, was mentally very rich. He saw more than most painters, and he saw better. While he had the best training of the Paris schools, there never was a more American spirit, but American in a peculiar and limited sense. From the new America of immigration and quantity production he stood quite apart.

His task was to fix the survivals of an older America. His little towns that nestle quietly in their river valleys, amid maples, are such as Thoreau loved to sketch in prose or Whittier

in verse. They have a frail, intense charm. Similar is the character of that notable gallery of young girls. They are fine and earnest, trained in scruple and nicety of thought and conduct. They are the descendants of Miss Catherine Sedgwick's heroines, and of Mrs. Harriet Beecher Stowe's—as rare in their somewhat brittle perfection as a Colonial meeting-house rising amid blast furnaces of yesterday. An observer of any imagination will ask: Will their daughters be like them? or are they the last wintry flowers of an autumn forever past?

Alden Weir was too much the artist, too good an eye and too fastidious a mind, to obtrude such legitimately sentimental considerations. These things are implied rather than underlined in his painting, but they are always there. And they give to his art a quality of race, which makes it unique. No one not an old American can understand the element of delicate truthfulness in his portraiture whether of persons or places.

To express this vision he made the fullest and most discreet use of all the resources of the new impressionism. Born May 30, 1852, at West Point, he had his first training from his father, an excellent historical painter, and

instructor in drawing at the Military Academy.
Alden Weir early followed the new current to
Paris. From 1872 his talent and his extraordi-
nary masculine beauty, as of an athlete by
Polyclitus, soon made him a marked person-
age. He worked under the best of the aca-
demic teachers, Gérôme, and soon attained a
style of great ease. In the age of the *morceau
bien fait,* few could handle the brush with
more elegance. Occasional flower and game
pieces survive to show that Alden Weir could
have rivalled Chase in the creation of lovely
surfaces and textures. But there was some-
thing to express that could not be compassed in
that fashionable mode.

Returning to America in 1876, Alden Weir
undertook the long task of reshaping an estab-
lished style in the light of the new luminism.
His mature pictures are built in an infinity of
strokes and tones. The surface constitutes a
restrained iridescence between the observer and
the object. Unlike the Parisian luminists, he
never forsook the determined contour and the
well-calculated pattern. His method was often
unfavorably criticized. People complained of
the kneaded and dissociated quality of his tex-
tures. The same objection was made to the
very similar technic of George Frederick

Watts, who in the decorative, as Weir in the luministic field, built up his pictures by insensible increments reflecting his own thoughtfulness. Current criticism never is quite just to pictures that to attain their end must be much thought over and worked over. All the world loves a juggler, in whatever art.

To Alden Weir came a slow and solid recognition. The National Academy made him an associate in 1885, and a member in 1886. He was a leading figure in the Society of American Artists, and later in the Ten American Painters. He was for several years President of the National Academy. While his practice was early crystallized, his taste remained liberal. He was unafraid of the new experiments and eccentricities, having a quiet confidence that in the long run the more excellent methods would prevail. Probably no artist of our day in America was more generally respected or more genuinely admired by both conservatives and radicals. Among his peers he was an imposing and a winning personality—strong, sensitive, resolutely honest, courteous without affectation or compromise. His pictures are in the Luxembourg and our best American galleries. He had full and deserved meed of honor and regarded it modestly as merely an

incentive to new endeavor. Even in his latter invalidism, he retained much of that classic beauty which is perpetuated by Olin Warner in one of the greatest of American portrait busts.

It is too early to appraise Alden Weir's accomplishment justly. No one but his friend Twachtman has expressed so well certain evanescent appearances in our American landscape. His series of women's portraits breathe training and discipline in pictorial intimations which are paradoxically precise and subtle. Whatever his final position as a painter, he has been immensely significant to us of older America. It is not likely that he will be wholly neglected by the new America which apparently is about to fulfill or supersede us.

[1919.]

XV

WILLIAM M. CHASE

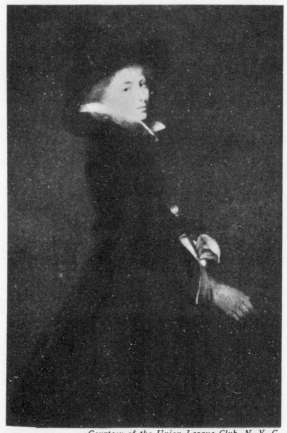

WILLIAM M. CHASE, "Ready for the Ride"

WILLIAM M. CHASE

William Merritt Chase, who died, in 1916, in his sixty-seventh year, with energies unabated, was the ablest painter of face values that America has yet produced. It probably never occurred to him to paint what was not before his eye. He saw the world as a display of beautiful surfaces which challenged his skill. It was enough to set him painting to note the nacreous sheen of a fish, or the satiny bloom of fruit, or the wind-smoothed dunes about Shinnecock, or the fine, specific olive of a woman's face. The patination and texture of things aroused not merely his admiration, but his will to possess. He drew unceasingly into his home and his several studios thousands of bits of old brass and copper, less resplendent but more precious pewter, floor weavings of the Orient, wall weavings of France and Flanders, mellow old pictures, barbaric jewelry. Ruskin used to carry a few uncut gems in his pocket; Chase made a background for himself of such material. His eye was feline, caressing, and requiring to be caressed.

It is difficult to refer all this to Franklin, Indiana, where he was born, November 1, 1849, or to Munich, where he got his first serious training in art. He adopted rather the notion prevalent in Paris of the 'sixties that art is a fine manufacture. How he got this from his rather dull master, Wagner, and his only slightly clever master, the younger Kaulbach, is a bit mysterious. Very likely, Chase took the idea to Munich with him, confirming it at Paris en route. As a young portrait painter at St. Louis he had had his chief success with his still lives. Throughout his career he would either limber up or rest up by producing masterpieces of this order. He seemed most himself when the problem was simplified to one of eye and hand. His art was complete before he was thirty, and never greatly varied thereafter. He was medalled at the Centennial Exposition in 1876, being twenty-seven years old, and constantly won new honors. Despite a truly American shrewdness and unfailingly American sympathies, he became somewhat an exotic in walk and conversation. Through the 'eighties and 'nineties his flowing cloak and his flat-brimmed "cylinder" astounded the New York philistine as fifty years earlier Théophile Gautier's red waistcoat had scandalized the *bourgeois* of

Paris. But the somewhat bristling and Meph-
istophelian front of Chase covered a very
real wit and geniality. He was an ornament in
all company, a true citizen of the world.

The year 1876, his twenty-seventh, was
crucial. He could have had his appointment
at the Munich Academy as a Herr Professor,
but he came back to New York instead to be
the first instructor of the newly formed Art
Students' League. It is significant of the
modern divorce of art from economics that,
whereas it is very difficult for an artist to make
his living by practicing his trade, it is quite easy
for him to make a living by teaching others to
practice it. Chase may have become a teacher
chiefly for prudential reasons. But his theory
that painting is a fine manufacture implied that
it could and should be taught. Into his teach-
ing he threw himself with rare wholehearted-
ness. If art should be discreetly manufactured,
by the same token it should be skilfully ex-
hibited and profitably sold. With entire con-
sistency, then, Chase associated himself with
that Society of American Artists which in 1877
began to claim for new talent a place on the
line. With much ability he served the Society
as its president from 1885 to 1895. Mean-
while he had painted some of his best portraits,

the "Woman in Black" at the Metropolitan Museum, the "White Shawl" at Philadelphia.

When this militant phase as an organizer was over, he set up his own art school, in 1897. It had and still has extraordinary success. It expanded in many directions. Shinnecock Hills, not yet holy ground for golfers, blossomed every summer with feminine talent. Chase varied the routine of teaching by recreations which involved personally conducting eager hordes for summers amid the art and nature of Holland, Italy, and Spain. It was a distinction of the Chase School that the master honestly tried to teach painting. Most art schools have taught drawing. Apparently the personal dictum of Ingres that anybody who can draw can paint well enough had frozen into a universal dogma. Chase rejected it. He strove to make his students see as painters. The color was to be the structure. Chase carried his pupils as far as he had gone himself. He was formed before the inventions of Manet and Monet had gained credence, and before the still more revolutionary procedures of Cézanne had declared themselves. To most of the problems of open-air illumination he was quite oblivious. He liked an attractive object that would "stay put" in the equable light of a studio. His art

at its best lies very close to the more sober
phase of Fortuny. The aim is merely fine and
just observation, with swift and delicate execu-
tion.

Once asked how he got his sombre richness
of color and fullness of form, the great Courbet
answered simply: "I take pains with my tones—
Je cherche mes tons." By Chase's time the
modest tones had become the "Values," with
a very big V. He was their American Apostle.
As a practical counsel this meant that appear-
ances must be re-created in paint according to
that optical law by which we grasp an object
through interpretation of its salient, colored
planes, the task being to read from these planes,
the farness or nearness and the structure of the
object. In a rough and ready way the average
eye does this unconsciously, but the artist has
to do this very consciously and delicately, since,
where the layman need only identify, the artist
must represent. Hals and Velasquez had
carried this research far, and Manet had re-
newed it most brilliantly. Chase made of it an
æsthetic and almost a religion, prudently seek-
ing the values in the stable luminosity of the
studio, while Theodore Robinson, John H.
Twachtman and young Childe Hassam were
more audaciously pursuing the quest out of

doors. It was the main endeavor of the last years of the nineteenth century.

Given their belief that the business of painting is representation, it is impossible to quarrel with those who held that appearances should be dealt with according to their own laws. And it would be ungracious to minimize triumphs in representation which meant its exhaustion as a leading principle. When Chase was painting the alert and gracious Lady in a Riding Habit, in the Union League Club, Cézanne was painting those uncouth and generalized portraits which powerfully asserted that art was now to be transformation, that the hard-won values were obsolete, that the appearance was now to be dealt with according to human laws which were not necessarily its own.

It must have been about 1908, at Florence, when I used to chat with Chase, escaped from his disciples, over a glass of beer at Reininghaus's. Leo Stein had already appalled me with his portable gallery of Matisses, Cézannes, and Gauguins, but I never broke the word to Chase. He talked delightfully about everything, with now and then a return to the old masters. We were both dodos *sans le savoir*. But there is no shame in being a dodo, and as such Chase played his part magnificently, and

after all legend usually holds the dou_ _onger
in memory than it does the bird who supersedes
him. I think it still a good bet that Matisse
may fade out of the future histories of paint-
ing sooner than Chase. It was probably the
teacher in Chase that prevented his even con-
sidering the new movements. The values could
in a manner be taught; there was a training
that reached to it. The bewildering transfor-
mations cried about by Expressionist, Cubist
and Futurist, evidently could not be taught, and
were no affair of his. Indeed as a champion
of a closed system in the face of many varieties
of revolution, Chase acted very well,—kept his
temper, let the world wag, continued to pursue
the values more delicately than his many rivals.

Being, as he was, distinctly of the school
of the *morceau bien peint,* he was free from
its besetting sin of showing off. The amiable
ostentation which was in his personality he kept
out of his art. There is a sobriety even about
the most prodigiously clever Chases, even in
those amazing codfish of his later years. His
hand never goes off into sheer flourish. It is
restrained by the loveliness of the thing, by the
conscience that will not enlarge on its personal
discovery, but will give true record.

Since Chase's concern was with beautiful sur-

faces, his art is necessarily one of epidermis. He avoided the syncopations, the sheer emphasis of structure, to which Manet had shown the way. He took objects quite at their face value, and rarely invested them with the tenderness, mystery, and understanding that comes from meditation and remembered feelings. He accepted to the full the Impressionist convention that every time is a first time, though otherwise he took nothing from Impressionism. We get in him a fine, bare vision, and must not expect therewith much contributory enrichment from mind and mood. He admired especially those painters whose eye is keenest, with mood in abeyance, Frans Hals and Velasquez.

So there are no great Chases, but there is a singularly fine and even accomplishment. His was an extraordinarily well-utilized talent. His pictures always suggest high analogies. To repeat the distinction of his finer portraits one must go to the best of Carolus-Duran, the early charming Carolus; in our time only Alfred Stevens has surpassed the cosey richness of Chase's little interiors; while the still-lives perhaps have no rival in our day for competent literalness. So far as we know, Chase never painted a decoration, nor desired to do so; never told a story in paint, rarely chose any

subject that anybody else might not have seen. His superiority was merely to see it more clearly. In the lucidity with which he accepted these limitations he was eminently of his generation. The defect of his art is its professionalism, its savor of the studio. Few artists of our time have done more successfully what they set themselves to do. Chase believed art to be a fine manufacture, and in his hands it became such—a manufacture intelligently and delicately fine. To lovers of things his art will long keep its appeal. Few men have painted surfaces better. The time will come when men will marvel at such a degree of specialization in the artist, and in Chase's case the marvel, doubtless the regret, will be accompanied by an unwilling admiration.

[1916, 1930]

XVI

ARTHUR B. DAVIES

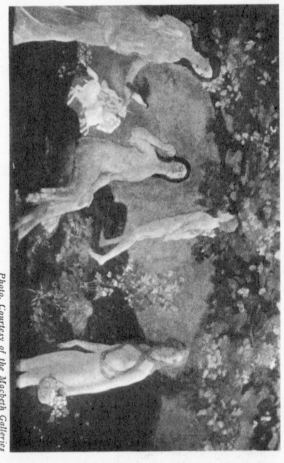

ARTHUR B. DAVIES, "Under the Bough"

Photo. *Courtesy of the Macbeth Galleries*

ARTHUR B. DAVIES

We do not so much criticize works of art as endure their criticism of ourselves. For they are created by finer perceptions than our own. Thus our attitude towards them reveals unsparingly both our capacities and our limitations. By this test, on my first contact with A. B. Davies' work, I failed. So I begin this essay on him in a spirit of contrition.

It must have been about twenty-seven years ago that I first used to see Mr. Davies' charming pastorals in Mr. Macbeth's old basement gallery. How could I have hardened my heart to these visions of children and lovers at play, dalliance, or pure meditation, amid verdurous fields? My judgment approved their attractions of clear and rhythmical arrangement and of glowing color, but my heart refused to accept the visionary mood. This only meant that I was an up-to-date young man and thoroughly indoctrinated in the false æsthetic of the 'nineties. We had been taught to suspect any art that was charming. For us the business of the painter was to convey with a certain

grimness the look of things. There was no feeling of things which the artist need regard. That way lay sentimentalism and the Royal Academy.

Probably I should after all have learned better had I seen the early work more thoroughly and often. Certainly such a picture as "Rose to Rose" would have captured me even in those days of professional *sangfroid,* and the exquisite torso of "A Girl Washing" must have convinced me that Mr. Davies too had, when he chose, an extraordinary eye for the look of things. But my visits to Mr. Macbeth's delectable basement were too rare, and I was not to see these admirable and lovely pictures for a matter of twenty years. Meanwhile it grew on me that Mr. Davies' exquisite vision was rightly his own, that he recked little of our look of things, that his world was only to be experienced in his pictures, and that I wanted to experience it. Into his world, then, I gradually entered after much shamefacedness and holding back.

For meanwhile I was learning that a person of taste is not necessarily a Claude Ireson, and was becoming aware of a certain inconsistency in my own likings. Surely if I lived happily in such dream-worlds as Giorgione's,

Watteau's, Monticelli's, my offishness towards
Mr. Davies could only be due to the fact of his
being alive after Manet's decease. Not even
the grim and humorless æsthetic in which I had
been bred could prevent my discerning the
snobbery of so untenable a position. So I ca-
pitulated very gladly to Davies of the idyls.

And then he drew away from me provok-
ingly. It must have been about 1903, when I
was beginning to write art criticism for the
New York *Evening Post*. Mr. Davies' color
changed from luscious azures and scarlets and
greens to spectral grays and blues. His paint
no longer glowed like that of the old Venetians
from the canvas, but became a pearly veil into
which one had to peer. And the mood changed
as signally—no longer bevies of youths in in-
timate fellowship on verdurous meads, but
enigmatic figures related to each other only in
pattern and rhythm, a tenser and less easy con-
tour with a new tendency to push posture and
proportions askew, but always expressively.
Everything was more aloof and more impor-
tant.

Fortunately I had by this time learned
enough not to reprehend Mr. Davies for work-
ing still further away from the look of things.
It had dawned upon me that representing the

look of things was only a small episode in the
long course of art, and possibly a not very im-
portant one, much art of the past having only
a bowing acquaintance therewith. And surely
I should have put it to Mr. Davies' credit that
he had become more serious and distinctly less
charming. As a matter of fact, I grieved over
him publicly, surmised that he was consorting
with Blake of the "Prophetic Books," wherein
I was doubtless right; and advised him against
such perilous association, wherein I was as
surely wrong. I admired the new work greatly,
and wrote loyally to that effect, but a tinge of
eccentricity and preciosity in it made its com-
plete enjoyment difficult. However, I still
recall vivid pleasures from that time. For
example, after three years with the old masters
in Italy, I happened on a Davies at the Venice
International of 1909 and wrote:

"Very delicious I found A. B. Davies' 'After
Supper'—a spectral group of little girls pro-
filed against a steely estuary beyond which
soars a ghostly New York. Davies is a con-
stant surprise and joy for the variety he con-
trives to employ within his well-marked man-
nerisms: There is about this little picture an im-
aginative quality and a beautiful strangeness in

arrangement and color that fix it in the memory."

And indeed after fourteen years I can still see and enjoy this once-seen picture by simply closing my eyes. As to the rest of the hurriedly scribbled notice, I believe it is still sound as to Mr. Davies' art in general. We have to do with exquisite mannerisms which are the flavor of the man, the flower of his art, and apparently its limitation.

When I returned from my three years with the old masters, about 1910, I found that Mr. Davies' art had again broadened. We now had to do with those vast mountain panoramas inspired by the Sierras. The little Arcadia of the early pastorals had become gigantic, cosmic. The closely grouped poesies—to use the good old Venetian word—had given place to wandering ambiguous nude forms—tiny pale flashes amid the pale vastness. Sometimes the tiny nudes formed in processional arrangements, carrying a crisp undulating rhythm below the larger angular serrations of the mountain tops. Again, the outgoing stretch of the sea, with crinkled surf near by, served as foil for similar processional groups on the strand. Here was a world with certain drastic intimations of the look of things, but of things perceived solely

in terms of rhythm, a world very unlike that which the rest of us see, yet credible from its spaciousness, and fit habitation for the unclad forms whose only business seemed to be to exist musically.

And the music itself was now a tense and solemn one. You get it in quintessence in the nude or lightly draped figures of this time which step out of the greater compositions and become pictures in their own right. They have a suppressed eagerness which is written in the athletic tension of their beautifully drawn contours. Nobody of the time except Degas had the gift of making every millimetre of a bounding line, which was also a modelling line, eloquent. And I suppose that it is this capacity for emotional and intellectual concentration that makes Mr. Davies the great artist he is, and I also believe that if he could further concentrate, to the point of entire self-forgetfulness, nothing would be denied him.

I do not remember how long Calderon's prince, for whom life was a dream, stayed in his tower. Mr. Davies remained in his ivory tower until he was past fifty. But when, in 1913, he stepped out as Director of the Armory Show, the creaking of the well-encrusted hinges sounded from ocean to ocean. And indeed Mr.

Davies' first and only public gesture was a most gallant one. He gave the new extremists their first chance for comprehensive exhibition in America, but he also subjected them to the company and criticism of whatever vital painting the nineteenth century had produced. More thinking has been devoted to painting in the ten years since the Armory Show than in the preceding century and a quarter of our existence as a nation. Mr. Davies' career as a super-showman was assured. Most men, under the pressure of deserved flattery, would have dwindled into presidencies. Not so Mr. Davies. The doors of the ivory tower came together most silently and have remained closed ever since.

It was inevitable that Mr. Davies, ever an ardent experimentalist, should take account of the new movements, and it was probably inevitable also that he should be a little dazzled by them. Far too intelligent to hope that mere programmes ever produce great personalities, gifted himself with the most intense capacities for feeling, and, withal, habitually critical of his own emotions, he naturally kept clear of the barbarous and morally untidy tricks of Expressionism. In cubism, with its laboriously ingenious analysis of forms and its highly intellectualized symbolism of mass, he as naturally

found something attractive. It was character-
istic of his eminently reflective spirit that he
refused to go the whole way with Picasso and
his cubist associates, merely investigating what
the new geometrical methods might contribute
to his own decorative practice.

What emerged was something that the real
cubists repudiated, but something in its own
way very interesting—a reinforcing of the old
strong rhythm of contours by a new interior
rhythm. More simply described, Mr. Davies
merely carried the incoming curves of the
figures across the forms, the intersections of
these refluent curves forming a vigorous net-
work, certain meshes of which could be en-
livened by abstract tone or color. What one
had was simply a novel enrichment of the old
patterns and a step towards a color that was at
once gayer and more conventional. One may
study and enjoy the experiment in the numer-
ous lithographs which date from the last dozen
years. The formula is usually to superimpose
upon a positive and semi-naturalistic rhythm a
veil which has an accordant but much subtler
rhythm of its own. The most audacious reali-
zation of the endeavor was in two large panels
of madly dancing figures shown about nine
years ago at Montross's. Here the veil was

as garish as a tartan, and as stimulating. Of this cubistic episode generally, I think that, while the experiment was brilliant and the works always distinguished and interesting, they were less satisfactory than those which preceded and followed. Yet Mr. Davies was not to quit cubism without getting some permanent advantage from his adventure therewith. His decorations for a private music room in New York rest in part upon cubistic devices and are perhaps his most memorable single achievement.

The problem was to make something of a rather small oblong room with windows, three solidly panelled doors, two connected by a long and narrow bracketed bookshelf, and a rather ugly black marble fireplace. The walls are much cut up, and only that which is opposite the window affords a generous space. Everything seemed to indicate an arrangement of small figures. But Mr. Davies characteristically did the unexpected thing. There are a few gigantic figures boldly and delicately indicated, some in Renaissance costume, others lightly draped or nearly nude. They hold their places admirably on the wall, being well enveloped, and they neither overweigh the small spaces nor yet clash with the numerous smaller

figures which, without being precisely in a second plane, occupy the intervals between the large ones. The linear pattern is less fluent and obvious than in the smaller pictures of the moment, 1914-15, with sharper contrasts and more salient uprights. One likes to imagine some analogy with the accented and unaccented notes of a bar of music. Overt musical suggestion there is none. The figures are without function or evident relation, but are sufficiently bound together by a common sense of a quiet eagerness and expectancy. They live in a purely mental world. They may be conceived more literally as waiting for the first chord of a music in which they are to join.

The *tour de force* involved in the scale of the figures—a procedure which gives the little room an illusion of monumental scale—is achieved by a novel beauty of color and of spatial arrangement. Imagine the conventional figures of an old Beluchistan rug suddenly embodied, and you will have approximately the rich and sober harmony of subdued hennas, darkling cerulean blues, and livid grays that Mr. Davies has woven over the walls. I say woven advisedly, for the whole surface, without imitation, has the unity of a sumptuous textile. I know nothing comparable unless it be

the rude but most effective painted cloths with
which the Turcomans, a century ago, used to
decorate their tents of ceremony. As compared
with these, Mr. Davies is infinitely subtle.

The whole design, without any sense of
actual or recognizable place, gives an illusion
of great space. This is effected along cubistic
lines, by an irregular diaper of geometrical
planes behind the figures, planes which tilt
towards or away from the observer, meeting
and evading each other in ever interesting and
suggestive relations. If we must have a for-
mula for the whole thing, it would be: human
symbols of the mood of song rhythmically
arranged before geometrical symbols for space.
The whole decoration is entirely lucid yet mys-
terious, completely strange without a false note
of exaggeration. As mere pattern and color
it is as quietly ingratiating to the eye as it is
in its mood captivating to the fancy. Since
Fragonard laid down his brush nothing so en-
trancing has been done in domestic decoration.

The fact that Mr. Davies had to wait for a
mural commission till he was past fifty is one
of the more discreditable oversights of the pa-
tronage of art in America. It was no fault of
his. For the Appellate Court of New York
he sent in an admirable design as early as 1890.

Its merits were not ignored even in the promiscuity of a general competition. But it was feared, as naturally as mistakenly, that so young an artist would be unable to execute the design acceptably. So the panels went to such veterans as Blashfield, Simmons, Cox, Mowbray and C. Y. Turner. As it stands, the Court House on Madison Square is an historic landmark of our mural painting. It contains nothing which has at once the graciousness of design and depth of color of Mr. Davies' rejected project.

Of about the same period as the music room is a little oval design for a ceiling which I have had the pleasure of seeing in the artist's studio. It is laid out formally in spandrels, but by the use of entirely conventional color in the figures it gives great height to the place it occupies. It was probably in hand during or soon after the time when Mr. Davies was hanging the Gauguins and Van Goghs in the Armory Show, though, for the rest, neither would have imagined such a pattern. It is this readiness to try a device or seek a principle, coupled with a vivid sense of beauty, that has made Mr. Davies a student of art of every period and an eager and successful collector. The same experimentalism has driven him into wood carv-

ing, metal work, enamel, and lately into modelling in low relief for the marble-cutter.

Mr. Davies' latest experiments are causing a renunciation of many of his older beauties in favor of a more resolute and unified effect. Unity has ever been the distinction of his art, but until recently he has been satisfied with what one may call the unity of melody and accompaniment, accepting in the same picture considerable contrasts and duality of rhythm. Indeed, this principle of a rhythm of higher tension for figure composition and of lower tension for the setting, justly involving a different type of pattern in foreground and background, might seem as consecrated by the practice of the great composers, as any similar musical conventions, for the same reason of long and successful precedent, will seem inevitable. I can hardly think of any great European painter except El Greco who habitually denies himself this dual rhythm. Greco carries the wildest rhythms into the depths of the picture in their full intensity, denying himself utterly the usual resources of contrast and relief.

For a year or two Mr. Davies has been working at a similar problem in his own way— to achieve a more vital rhythm and to keep it throughout the picture. Again a very heavy

sacrifice is involved, for Mr. Davies' use of contrasting and mutually supporting patterns has ever been consummately skillful. And he is working in a direction as perilous as alluring, for it could readily be maintained that Greco himself is too unified, too logically tense, too unmodulated. However that may be, Mr. Davies has always accepted hardily all the exclusions implied in his choices. Such moral lucidity, we may call it, is no small part of his superiority as an artist, and his new adventure is being pursued tenaciously. The new manner, which it would be premature to do more than briefly characterize, implies a more intense and dynamic figure composition, and a reinforcing composition of colors also arranged in terms of positive movement. The first part of the experiment is well advanced, and some cartoons have been exhibited. Those clusters of nudes boldly set in white chalk on black paper represent a sharp break with the old geometrical patterns of fifteen years ago and an only less abrupt departure from the undulating and processional arrangements of more recent years.

The composition now seems to grow out of some sharply bent figure, from which others are derived in natural relations of repetition,

reciprocation or opposing thrust. The initial
motion is determined by the physiological state
of the artist while working. Some such form
of composition Raphael employed for the Juris-
prudence and the Sibyls. Nature avails her-
self of a similar scheme when she builds an
eddy about its vortex. The finest part of Ba-
roque composition, for example, Tiepolo's, is
often of this sort, resting less on geometrical
pattern or space-filling than on guiding lines
and thrusts which emanate from a positively
disposed central figure. The numerous experi-
ments which Mr. Davies is making in this com-
positional form are powerful, ingenious, and
most stimulating. Doubtless the decorations
toward which such exercises look will be quite
different from these black and white sheets.
For the artist is also seeking a color which shall
grow out of the central color motive, support-
ing and opposing it as the figures support and
oppose each other. To this end Mr. Davies is
reviewing old experiments with tempera and
making new investigations of painting in fresco
and wax. He is in the plenitude of his powers,
in pink of form for great mural painting.
Where is the American amateur or organiza-
tion that will have the simple wisdom to profit
by the moment? For those who give Mr.

Davies a great mural commission today should incidentally build for themselves an enduring memorial.

And it is the moment perhaps when Mr. Davies' own precious talent should come out into the sunlight. To cope with the necessarily public character of mural painting would give the ivory tower that ventilation which it has sometimes lacked. In such a quest of absolute painting as Mr. Davies is conducting there is always peril. Strenuousness, refinement, preciosity, ever tend towards some sort of vanishing point. Mr. Davies' sound grasp of the data of nature, and his most scrupulous craftsmanship have so far kept him moving around the vanishing point rather than approaching it. Each new quest of the abstract has been accompanied by restudy of nature, and this has kept a basis of athleticism and wholesomeness in Mr. Davies' most subjective adventures. Yet it seems to me that it is the moment when he must either look out of himself, as the greatest artists ever do, or look deeper in, and strengthen his position among those intensely personal artists who, while often infinitely attractive, are never quite great. In short, the moment and the opportunity, unless I badly misread the situation, are critical for

Mr. Davies, and incidentally for American painting. The glory and the shame of a nation are largely bound up with the use it makes of its great talents.

In emphasizing and somewhat exaggerating the experimental and progressive side of Mr. Davies' genius, I have inevitably failed to express its unity. At all times he has been an idyllist of rarest distinction. Beginning with the frank idyllism of the senses, he achieved in his early work material beauties which he has since hardly surpassed. As he has worked, his Arcadia has widened from the intimate nooks that the outer eye readily grasps, to those larger spaces that are only discerned by the mind's eye. Latterly he has evoked a still more intellectualized Arcadia in which the eye calls up long memories of sound and of bodily action. One may say that he successively demands more of his observer and gives a little less, passing from full lyrical utterance and frank melodies to pregnant half-words and arpeggios of which the relations, though real, are occult. But in every phase he has created his world and has made it habitable and desirable for elect spirits—which is perhaps the simplest form of words wherewith to express high success in any art.

Postscript. The hopes expressed above were only in part to be realized. Davies completed for International House, New York, a series of decorations in which he returned to the idyllism and charm of his early manner. In them he probably reached his limit as a mural painter. He was soon to pay the price of his merciless endeavor for perfection. His studio was inviolate, and when the seizure came he lay unconscious on the floor for more than a day. He made a measurable recovery, busied himself with tapestry designs woven at Paris by the Gobelins workmen out of hours. In the autumn of 1929 while sketching in Italy he was again stricken, and after a considerable period of unconsciousness in hospital, died unknown—the news of his death filtering back to his friends in America after months. It was a solitary end, befitting the spirit that had ever observed a cult of solitude.

The Memorial Exhibition of 1930 in the Metropolitan Museum brought Davies' somewhat enigmatic work into a just perspective. The repetition of his elegant and scholarly formulas became a little cloying and monotonous. We had to do with cerebral evocations, in a sense with doctrines, seeking too deliberately and not quite successfully inevitable

forms. And again the spontaneous and lyrical pictures of his young manhood seemed the best. Such comparisons did not so much diminish as define him. He was evidently of the race of painters of charm, but had wanted to transcend his destiny. He had with mingled learning and audacity attempted to create a personal mythology. It had relatively failed as must all mythologies which are merely personal.

The endeavor was limited to a high and delicate exercise of the conscious fancy, not reaching to those depths of imagination in which the poet-painter meets and embodies the creative experience of his fellows and of the race. In New York and in our time probably an authentic myth maker was impossible. We had thirty years ago witnessed the portent in Ryder, and the miracle was not to repeat itself. The Davies of the idylls needs no praise of mine. They will count as long as charm itself. For Davies of the abstractions, the future seems less sure. At least our admiration is due for that heroic passion and rectitude with which Davies pursued an ideal quite alien to the place and time in which it was decreed he must work.

[1924, 1930.]

THE END